ARTWRITING

ARTWRITING

David Carrier

The University of Massachusetts Press
Amherst, 1987

Copyright © 1987 by
The University of Massachusetts Press
All rights reserved
Printed in the United States of America
LC 86-24995
ISBN 0-87023-561-3 (cloth); 562-1 (paper)
Set in Linotron Sabon by Rainsford Type
Printed by Cushing-Malloy, Inc. and bound by John H. Dekker & Sons

Library of Congress Cataloging-in-Publication Data

Carrier, David, 1944–
 Artwriting
 Bibliography: p.
 Includes index.
 1. Art criticism—History—20th century. 2. Art
criticism—Philosophy. I. Title. II. Title: Art
writing.
N7476.C37 1987 701'.1'80973 86-24995
ISBN 0-87023-561-3 (alk. paper)
ISBN 0-87023-562-1 (pbk. : alk. paper)

British Library Cataloguing-in-Publication Data are available

9.95

Portions of *Artwriting* have appeared in earlier versions in the following publications:

"Art and Its Market," in *Theories of Contemporary Art*, ed. R. Hertz (Englewood Cliffs, N. J.: Prentice-Hall, 1985).

"Gombrich on Art Historical Explanations," *Leonardo* 17 (1984):288–94; "Postmodernist Art Criticism," *Leonardo* 18 (1985):108–13; "On the Possibility of Aesthetic Atheism," *Leonardo* 18 (1985):35–39. Copyright © 1984 and 1985 by ISAST. Reprinted by permission.

"Color in the Recent Work," *Sean Scully* (Carnegie Institute, 1985), pp. 22–27. Copyright © Museum of Art, Carnegie Institute.

"Manet and His Interpreters," *Art History* (September 1985); reprinted with permission of *Art History* and Routledge & Kegan Paul PLC.

"The Presentness of Painting: Adrian Stokes as Aesthetician," *Critical Inquiry* (Summer 1986). Copyright © 1986 by The University of Chicago.

"Suspicious Art, Unsuspecting Texts," *Arts* (November 1985).

For A. C. D.

In contemplating history as the
slaughter-bench at which the hap-
piness of peoples, the wisdom of
states, and the virtue of individu-
als have been sacrificed, a ques-
tion necessarily arises: To what
principle, to what final purpose,
have these monstrous sacrifices
been offered?

<div align="right">HEGEL</div>

As regards plots I find real life no
help at all. Real life seems to have
no plots. I think a plot desirable
and almost necessary.

<div align="right">IVY COMPTON-BURNETT</div>

Contents

Acknowledgments

Artwriting is the product of my efforts as philosopher and art critic to understand the development of recent American art criticism.[1] When I was a graduate student, Richard Wollheim awakened my interest in aesthetics and in the work of Adrian Stokes. Stokes encouraged that interest, as have Ian and Ann Stokes Angus. In the late 1970s I began writing criticism under the influence of Joseph Masheck, then editor of *Artforum*; he has continued to support my work generously.

Mark Roskill patiently informed me about art history, read many drafts of this manuscript, and persuaded me that it would become a book. The philosopher Alexander Nehamas has been a friendly critic of much of my work. Sir Ernst Gombrich and Clement Greenberg have made brief, pungent comments on my interpretations of their texts; Michael Podro, Stephan Bann, and Norman Bryson have influenced my thought. Marianne Novy has helpfully argued with me, and I have taken some—no doubt, too few—suggestions from her. I thank also Elizabeth Frank, Leslie Strickland, my family, and the artists who have talked to me, some on many occasions: Thomas Bang, Jake Berthot, Howard Buchwald, William Coldstream, Maureen Connor, John Duff, Elizabeth Dworkin, Jean Feinberg, Craig Fisher, Sharon Gold, Richard Hennessy, Christopher Hewat, Stewart Hitch, R. B. Kitaj, Frances Lansing, Jonathan Lasker, Catherine Lee, Vered Lieb, Thomas Nozkowski, Harvey Quaytman, David Reed, Joyce Robins, Sean Scully, Barbara Westman, and Thornton Willis.

Acknowledgments, Leo Steinberg writes, create a characteristic "per-

sona engendered by the influence of the form.... Not a word about grievances, or about offenses received and inflicted."[2] In lieu, then, of mention of my colleagues, I thank those who did encourage this slowly developing project by publishing related materials and earlier versions of portions of this text: John Fisher and the late Monroe Beardsley, *The Journal of Aesthetics and Art Criticism*; John Caldwell, Curator of Contemporary Art, Museum of Art, Carnegie Institute; Terry Diffey, *The British Journal of Aesthetics*; Denis Dutton, *Philosophy and Literature*; Eugene Freeman, *The Monist*; Richard Hertz; Frank Malina and Roger Malina, *Leonardo*; Richard Martin, *Arts*; the other Richard Martin and Pam Wilkinson, my infinitely patient editors at the University of Massachusetts Press; John Onians, *Art History*; and Joel Snyder, W. J. T. Mitchell, and Margaret Berg, *Critical Inquiry*. I am thankful to them for permission to republish revised portions of the parts of this text which have appeared earlier. Thanks are due, as well, to those galleries which, waiving fees for reproductions, have helped make the publication of my illustrations possible.

My deepest debt is to three correspondents whose kindness has meant much to me: the painter Sean Scully; the art historian Mark Roskill; and the philosopher to whom *Artwriting* is dedicated, who will, I hope, read his influence in every line and accept this gift, small return for his generosity and friendship.

ARTWRITING

Overture

Artwriting is concerned with texts of recent art critics. The analysis draws on Arthur Danto's theory of interpretation and upon three connected conceptual points: the need to properly identify an artwork; the possibility of conflicting interpretations; and the use of rhetoric in interpretation. Because discussion within the text is focused on recent criticism, it is convenient to introduce these issues here with reference to examples from earlier periods of art history.

DANTO'S THESIS: IDENTIFYING THE ARTWORK

Danto's central thesis is that visually identical objects may be quite different visual artifacts when they are interpreted. Consider seven visually identical panels:

> *The Egyptians Drowning*, depicted as they chase the Jews across the Red Sea
> *Kierkegaard's Mood*, an expression of his inner state

Red Square, a Moscow landscape
Red Square, a minimalist painting
Nirvana, a Buddhist image
Red Table Cloth, a still life by a Matisse pupil
a red surface.[1]

These are six very different artworks plus one nonartwork, and the fact that each one of them can be described as a "red square" does not mean that they are identical visual artifacts. On the contrary, artists of earlier times would have been unable even to recognize that six of these artifacts are artworks. The minimalist *Red Square* could only have been created in the 1960s, after critics proclaimed that artworks need neither represent nor be expressive. *Kierkegaard's Mood* would have been incomprehensible to Piero, and *Red Table Cloth*, to Giotto; abstract images expressing inner states and still-life paintings were unknown to them.

These seven things, I am saying, are visually identical, but different visual artifacts. To tell *The Egyptians Drowning* from *Nirvana* what is required is not the connoisseur's eye, so keen at distinguishing an original from a school piece; nor the iconographer's skill, which permits the identification of a mysterious symbolic figure: what is required is some theory of art.

Danto's point is developed in conjunction with a systematic metaphysics. Consider an example from the theory of action. I move the switch and the light goes off; alternatively, I move the broken switch just at the moment when the electrician in the basement removes the fuse, and the light goes off. In both cases I move the switch and then the light goes off, but only in the former case does my action *cause* the light to go off. Consider a case from epistemology. I see a Datsun approaching and—because it appears to be my wife's car—believe that she will soon arrive. My belief is correct, for she is in her car; alternatively, it is another Datsun, but in fact she approaches on foot. In both cases my belief that she will soon arrive is correct but only in the former case is the belief *justified* by my perception of the car. Danto's important insight was to recognize the affinities between such cases studied in aesthetics, the theory of action, and epistemology. But his distinction between visually identical objects and different visual artifacts can be challenged. Leaving aside the more general philosophical disputes, that challenge is important for the discussion of artwriting.

Danto asserts that the seven visually identical panels are different visual artifacts once they are properly interpreted. The picture of the drowning Egyptians looks like the image of Kierkegaard's mood, but once we interpret these pictures, we recognize that they are different artworks. Suppose I instead describe the following seven entities:

a red panel depicting the Egyptians drowning
a red panel expressing Kierkegaard's mood
a red panel portraying a Moscow landscape
a red panel, a minimalist painting
a red panel, an image of Nirvana
a red panel, a still life by a Matisse pupil
a red panel, a paint sample

The fact that the phrase describing each of these visual artifacts contains the words "a red panel" gives no reason to think that they are identical entities. We have seven phrases which are identical only in part. And things that are identical only in part usually are not identical. To be sure, the seven panels are visually identical, but we are interested in the different visual artifacts picked out by these descriptions. Danto's claim that the seven panels are visually identical relies, it might thus be argued, upon an incomplete account of those panels; once their full description is spelled out, then his claim is unconvincing.

This is an abstruse argument. Sometimes, however, actual conflicts of interpretation depend upon such arguments about how to identify the artwork. Pontormo's Santa Felicita Altarpiece (see fig. 1) was traditionally identified as a Deposition in which "there is a tight emotional consistency."[2] Leo Steinberg argues that the work is not a Deposition; rather, Christ's body is depicted as being handed upward toward God the Father, who was represented on a dome, now destroyed, above the altarpiece.[3] "Pontormo's Santa Felicita Altarpiece" and "Pontormo's Santa Felicita Altarpiece Plus an Image above of God the Father" are different entities; and the art historian who misidentifies Pontormo's artwork will misinterpret it.

Steinberg's analysis depends both upon his interpretation of the existing work and upon a reconstruction of a larger work known today only from drawings and a written description. Other cinquecento paintings might offer relevant data, and further archival research could pro-

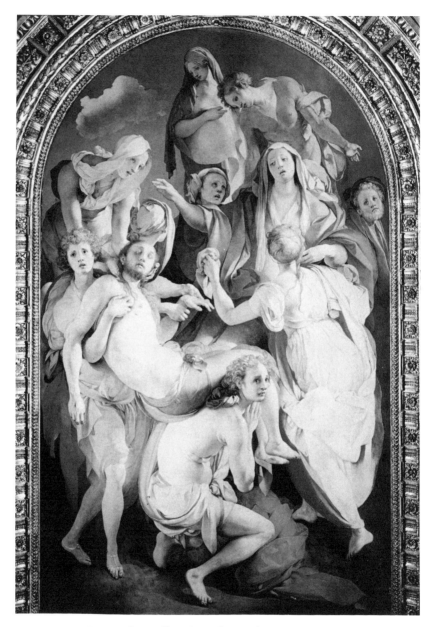

1. Pontormo, Santa Felicita Altarpiece, Capponi
Chapel, Santa Felicita, Florence.
(Alinaria/Art Resource, New York)

duce additional evidence; one clear drawing showing the entire original work *in situ* would settle this dispute. To speak of conflicting interpretations, then, is both to acknowledge that today the authorities disagree and to note that there is some agreement about what evidence is relevant to this argument.

An object is an artwork, Danto says, "only under an interpretation."[4] How do we understand his suggestion that a red square can, depending upon how it is interpreted, be seven different artworks? That one of any physically identical squares could be one of seven different works is no more surprising than that the surviving Pontormo in Santa Felicita, Florence, is so differently interpreted by Steinberg and his critics. The interpretation of the Pontormo is disputed because identifying the artifact made by the artist is a problem; Danto's cases involve relating a physical object, whose nature as such is not in question, to a written interpretation. If we take seriously his claim that the unit of discourse in artwriting is the artwork plus a text, then we cannot simply extract the red square from the various verbal contexts in which it is presented. It makes no sense to ask, "independent of context, what does a written phrase mean?" The same is true of a visual artifact.

Some literary critics espouse the slogan, "There is nothing outside the text." In a discipline in which both the objects of study and the commentaries on them are texts, maybe it is natural to have some difficulty finding any relevant evidence outside of the texts. Because artwriters describe visual artifacts, they are not likely to have this problem. Danto's book reminds us, however, that these artifacts are identifiable as artworks only by being placed in relation to texts.

There is a certain tension apparent, then, between thinking of an artwork as a self-sufficient thing and as an object ultimately inextricable from the texts in which it is interpreted. Unless there is some common object, a red square, in his seven different descriptions, how can Danto say that the artwork is not identified merely by relation to its visual qualities? Unless conflicting interpretations describe some such artifact, how can interpretations conflict? Yet, to the extent that an artwork *is* an artifact plus an interpretation, it is hard to understand how such conflicts are ultimately genuine. Another example is helpful.

Manet's *Bar at the Folies-Bergère* (fig. 2) has recently been much discussed. We see a barmaid facing us, with her reflection in the mirror in a position inconsistent with that frontal view. How then can we understand the picture space?

Referring to Lacan's account of "the mirror stage," T. J. Clark treats this image as a play on the illusory nature of the self.[5] Because we have an ambiguous relation of the girl to the reflected man—"the transaction with the girl who leans towards him taking his order cannot be the same as our transaction with the girl who gazes back at us"—we look into an impossible space, one where "we are left no place . . . least of all the place we are allotted in the mirror." Clark sees a scene of capitalist alienation; the barmaid is a whore soliciting our gaze.

Richard Wollheim sees the painting as not excluding us, but as putting us in the picture space. If we identify with the reflected man, we see Manet using "the man's reflection . . . to inculpate the spectator in the man's sexual advances. . . ."[6] As Leo Steinberg wrote earlier, this is a picture "which, like the sexes, require(s) opposites for consummation."[7]

Another artwriter describes the inconsistent reflection as a formal device: "Manet's space is not explainable or enterable, but remains poised at that curious point of tension between plane and illusion—the very tension which was to lead artists to new solutions in the twentieth century."[8] Alternatively, for George Mauner, the image reveals neither capitalist alienation nor a new kind of space, but concern with "the age-old question of 'existence' and reality."[9] It has also been claimed that from the barmaid's position, the picture *is* consistent; viewed as "a reflection of reflections . . . the picture holds together."[10]

Violent exception has been taken to Clark's claims. Perhaps Manet "had no intention of portraying the degradation of a fallen woman," though such barmaids could, admittedly, "easily enough become whores [if] pretty."[11] It is also possible to note that the image is inconsistent without adopting any of these explanations. "Probably Manet never intended that such a static position" for the spectator be inferred; rather, he sought to suggest the "confusion of sounds, the clink of glasses, the performers' music, and the chatter of agitated conversation" of the entertainment hall.[12] An older tradition of Manet interpretation discussed

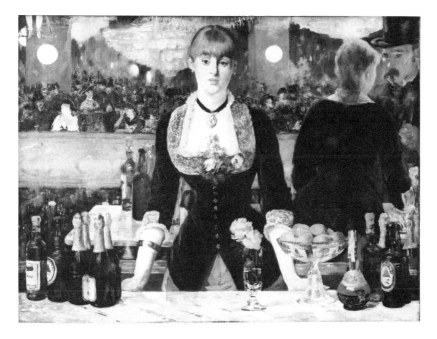

2. Edouard Manet, *A Bar at the Folies-Bergère*.
(Courtauld Collection, Courtauld Institute
Galleries, London)

his weaknesses in composition, so it would be possible to assert that this inconsistent image simply shows his ineptness.[13]

Clark's claim that we are excluded from the picture space seems inconsistent with Wollheim's belief that we are to identify with the depicted man. Still, someone with a high tolerance for visual ambiguity might note that these are mutually incompatible accounts only if we assume that a painting must present a consistent space. In any case, neither account is necessarily incompatible with viewing the painting as a play on existence and reality. Asserting that the woman cannot be a prostitute is unconvincing, though. Contemporary Paris guidebooks tell us that prostitutes were found in the Folies-Bergère, but they cannot tell us how to understand the mirror image. Obviously, Clark's is in part a political argument, as identifying her as "a fallen woman"—what a Victorian phrase!—indicates. Clark is heavily influenced by Guy Debord's view of the modern city as spectacle: "The spectacle is not a collection of images, but a social relation among people mediated by images . . . it is the common ground of the deceived gaze and of false consciousness. . . ."[14] Wollheim, while acknowledging that cities may become spectacles, resists our tendency to turn "the city in which one actually lives into a succession of flickering images."[15]

Consider two ways of describing this debate in relation to Danto's thesis.

First, debate can proceed only because there is so much agreement. Everyone sees the barmaid and sees that the space is inconsistent; the argument is about the meaning of these visual facts. Nobody who found Clark's politics entirely unacceptable could accept his analysis. He elsewhere claims:"Impressionism became very quickly the house style of the *haute bourgeoisie*, and there are ways in which its dissolution into the decor of Palm Springs and Park Avenue is well deserved. . . ."[16] An art historian who found this remark unfair could still debate with Clark.

Second, acknowledging that there is a common object of discussion is peculiarly unhelpful in resolving the conflict of interpretations. Because Clark's account is linked to Debord's political viewpoint, Wollheim's analysis placed in another political context, and so forth for all the accounts, where is the conflict? Compare the entities:

A Bar at the Folies-Bergère plus Clark's text
A Bar at the Folies-Bergère plus Wollheim's text
and so on.

These phrases, which all mention the same painting, differ one from another as much as what remains today of Pontormo's Santa Felicita Altarpiece differs from that work as controversially reconstructed by Steinberg.

Both ways of describing this debate have some plausibility. The interpretations disagree about an artwork, and those disagreements are embedded in their differing contexts. We need some way of describing this situation that both allows for genuine disagreement and recognizes that this disagreement reflects how the work is inserted into these contexts. An analysis of rhetoric is useful in explaining this conflict.

THE RHETORIC OF ARTWRITING

Artwriting aims to be suasive. An interpreter of Manet aims to make his or her account as convincing as possible. In art criticism, much rhetoric seeks to persuade viewers that the works described are aesthetically significant. Today we all do know the importance of Manet's work is agreed upon. The value of contemporary art, however, remains to be established, so art criticism, unlike art history, is never disinterested.

Consider earlier examples of the rhetoric of artwriting on Venetian painting. Bernard Berenson's account borrows from and modifies the claims of earlier writers. A complete account of that tradition would begin with Vasari and Dolce; for my purposes, Hegel's early nineteenth-century analysis provides a better starting point.

According to Hegel, painting, "the art of pure appearance," uses color to rich effect when "with light, nature begins for the first time to become subjective."[17] Modern art thus distinguishes itself from Egyptian architecture and Greek sculpture. "We see fixed the most fleeting appearance of the sky, the time of day, the lighting of the trees." Color appears most vivid in Dutch and Venetian painting, art from places "near the sea in low-lying country intersected by fens, streams, and canals." Hegel never

saw Venice, but in Goethe's *Italian Journey* he could read, "As I glided over the lagoon in the brilliant sunshine, I felt I was looking at the latest and best painting of the Venetian school."[18] Such observations became commonplace in travel literature. H. A. Taine notes "these fluctuating and voluptuous appearances of things that the Venetian coloring" derives from; Jacob Burckhardt, that Venetian painting replaces "so called poetical ideas" with "picturesque ideas."[19]

In Venetian art, according to Walter Pater, "the meaning reaches us through ways not distinctly traceable by the understanding."[20] Pater draws on Hegel, while deriving his information about Giorgione from the Victorian artwriters Crowe and Cavalcaselle. Their somewhat flat-footed account describes Giorgione's life and provides a list of attributions.[21] Unlike Hegel, Pater is interested in an individual artist and his followers; unlike Crowe and Cavalcaselle, he is not concerned with attributions. He draws a group portrait of Giorgionesque painters.

Berenson sometimes borrows openly from Pater. The Venetians, he writes, deal with subjects "for the sake of the effects of colour and light and shape ... [that] could no more permit being translated into words than a sonata." A Hegelian and Pateresque account, however, would not have persuaded his patron, Isabella Stewart Gardner, to purchase Venetian paintings; nor were these speculative thinkers concerned with the connoisseur's primary interest, reliable attributions. Unlike his precursors, Berenson lived on commissions from sales of works for which he provided attributions, and his scholarly objectivity existed in a sometimes uneasy relation with that activity. Attributions involve both purely art historical and practical concerns; to properly identify Giorgione, we must have reliable attributions, which distinguish valuable originals from less valuable school works, copies, and mere forgeries.

The very structure of Berenson's *Venetian Painters*, which joins a long list of attributions to an essay explaining why Venetian painting deserves attention, illustrates this position. The title of Pater's essay "The School of Giorgione" indicates his lack of interest in attributions; Berenson says that defining the artist's oeuvre is important. "Giorgione created a demand which other painters were forced to supply at the risk of finding no favor. . . . followers had only to exploit the vein their master hit upon to find ample renumeration."[22] Berenson treats the Venetians as if they were contemporary artists. Though "nominally continuing to paint the

Madonna and saints," they actually painted "handsome, healthy sane people like ourselves," good practical Bostonians, not crazy Catholic saints. Their art shows "an acceptance of things for what they were." They are artists with whom an American collector could identify.

Berenson's early career marks the dividing point between nineteenth-century amateur art history and its modern professionalization. Hegel wrote about Italian painting without visiting Venice; Crowe, originally a journalist and war correspondent, was in large part self-taught; Pater was a classicist. Unlike them, the young Berenson wrote at a time when nouveau riche Americans sought social prestige by amassing collections of "old master" art. Art collecting had long existed, but only in Berenson's time was this large new market opened up. By the date of Berenson's death, most old master works were in public collections or their export controlled by law; his successors are curators or professors.

Frank Jewett Mather's *Venetian Painters* (1936) illustrates this transition between Hegelian speculations and modern art history.[23] Unlike Berenson, he reconstructs Giorgione's life in detail. The artist knew Leonardo; "is it hazardous to assume" that the "courteous Florentine would have repelled the advances of a youth with such ability and social charm?" he asks. The woman with the child in *The Tempest* is seen as perhaps a love of Giorgione; still, though "no doubt a great lover," Giorgione was no debauchee. If his self-portrait as David, Goliath's slayer, shows a mouth that "has known many kisses," he was still a gentleman.

Asserting, instead, that Giorgione and Leonardo were lovers, and that the Venetian identified with Goliath rather than David, though as plausible, would have made Giorgione sound considerably less Bostonian. Because Mather finds it "positively humiliating" to write about "a man whose works are so poorly documented," why offer these conjectures? Historical narrative must have a *subject*, some person or thing that develops in that narrative.[24] For example, Roger Fry's *Cézanne* asserts that the young expressionist became a mature classicist. The book relies on a "law" of psychology—"all great Classics are made by the repression of a Romantic"—as well as a selective reading of the evidence; Cézanne's late nudes, seemingly romantic, are of marginal importance for Fry.[25] Not every artist provides the historian with a *subject*. Some die young, almost without developing (such as Seurat); others do much derivative work before finding their styles (for example, Morris Louis); some almost

cease to evolve (Morandi) or change without necessarily evolving (Picasso). Obviously one man made all the genuine Giorgiones; Mather's problematic assumption is that we can usefully relate that man's life to Giorgione's work.

Mather's *subject* is Giorgione; Pater's, the school of Giorgione; Berenson's, Venetian painting. An artwriter's *subject* may thus be an individual or a group of artists. Giovanni Bellini, Giorgione, and Titian did work similar enough that we may usefully speak of a fictional *subject*, Venetian painting, as if the work of all these different artists had been done by one man. I henceforth use the word *subject* as a technical term, italicizing it to indicate this special meaning; just as we speak of the development of the work of an individual man, so I think of a *subject* as having an origin, a period of mature work, and—some centuries later—a decline and "death." Unlike a person, this *subject* has only a fictional unity; we must decide what works belong to the *subject*, Venetian painting.

Some modern art historians borrow from this Pateresque tradition of writing about Venetian art. Johannes Wilde describes a Giorgione altarpiece as expressing "a dream-like state of mind" related to those "in which almost all Giorgione's figures appear to indulge"; in a focused analysis of one work, he echoes Pater.[26] S. J. Freedberg employs another technique, setting up a group of comparisons: Giorgione assigned primacy "to conceptualized feeling"; Bellini's forms are more naturalistic. Leonardo's light defines form, whereas Giorgione's concern is with "seeing light primarily as colour."[27]

Pater mentions *The Tempest* without interpreting it; he says that Giorgione achieves a "perfect" unity in which "form and matter in their union or identity, present one single effect to the 'imaginative reason.' ... "[28] Salvatore Settis's *La "tempesta" interpretata* (1978) summarizes twenty-eight earlier accounts before giving his interpretation, which involves a complex comparison with a relief in Bergamo showing God creating Adam and Eve.[29] A still more recent paper argues that the painting is about the loss by the Venetian Republic of mainland towns in 1509.[30] As with *A Bar at the Folies-Bergère*, interpretations that draw on visual analyses contrast with those that treat the painting as a political com-

mentary. Today, in any case, the study of Giorgione has become an affair for professionals only.

Goethe, Hegel, Taine, Crowe and Cavalcaselle, Burckhardt, Pater, Berenson, Mather, Wilde, Freedberg, and Settis describe some of the same Venetian paintings; so one way to understand their writing is to reflect on the changing role of the artwriter. Freedberg admires Berenson, but no professor today could write a serious essay in the style of *Venetian Painters*. It is easy to be condescending about earlier writers. Hegel and Pater knew few of the facts that our historians have discovered; Berenson's essay is a semipopular text; Mather's book is charmingly naive. On reflection, however, we might recognize that these different styles of argument serve differing goals. Modern art historians are uninterested in Hegelian speculations, marketing Venetian painting, or writing historical novels about Giorgione; consequently, they write differently from their precursors. Pater's evocative essay does not inspire further research; Settis's does, since he offers a debatable thesis. Thus, understanding artwriters' claims relative to their goals avoids the error of judging our ancestors to be limited merely because they do not conform to our standards.

The above conclusion enriches and complicates my earlier discussion on the conflict of interpretations. The perhaps inevitable effect of describing these historically changing styles of interpretation is to undermine the belief that there are ahistorical standards by which to judge interpretations. Of course, we might conclude that present-day interpretations are the best. Because standards of interpretation continue to change, however, in another century perhaps our interpretations will seem as dated as Berenson's and Pater's do today. If evaluation of an interpretation requires consideration of the interpreter's goals, it may be hard to see how we could arrive at such an ahistorical standard. Today the various interpreters of Manet compete one with another; because Pater, Berenson, and Settis wrote at different times and pursued different goals, locating the conflict between their accounts seems less important. Instead of asking "Is this account true?" we might better ask "What function does this text serve?"

This is not to say that I am uninterested in argumentation in artwriting;

on the contrary, *Artwriting* itself contains much argumentation. We should admit, though, that an account of abstract arguments tells only part of the story. One goal of interpretation is to analyze the artwork truthfully, but in the practice of artwriting, the notion of truth is highly complex. Let us turn now to a discussion of that analysis.

I Beginnings in Narrative Art Histories

How does a historical narrative begin? "In the beginning God created the heaven and the earth"—Genesis 1.1 describes an absolute beginning, the moment before which nothing happened. Other more parochial narratives have some starting point in time. "It is a truth universally acknowledged that a single man in possession of a good fortune must be in want of a wife"— *Pride and Prejudice*'s first sentence marks the absolute beginning of Jane Austen's narrative. Because her fictional characters exist only in that text, it does not make sense to ask what they were doing earlier, even if her realism encourages us to think of the Bennets as existing at previous times. Because a historian represents a chosen segment of history, he or she needs to defend that choice by explaining why events before its beginning lie outside the scope of that history. A history of Venice could discuss the weakening of Byzantine power in early medieval times; the story of the Roman Empire's formation would probably lie outside such a narrative's beginning.

Such a narrative I distinguish from a mere *annal*, a listing of events in order of their occurrence.[1] For example, consider the following annal:

Giotto paints Arena Chapel, 1306
Leonardo paints *Mona Lisa*, 1502
Constable paints *Wivenhoe Park*, 1816

A historian can turn this annal into a narrative by connecting these events: "*Wivenhoe Park* marks the culmination of the naturalist tradition, exemplified in Leonardo's *Mona Lisa* and begun by Giotto's work in the Arena Chapel." Note that just as Vladimir Nabokov's biography of Gogol begins with his deathbed scene, this little history also has a beginning, middle, and conclusion, but not in that order.

Clement Greenberg and Ernst Gombrich write such narratives, and much is to be learned about the strengths and ultimate limitations of Greenberg's criticism by comparing and contrasting his and Gombrich's texts. Both construct what I called a *subject* in the Overture, the history of naturalistic art for Gombrich, the story of modernism for Greenberg. For Gombrich, modern naturalism begins with Giotto. For Greenberg, modernism starts with Manet; pre-Giottoesque art and old master painting come before the beginnings of their subjects. If the natural order of an art history narrative is "prophet-savior-apostles," this is because in such a story painters who come before its beginning are interesting insofar as they prepare the way for the figures who do appear in that narrative.[2] For example, Vasari begins his account of Giotto, his first real figure, by reference to Giotto's precursors: "Instructed by Cimabue and aided by Nature, the boy not only equalled his master ... but ... totally banished the rude Greek manner, restoring art to the better path adhered to in modern times. ... "[3] Pre-Giottoesque painting stands outside his story as, for Greenberg, painting before Manet stands outside modernism. Gombrich's *Art and Illusion* builds on Vasari, telling the story of naturalism in a vocabulary borrowed from modern psychology.

More exactly, Gombrich's history has two beginnings: Greek naturalism and the revival of that tradition in the Renaissance. Just as his history starts twice, so in effect does the book *Art and Illusion*; Gombrich devotes his first two chapters to explaining the limitations of naturalistic

images before beginning his account of Greek art. This is puzzling. Why not begin with the beginning of naturalism? Gombrich's annal is:

Egyptian prenaturalism
Greek naturalism
Byzantine antinaturalism
the Renaissance revival of naturalism
the development of naturalism
the end of naturalism in the nineteenth century.

But his *narrative* has a more complex order. A picture "is a transposition, not a copy" of what it depicts.[4] Gombrich shares with Vasari the belief that Giotto did something new, but he cannot simply equate Giotto's naturalism with lifelikeness of imagery. For Vasari, the naturalistic tradition reaches its culmination in his own time; for Gombrich, that tradition has ended some time ago. These differences are signaled in Gombrich's complex opening strategy.

"In real history," Gombrich asserts, "there are no new chapters and no new beginnings."[5] Still, he, like any writer, must divide his story into chapters. Other art historians tell this story differently. For Andre Grabar, Byzantine art does not break with classical naturalism: "we must not forget that the art of late antiquity was a large family, to which the first Christian art also belonged."[6] For Otto Demus, "Byzantine art was the living continuation of Greek art and so led Western artists back to the classical sources"; Giotto is a figure in that unbroken tradition.[7] Grabar and Demus reject the older claim that pre-Giottoesque art was decadent. Taine reflected this older view when he found the angels in Ravenna "great simpletons with staring eyes, hollow cheeks, and that chilled air common to peasants who, taken from the fields and transported amid the bickering, formalities and restraints of theology and the seminary, become bleached and yellow, stupid and abashed."[8] Gombrich grants that such a view is unfashionable without really giving up his belief that Grabar and Demus are wrong. He claims that "the achievements of Greek illusionism *were* gradually discarded" and Giotto did revive that tradition.[9]

How does the process of naturalistic image making begin? Gombrich distinguishes image making as such from the naturalistic tradition. For

him, understanding the absolute beginning of image making requires a myth. A child plays with a stick that "becomes a horse in its own right"; Pygmalion makes a statue that comes alive. The distinction between a substitute that represents something and that thing itself becomes blurred.[10] Pygmalion and the child satisfy their desires, as we all do in dreams, according to Freud, by treating those desires as if fulfilled. The origin of representation making is thus hard to trace and probably impossible to date.

In that the Pygmalion story is a myth, what function does it serve as described in Gombrich's work? Seeking the historical beginnings of naturalism in ancient Greece and Renaissance Italy is to look for a real historical event; by contrast, this playing with magical symbols falls outside the boundaries of recorded history. Gombrich uses this mythical prehistorical moment to identify the birth of naturalism by contrast. Pygmalion makes a symbol, Giotto engages in making and matching. Thus they have different attitudes toward reality. Byzantine art regresses to a form of magic; Giotto creates pictures showing holy figures as we might actually imagine them to appear. Perhaps he was influenced by the Franciscans, who "took the Gospel story to the people and spared no effort to make the faithful re-live and re-enact it in their minds," just as hearing Homer's poems might have inspired Greek naturalists.[11] Compared with a sculptor, the earlier Nicola Pisano, Giotto really does something new. Now "we seem to witness the real event as if it were enacted on a stage."[12]

Because Gombrich so brilliantly reworks this Vasarian view, we need to consider closely his exact assumptions. Treating a Giotto as a precursor to a Constable is to point to their common features: unlike Byzantine works, both aim to re-present some actual scene. Still, although we can compare *Wivenhoe Park* to the actual Wivenhoe Park, a Giotto *Last Supper* depicts an event neither he nor we could witness. Many Renaissance *Last Suppers* treat that event as if it took place in contemporary Italy, but once painters worried about achieving archeological accuracy, such images seemed unsatisfactory. Gombrich's *subject* elegantly brings together otherwise different works, Renaissance religious narratives and landscape painting. We may better understand his skill as narrator by comparing *Art and Illusion* to more limited accounts.

Edgar Wind's clever, perverse argument is that art without icono-

graphic significance is relatively impoverished.[13] To him, Pontormo's *Santa Felicita Altarpiece* is both a beautiful image and a meaningful symbol; *Wivenhoe Park* just shows a landscape. Interpretation for Wind requires the study of iconography. Gombrich's more subtle suggestion is that there are similarities between the iconographer's search for symbolism and the act of interpretation required in viewing a Constable. The *subject* of *Art and Illusion* thus can be "naturalism from Giotto to Constable" because a religious narrative is akin to a landscape.

Gombrich's admits that his *subject* has a complex identity: "From Giotto through impressionism, artists' interests gradually shifted from the best way of telling a sacred story . . . to the methods of representing a piece of nature in the most faithful way."[14] Though these ideals "do not necessarily clash," obviously their relation is complex. New genres such as landscape painting are created in response to demand. For instance, an interest in Dante's appearance produced portraits of him, and the origins of still life and of caricature can be similarly understood.[15] What links these genres together is that they all involve the use of schemata in making and matching. Schemata, for Kant, are methods of constructing images: "images become possible only through and in accordance with schemata. . . . Images are always particular; schemata always universal."[16] Gombrich identifies four distinct types of schemata; simplified visual forms, like those in elementary drawing books; "Morellian" forms, such as Poussinesque eyes and Belliniesque ears; compositional structures, as those poses created by Michelangelo or Rubens, which later artists can imitate; and traditional themes, including Annunciations, Last Suppers, and Arcadian figure groupings.[17]

Gombrich provides relatively few clues about how these different uses of schemata are connected; to speak as if his narrative took us step by step from Giotto to Constable is to overestimate even his narrative skill. At most, the concept of "making and matching" provides some hints about how he tells the story. Only schemata of the first sort lead toward more naturalistic images. Drawing books often start with a generalized image and then show how to depict the features of an individual man, dog, or tree. Analogously, we can perhaps envisage successive generations of artists learning to depict their figures more accurately, as if the history of naturalistic painting were the story of one *subject's* education.

Another myth about the origin of painting is available, and it is useful

to see how it gives a different view of naturalism from Gombrich's Pygmalion fantasy. In Gombrich's story, the first representation is a symbol indistinguishable from what it depicts. The story of the Corinthian maid, told by Pliny, and often illustrated in the eighteenth century and, more recently, in a parody of socialist realism by Komar and Melamid (see fig. 3), has quite different implications.[18] The maid makes a representation of her soon-to-be-absent boyfriend in order to retain an image of him; like a photographer, she produces that image by direct tracing. For a historian of naturalism, her image provides a less useful starting point than the Pygmalion fantasy. It fails to suggest why Giotto is the first Renaissance naturalist artist, since her image already is an accurate, "naturalistic" representation. Linear representations are important in neoclassical art, but that movement comes late in the history of naturalism; so its relation to the origin of naturalism is unclear.[19]

Gombrich seeks to tell the story of naturalism while avoiding the historicist assumption that artists early in that tradition do not understand their own activity. For Hegel, artists are not aware of the full significance of their activity. Gombrich wants to deny this claim. In one sense, of course, any history redescribes earlier works; Giotto could not have known that his art was the starting point for a tradition in which Constable plays a role. Still, Giotto intended to make naturalistic images, and so he could understand Gombrich's account of his work.

Greenberg's story is a Hegelian account. This, even more than his very different view of modernism, distinguishes his historical narrative from Gombrich's. His thesis is that modernism originates in making explicit properties of art "treated by the old masters as negative factors that could be acknowledged only implicitly or indirectly."[20] For example, whereas the old masters "created an illusion of space in depth that one could imagine walking into," that space in a modernist work "can be traveled through only with the eye." A pre-Giottoesque painting and a naturalistic work look different, and Gombrich's aim in beginning his history is to explain that difference in visual appearance. By comparison, Greenberg's beginning is harder to define, because his concept, acknowledgment of the medium's properties, is more complex. He and Gombrich share the belief that the story of art is best told in a historical narrative, but disagree radically about how to write that narrative.

Consider some cases where their accounts conflict. Greenberg gives

3. Komar and Melamid, *The Origin of Socialist
Realism*, 1982–83. (Photo: D. James Dee.
Courtesy Ronald Feldman Fine Arts, New York)

Manet an important role as the first modernist; Gombrich treats him as a traditional naturalist. If at first those "not acquainted with Manet's intentions" were baffled, today "we have the illusion that we really stand face to face" with his depicted figures. *Luncheon on the Grass* is "a simple transposition of a detail from a composition by Raphael," an instance of making and matching.[21] What for Gombrich are traditional works inaugurate modernism for Greenberg. Gombrich's *subject* is naturalism from Giotto to Constable. Greenberg's *subject* is modernism from Manet to the present, so the old masters come before the beginning of his *subject*.

For Gombrich, cubism marks the end of the tradition. It "prevents a coherent image of reality from destroying the pattern in the plane," thus driving "home the message that this is an exercise in painting, not an illusion"; and Pollock's visually ambiguous paintings (see fig. 4) can only be read as images of urban rubbish.[22] For Greenberg, impressionism leads toward cubism and abstract art. Cézanne's planes of color, creating a "vibration, infinite in its terms, between the literal paint surface . . . and the 'content' established behind it," lead to cubism; and Pollock continues that tradition.[23] "Pollock pinned the facet-plane down . . . in the interstices and flecks of the skeins of paint that fill his 1947–1950 pictures," thus creating "an illusion of indeterminant but somehow definitely shallow depth that reminds me of . . . Analytical Cubism"[24] (As in Picasso, see, for example, fig. 5.) As in making and matching, artists learn from their precursors for both writers; but what they learn is described differently. Like Gombrich, Greenberg sees cubism as creating a visual deadlock, and Pollock as constructing an ambiguous space. But what are defects, if we think that painting should depict recognizable forms, become virtues when we believe that modernism aims to open up an illusionistic space without depicting recognizable forms. What for Gombrich was a break with tradition becomes in Greenberg's account a way of continuing the tradition.

Compare now Gombrich's view of the relation between Cézanne and the cubists. Cézanne's "uncompromising honesty . . . made it manifest that if you were really faithful to your vision . . . the elements will not fuse in the end into a convincing whole. . . . The cubists took the opposite path. They kicked aside the whole tradition of faithful vision. . . ."[25] Though different from Greenberg's claim that cubism emerged "in the

course of " the effort "to fill out that vision of a 'purer' pictorial art which" the cubists "had glimpsed in Cézanne," this observation is not inconsistent with Greenberg's history. It is true both that the cubists, unlike Cézanne, did not make consistent representations and that they were influenced by him; indeed, in his discussion of collage, Greenberg cites *Art and Illusion* to support his analysis.[26] In a history of naturalism, cubism has no role; in a formalist history of how paintings create an illusionistic space it is important. So here Gombrich's and Greenberg's accounts need not conflict.

One commonplace objection to *Art and Culture* is that in it Greenberg gives a prescriptive history, a story in which Cézanne's art inevitably leads to cubism and on to Pollock's paintings. The only necessity I detect in his texts, however, is narrative necessity; like any gifted historian, he represents what happened as if it were inevitable. He does, I grant, write of Diebenkorn, "His development so far is what one might say the development of Abstract Expressionism as a whole should have been."[27] What this means, though, is that now, when the movement has ended, we can look back and understand what the artists did.

As Greenberg is interested in how the logic of impressionism "had to work itself out regardless of the volition of individuals,"[28] I am interested in how his historical narrative functions, whatever his intentions. *Art and Culture* has five parts: Marxist essays on Eliot and kitsch; studies in early modernism; a section on theory; brief accounts of the abstract expressionists and other American artists; and a concluding selection of literary criticism. The annal is:

> old masters
> early modernism (impressionism, Cézanne, cubism)
> abstract expressionism.

The opening Marxist essays and concluding essays on literature constitute a frame for this annal. In analytic cubism, "the corners or margins in which the signatures would have had to be placed were just those areas of the pictures that could least afford having attention called to their literal flatness."[29] Analogously, Greenberg's marginal essays call explicit attention in some surprising ways to his strategies.

His general thesis seems straightforward. The chapter "Avant-Garde and Kitsch" asserts that modernism imitates "the disciplines and pro-

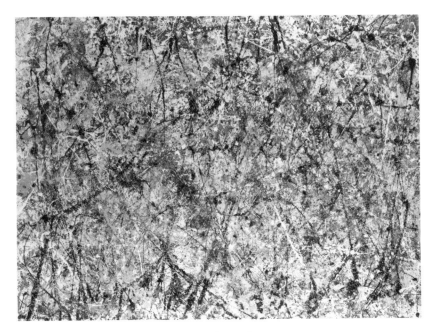

4. Jackson Pollock, *Number 1, 1950 (Lavender Mist)*. (Courtesy National Gallery of Art, Washington. Ailsa Mellon Bruce Fund)

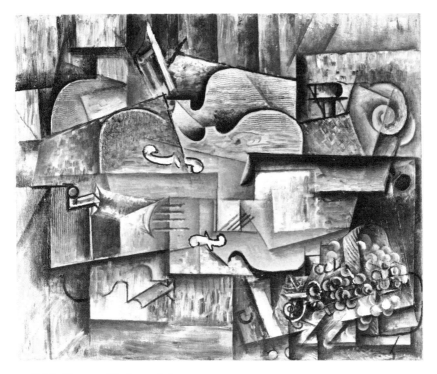

5. Pablo Picasso, *Violin and Grapes*, 1912,
summer or early fall, 20″ × 24″, oil on canvas.
(Collection The Museum of Modern Art,
New York. Mrs. David M. Levy Bequest)

esses of art and literature themselves." If Picasso and Pollock merely played with nonrepresentational images, then their work would be "arbitrary and accidental"; in fact, they create "in obedience to some worthy constraint or original." Constable imitated nature; abstract art "is the imitation of imitating." But in the narrative this thesis becomes more complex.

Greenberg's second section describes early modernism and the fourth section, abstract expressionism; the intervening essays on theory place modernism in a relation to "old master" art. This narrative order,

> early modernism
> old master art
> abstract expressionism,

undermines, implicitly, the annal, which emphasizes the continuity between French modernism and American painting. Greenberg thus, in effect, acknowledges the difficulty of constructing a genealogy for Pollock, in which he is Picasso's successor. Nowadays when art history survey texts appropriate his argument, Greenberg's originality is hard to appreciate fully. In the 1940s Pollock and his fellow abstract expressionists were little known; there was no tradition of ambitious American painting. The assertion that Pollock was the successor to the old masters must have seemed fantastical. Roger Fry's somewhat Greenbergian account of Cézanne failed altogether to link him to cubism; making the further connection to Pollock took even more boldness.

Greenberg did not, of course, invent the concept of modernism, but comparison with one important earlier account indicates how original his analysis was. Baudelaire discusses modernism, but when he argued that beauty has both an eternal element and a variable aspect— "contemporariety, fashion, morality, passion. . . . Since every age and every people have had their own form of beauty, we inevitably have ours"— his analysis seems relatively superficial.[30] He wants depictions of contemporary Paris, not a novel use of the medium of painting.

Greenberg's analysis of old master art is as relatively undeveloped as Gombrich's account in *Art and Illusion* of nonnaturalistic painting. "From Giotto to Courbet, the painter's first task has been to hollow out an illusion of three-dimensional space on a flat surface."[31] Though the word "first" reminds us that Greenberg concentrates on describing a

space, and not the subject matter filling it, these words are a recognizable variation on Alberti (1435): "I inscribe a quadrangle of right angles... which is to be considered to be an open window through which I see what I want to paint."[32] Gombrich describes the making and matching that makes that content identifiable; Greenberg, the space itself. Thus, as we have seen, how old master paintings are described determines how modernism is understood.

Although Greenberg disagrees in some ways with Roger Fry's formalism, Fry's analysis of a picture he believed to be by Poussin illustrates some strengths and limitations of this way of thinking about old master art. Fry describes his impressions of *Achilles Discovered among the Daughters of Lycomedon* (see fig. 6) in "as nearly as possible in the order in which they arise." First he sees the composition: "the curious... receding rectangular hollow of the hall seen in perspective... in contrast to that of the chamber in which the scene takes place.... This we see to be almost continuously occupied by the volumes of the figures disposed around the circular table." Though a strict formalist could only note the position of forms in the picture space, Fry identifies architectural elements and human figures. "We note, too, almost at once, that the excessive symmetry of these four openings (at the end of the hall) is broken by the figure of one of the girls, and that this also somehow fits in with the slight asymmetry of the dark masses of the chamber walls." Fry contrasts this "brilliant" composition to the dull story, which "has not even suggested itself" until the formal analysis was completed. After studying that story, we turn "from it, if not with disgust, at least with relief at having done with so boring a performance."[33]

His analysis is of course deliberately provocative, and the claim that we study the space before identifying Ulysses, Achilles, and the other figures is plausible only if we accept his formalist assumptions. Fry's very verbs, "we note," "we see," imply that everyone should accept his narrative, as if formalism provided the only sensible way to interpret the picture.

To acknowledge, as Anthony Blunt said, that Fry was right to think that his account would have made Poussin "speechless with indignation" would indicate why today no art historian could find this interpretation adequate.[34] Still, to simply reject the analysis fails to do justice to Fry's aim. Although his attribution is faulty, his belief was that attributions

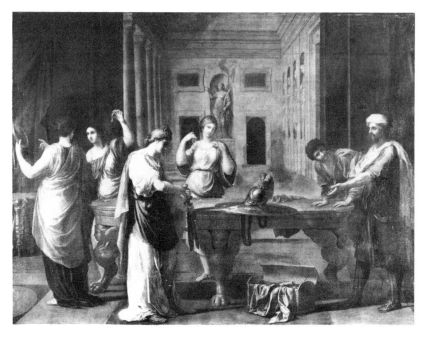

6. Poussin, *Achilles Discovered among the Daughters of Lycomedon*, Reims, Musée Saint-Denis. (Photo: Robert Meulle, Reims) This attribution is not accepted by the recent catalogues raisonnés, which give the work to a follower or imitator of Poussin.

are irrelevant to aesthetic experience. He championed Cézanne at a time when the artist was only beginning to receive recognition, and his formalist theory served that purpose admirably. An antiformalist account focusing on Poussin's story would have made Poussin seem very different from the Cézanne Fry admired. "What is remarkable is the extraordinary power our artist shows of holding together in a single rhythmic scheme such an immense number of small and often closely repetitive movements." Fry might be talking here about either Poussin or Cézanne.[35] Today, because Cézanne is acknowledged as a master and much has been said about the content of his pictures, such a formalist analysis would be unhelpful. The very success of Fry's rhetoric has helped to make his account seem dated.

These remarks also apply to Greenberg's account of old master art. For him, making distinctions between Giotto, Raphael, and even Courbet that are important to the art historian is irrelevant; in his text, these painters function as a group of artists to whom modernists may be contrasted. Greenberg's claim that modernism makes explicit what earlier was implicit involves an unavoidably circular argument. His assumptions are best defined in relation to Gombrich's.

Giotto and Constable both do making and matching, so for Gombrich their shared goals are more important than the obvious differences between Giotto's re-creating of sacred scenes and Constable's portraying of a country estate. Linking Manet, analytical cubism, and Pollock is more complex, for their works are not even all representations, but here Greenberg's concept of modernism plays a central role. An old master might not, Greenberg allows, recognize this account of his art-making activity: "Whereas one tends to see what is *in* an Old Master before seeing it as a picture, one sees a Modernist painting as a picture first.... Modernism imposes it as the only and necessary way."[36] Who necessarily sees a picture thus? Greenberg also says that painting has two norms, flatness and two-dimensionality. "It quickly emerged that the unique and proper area of competence of each art coincided with all that was unique to the nature of its medium." When did this truth, this necessity, emerge? Not for all twentieth-century artists. Sometimes in Greenberg's texts artists perform actions, but often actions are "performed" by painting itself, *as if* artworks could act:

Nature, probed by an eye obsessed with the most naive kind of exactness, responded in the end with textures of color. . . . Painting had to spell out, rather than pretend to deny, the physical fact that it was flat. . . . Flatness may now monopolize everything, but it is a flatness become so ambiguous and expanded as to turn into illusion itself. . . . [37]

One familiar test for validity in interpretation is the matching of a reconstruction of the work to the artist's intentions. Gombrich believes that Constable sought to depict Wivenhoe Park as accurately as possible, so he analyzes the painting by comparing it to photographs of the place. By comparison, identifying a modernist painting involves the more problematic activity of distinguishing artifacts that merely have the properties of painting from those that exemplify such properties. How can we understand this notion of the medium of painting? How can we now reinterpret Greenberg's account?

Some art historical theories can be criticized by straightforward counterexamples. Heinrich Woelfflin contrasts classical painting, with its closed, planar composition, to baroque art, which has open, recessive spaces. For example, Leonardo places the figures in his *Last Supper* in a plane with Christ at the painting's center; in Brueghel's baroque *Village Wedding* the "bride is certainly distinguished by the rug hung behind her, but in apparent size she is very small. . . . she *must* be seen in immediate relation to the great figures of the foreground."[38] Accumulate enough cases of sixteenth-century works with baroque qualities and seventeenth-century paintings that are classical and this theory becomes untenable, though. *Achilles Discovered among the Daughters of Lycomedon*, for example, though from the baroque, has a closed planar composition; Poussin himself is hard to place within Woelfflin's framework.

Consider three such possible counterexamples that Greenberg discusses. Paleolithic art, unlike modernism, he says, disregards the norm of the frame, creating images that do not exist in relation to an edge. A tradition of ceiling and cupola art—work by Mantegna, Correggio, and a host of baroque decorators—does not, like Greenberg's old master art, cut "the illusion of a box-like cavity into the wall." The surrealists, though coming after cubism, "do . . . see new things, but no differently in essence

than painters of the past would have seen them had they accepted Surrealist notions of subject matter."[39]

Greenberg responds to these counterexamples in different ways. The Paleolithic artist created "the surface in both a literally and a visually sculptural way because he made images rather than pictures"; failing to identify the conventions painters would later discover, he did not make paintings.[40] Identifying old master painting with easel art leaves aside ceiling and cupola works; but in an analysis in which the concept of old master art is undeveloped, this is not important. The surrealists are not part of the modernist tradition; like icon painters working after Giotto's time, they play no role in the dominant movement of their day.

Gombrich likes Dali (see fig. 7), so his interpretation of surrealism is different. Dali's "way of letting each form represent several things at the same time may focus our attention on the many possible meanings of each colour and form—much in the way in which a successful pun may make us aware of the function of words and their meaning."[41] Dali's works are for Gombrich the visual equivalents to jokes which, Freud claims, control hostile thoughts by word-play. For him, Dali belongs to painting's history, but Pollock does not; Dali engages in making and matching, while Pollock, by preventing "us from interpreting his marks on the canvas as representations of any kind, leaves us unable to discover any meaning in his forms."[42]

Like the commentators on *A Bar at the Folies-Bergère*, Gombrich and Greenberg agree about much, notwithstanding their fundamental disagreement. Greenberg can accept Gombrich's account of Dali's ambiguity; Gombrich agrees that Dali uses an old master space with novel content. To say that they interpret Dali and Pollock differently is slightly misleading. They do not disagree about how to describe these pictures, but about their significance. Given Greenberg's theory of the medium of painting, what follows is that Dali is not a modernist, and that Pollock is an important figure.

To some extent, ultimately, this is an argument about taste. Someone who admires Dali but not Pollock is unlikely to accept Greenberg's account of the medium of painting. We can test our taste by introducing another example, a figure not discussed by either Gombrich or Greenberg.

R. B. Kitaj is a self-consciously literary painter. Much of the debate

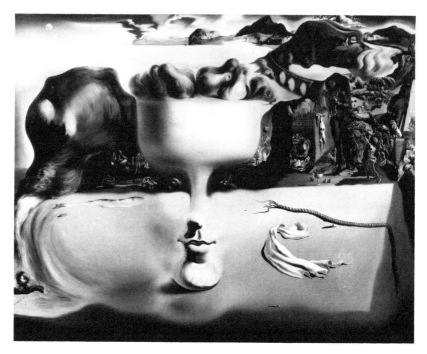

7. Salvador Dali, *Apparition of Face and Fruit-dish on a Beach*, 1938. (Photo: Joseph Szaszfai. Wadsworth Atheneum, Hartford, Conn. The Ella Gallup Sumner and Mary Catlin Sumner Collection)

about his art centers around his claim that representational art is inherently richer than abstract painting.[43] *From London (James Joll and John Golding)* (1975–77), for example, (see fig. 8) depicts the distinguished historian and the art historian in a scene full of visual references. Joll wrote a book on Gramsci and Golding one on Leger, which appear in the painting. Another book depicted refers us to the English edition of Richard Wollheim's *Art and Its Objects*, which had a cover design by Golding. Joll's head is shown as if on a partly destroyed fresco; the Chagall before him and the Mondrian on the wall behind him refer us to Golding's work on early modernism. The carefully drawn kitchen utensils, which contrast with the reverse perspective of the table top, perhaps hint at Golding's interest in the cubist destruction of perspective; and the rotary utensils just in front of Golding's left thigh remind us that he has also written on Duchamp.

Just as Fry's formalist reading of the Poussinesque work leaves out the story, which was important for the artist, a formal account of the Kitaj would fail to identify these visual references. All things being equal, the interpretation that describes an artwork in a richer way is a better account. This plausible general principle implies that Greenberg's view is less useful than Gombrich's, at least for the interpretation of Kitaj's painting.

Greenberg's essay "Abstract, Representational, and So Forth" replies to this argument. "More and less in art do not depend on how many varieties of significance are present, but on the intensity and depth of such significances, be they few or many, as are present."[44] Everyone would agree that many paintings with complex iconography are aesthetically trivial. Even the claim that such iconography is a necessary condition for artistic excellence is debatable. Certainly Kitaj's work is about many issues, but such "aboutness" does not guarantee aesthetic significance.

Consider an imaginary painting, *The Red and the Black: A Homage to Motherwell*. This simple-looking diptych, a red square next to a black square, refers to Stendhal's novel of that title; to the conflict of the Communists and anarchists in the Spanish civil war; to Goya's deep blacks and to Matisse's great *Red Studio* (1911); to Robert Motherwell's *Homage to the Spanish Republic*; and to the writing of his admirer, Arthur Danto, whose work suggested this example to me.

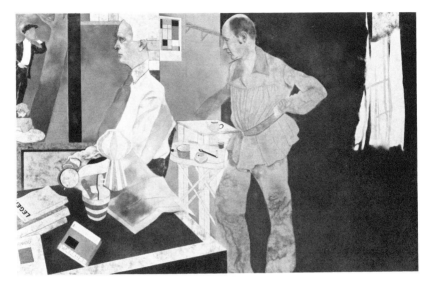

8. R. B. Kitaj, *From London (James Joll and John Golding)*, 1975–77. (Courtesy Marlborough Fine Art [London] Ltd.)

The Red and the Black may be an unfair example; it is about all of these issues only in the sense that I arbitrarily attribute such meanings to it. Still, this imaginary example is not inherently different, we will see, from many actual seemingly visually simple works to which critics give complex interpretations. Furthermore, as *The Transfiguration of the Commonplace* reminds us, even to identify *The Red and the Black* as visually simple begs the question; the work I have described is visually identical with, but a different artwork from, a simple diptych of an apolitical minimalist who merely juxtaposes a red square with a black square.

This analysis drastically oversimplifies the relation between a writer's taste and his theory of art. I imply that Greenberg developed a theory of modernism and then used that account to make quality judgments; in fact, it was probably the other way around. Admiring Pollock but not Dali, he was naturally led to produce an explanation of his experience.

Still, in some ways we understand that theory differently today than Greenberg originally did. Anyone who began seriously looking at painting in the 1970s, as I did, was very aware of Greenberg's theorizing. The very layout of the Museum of Modern Art, which took me from Cézanne and Monet through cubism to abstract expressionism, illustrated *Art and Culture*; admittedly, the inclusion of surrealist work and the importance given to *Guernica*, not admired by Greenberg, gave hints of another view of modernism. The 1984 redesign of the museum reflects a changed estimate of Greenberg; now in the display of post-1960s art there is much Greenberg thinks undistinguished. For me, in the 1970s, quality judgments and Greenberg's theory of modernism were linked; my admiration of Pollock reflected my awareness of Greenberg's work. In the late 1940s and early 1950s, Greenberg's claims for Pollock's importance were prophetic. "Were Pollock a Frenchman, there would be, I feel, no need by now to call attention to my objectivity in praising him" (1952).[45] Greenberg gained a great reputation in part because his theory of modernism was elegant, but also because his value judgments became generally accepted.

Today biographies of Berenson reveal his role in the art market; soon enough we may expect similar accounts of Greenberg.[46] Just as Berenson's essays gave reason to purchase the old master works for which he provided attributions, when the market in abstract expressionism developed,

Greenberg's defense of the movement served to validate the belief that this was important and valuable art. The differences in their roles are as important, however, as the similarities. As a connoisseur, Berenson filled an essential role in an art market in which scarcity of works by the masters determined value. In dealing with contemporary art, attributions are less important, so the artwriter has a quite different role. When Greenberg argued that Pollock and the other Americans were major figures, far superior to their French contemporaries, he gave reason to value their works highly. Greenberg believed that Pollock was superior to Soulanges, and his aim, achieved with great success, was to provide a narrative history in which Pollock was the heir apparent to the early French modernists.

Here the difference between the goals of Gombrich's and Greenberg's narrative histories becomes important. If *Art and Illusion* has not caused fierce debate, as *Art and Culture* once did, it is partly because Gombrich's taste in old master art is uncontroversial. A history of naturalism, though an important achievement, has few immediate implications for the practice of art history; Gombrich describes the present practices of his discipline in a way that most art historians find acceptable. By contrast, Greenberg's genealogies had practical implications. If Pollock is Cézanne's heir, then Pollock should command the same prices as Cézanne; and he does. I do not mean that Greenberg was the only critic who admired the abstract expressionists or that he was able to imagine that his theorizing would help produce this result. On the contrary, the various social histories of abstract expressionism tell how little he or the artists expected worldly success.

That Greenberg's theorizing played a role in the art market is an irony almost justifying belief in Hegel's cunning of history. Greenberg's theory of modernism is a variation on the Hegelian analysis of Spirit's self-critical power. Marxists interpreted his argument to mean that the real world could only be changed by the practical activity of the proletariat. Greenberg limited that self-critical activity to a strictly artistic framework and provided a quasi-Marxist explanation of how the social structure of contemporary society permitted an autonomous development of art. The unintentional result was to set this self-critical art back into that social world, making it highly marketable.

This reading of Greenberg's texts is highly selective. The essays on

American art in *Art and Culture* comprise only one part of the book, and of those eight essays, four are about artists working before abstract expressionism. The essay on Thomas Eakins interests specialists. Greenberg does not work out his genealogies in detail. What gives his beautiful writing a somewhat dated quality is the casualness of his observations. "In its first stages, Hofmann's 'mosaic' series seems closer to Pollock, and then it seems to recapitulate Mondrian's expanding and squaring-up of the facet-plane."[47] This important observation, which an art historian could develop into a book, is continued for only a few more sentences. As he has said, Greenberg is a short-winded writer, so the power of the historical framework that he sketches so lightly is all the more impressive.

Clark, Wollheim, and others can debate about Manet because they agree that the implied space in the mirror in *A Bar at the Folies-Bergère* is inconsistent while disagreeing about the meaning of the composition. By contrast, Greenberg and Gombrich do not really provide competing interpretations. Greenberg asserts that modernist art is important, part of a tradition developing out of old master art; Gombrich denies this. But this is less a conflict of interpretations than a dispute about taste.

Both Gombrich and Greenberg have theories of taste; paradoxically, Greenberg's is the more traditional analysis. He writes, "Practiced taste speaks as if with one voice."[48] This consensus is proof of the objectivity of taste; "as far back as we can see into the past, agreement has been overcoming disagreement." To offer reasons for thinking a Pollock excellent is never ultimately convincing; such an account can always be rejected. If we can show an agreement of taste, however, giving such reasons becomes less important. Here we appeal to the test of time. Just as an artifact is judged good, all things being equal, when it is durable, so artworks—artifacts that serve no obvious function—are good when their aesthetic quality is durable.[49] New work is hard to judge properly, but with time, this difficulty disappears.

This thesis poses both theoretical and empirical questions. The belief that I first confront the artwork as an isolated individual and then discover that my judgment may agree with other people's underestimates the importance of critics. Knowing what Greenberg thinks of a painting, I am likely to look at it differently. I will not necessarily agree with him, but I, like everyone (I believe) form my taste partly in response to what

others say. To believe that people can form judgments absolutely independent of what they hear and read shows unwarranted confidence in both their independence and capacity for introspection.

The test of time is itself puzzling. Why, after a century, can we better understand Manet, when we must read Clark to discover simple facts about the Folies-Bergère known to Manet's contemporaries? Why do four decades give us perspective on Pollock? Sometimes, I grant, time does bring understanding; perhaps a child, after becoming an adult and having children of her own, better understands her parents' limitations. Sometimes, however, memories simply become vague, or later experiences change our perspective. Today, when everyone knows that Manet and Pollock are admired by almost all the best judges, only philistines or sophisticated revisionists say that they are boring painters; forty years ago most observers made that judgment of Pollock. How, then, can we distinguish between judging Pollock more accurately because time has passed and judging him more favorably because we know today's consensus?

Modernism, Greenberg claims, has both changed our view of the old masters radically and "left most of our old value judgments intact."[50] We see Titian differently, yet agree with the traditional view of his greatness. Empirical studies, however, though they can say nothing about the causes of a change, show that tastes *have* changed, sometimes radically. Consider some examples.

Giorgione's *Tempest* was discussed around 1530, again in 1569, and then forgotten until 1851, when it was assigned a small fraction of the value of another Venetian painting today known only to specialists.[51] Since he has always been admired, how can we explain this reevaluation of his masterpiece? In general, auction prices provide some indication of comparative aesthetic values. In 1856 Reynolds's *The Strawberry Girl* was sold for £2,005 and Giotto's *Madonna and Child* for £325; a few years later, a Dolci *St. John* went for £2,165 and a Murillo *Immaculate Conception* for £9,450, while Sir Charles Eastlake purchased Piero's *Baptism of Christ* for £241.[52] Our Victorian great-grandparents looked at much Italian art, so why these shocking prices? If 1856 was too soon to apply the test of time to Reynolds, can we adequately judge Pollock today? Why should just one more century make us better able to judge

Giotto and Piero in comparison to Dolci and Murillo? It is easy to produce sociological theories explaining these changes in tastes, but what then remains of Greenberg's consensus?

As Greenberg's own view of post-1960s art has become less influential, he himself appeals to sociological theories of taste. An interest in pop art marks "a retreat from major to minor quality"; now the genuine avant-garde is "kept in the background more or less."[53] Olitski and Noland are thought less important than they were two decades ago, and their relative prices have fallen. Maybe in a century they will be properly appreciated, but that claim cannot be tested today. When Greenberg agrees with the consensus, he appeals to the uniformity of taste; when he does not, he introduces a sociological hypothesis. Consensus shows the greatness of Raphael today and a century ago, and the importance of Pollock today; sociological theories explain why Piero and Giotto are more accurately valued today than a century ago, and why Olitski and Noland now are underrated. Obviously this is not a coherent analysis.

Perhaps a quasi-sociological analysis is more promising. Consensus about old masters is easier to achieve than agreement about recent work, in part because less is at stake. Rembrandt's status is secure, and so even if I say, truthfully, that often he bores me, that judgment is merely eccentric. Arguing that Jasper Johns is boring is more controversial, for his position in the museum is less secure. Compare the recent revivals of the baroque master Bernardo Cavallino and the modernist Milton Avery. Determining whether Avery is a minor precursor of Rothko or a great master will tell us whether his work belongs in every major museum; a major debate about how to write the history of modernism is at stake. By contrast, since there is agreement about the importance of the baroque, and since few, if any, Caravaggios remain on the art market, justifying the attention given to Cavallino is easier. In the late eighteenth century Reynolds debated the relative merits of Raphael and Michelangelo, while allowing some merit to figures he thought less important, such as Titian, Rubens, Poussin, and Rembrandt. Though our tastes are broader, the principles by which we argue are similar. Most critics agree with Greenberg about Pollock, while questioning his severe views of Kandinsky and Soutine. The effect achieved by outrageous judgments—as, for example, when a critic recently called de Chirico the greatest modern painter—is

understandable only against the background of broad agreement. Some measure of agreement is needed to make disagreement about tastes possible.

Gombrich's account of the canon of taste makes such an argument. He offers two key points.[54] First, standards are defined by the work "handed down in tradition as a touchstone of excellence." Second, because there is a canon, any artist is involved in concerns "which will always transcend his skill." The alternative suggestion, that perhaps "all our reactions are equally subjective," produces "a curious feeling of unreality."

Still, this argument accomplishes less than we might hope. The closer we look at this canon, the less agreement it demonstrates. Everyone agrees that Raphael is in the canon; for Greenberg, but not Gombrich, Pollock is included; for many critics, but not Greenberg, Duchamp is a part. So, speaking of "the canon," as if all disagreements about its constitution were trivial, is misleading. Disagreements appear at just those points when appeal to the canon is made in arguments about taste, but the alternative is not to assert that quality judgments are merely subjective. After all, my taste agrees in some large part with both Gombrich's and Greenberg's.

Perhaps it is better to reverse the usual order of argument. Instead of asking "How does objectivity of judgment arise?" let us say that a precondition for discussion is a certain amount of agreement. Were there no agreement, discussion would be impossible; if we agreed about everything, talk would be unnecessary. Furthermore, once Caravaggio and Rothko have been much studied and their works become very expensive, more attention is given to Cavallino and Avery. Such reevaluations have less to do with the test of time or objectivity of taste than with the understandable desire to discuss relatively unfamiliar work.

If, then, the analysis of taste cannot by itself determine how to judge the work of Greenberg's favored artists, how can we evaluate his analysis of modernism? What made his account brilliantly persuasive was that he both provided a genealogy for the abstract expressionists, linking them to early modernism, and explained how modernism related to old master art. By comparison, Harold Rosenberg's analysis, which described abstract expressionism as "action painting," soon came to seem a much more limited theory. As Greenberg has noted, Rosenberg's analysis left

unexplained why such new artifacts were artworks; and once it became clear that abstract expressionism itself was part of an ongoing tradition, it was hard for Rosenberg to say anything interesting about post–abstract expressionist art.[55] Greenberg's success reflected the strength of his narrative, which gave reason to admire Pollock and his contemporaries. Yet to merely acknowledge that his account was plausible does not tell us what we ultimately want to know: is his history truthful?

This chapter began by comparing beginnings in historical narratives with beginnings in novels. My question now brings up the apparent limitations of that parallel. *Lolita* begins differently than *Pride and Prejudice*. Because both describe fictional figures, their worlds cannot in any straightforward way conflict. Gombrich and Greenberg describe the same figures, however. For Greenberg, Manet marks the beginning of modernism; for Gombrich, Manet is part of the tradition of naturalism. I have tried to identify the difference between these narratives by pointing to the different goals of these two artwriters. Greenberg constructs a genealogy for Pollock; Gombrich tells the story of naturalism. If we thus judge *Art and Culture* and *Art and Illusion* as books that have different goals, then perhaps they can no more conflict than can Austen's and Nabokov's narratives. Yet the idea that two histories discussing the same artworks are so different remains disconcerting. Even if Gombrich and Greenberg offer us two different viewpoints between which we must ultimately choose, it would be useful to learn as much as possible about how to make that choice.[56]

Like beginnings in historical narratives, endings in artwriters' texts are especially revealing of their larger strategies. Let us now pursue this analysis by comparing the endings of Gombrich's and Greenberg's accounts.

2 Endings in Narrative Art Histories

Darcy and Elizabeth "were both ever sensible of the warmest gratitude towards the persons who, by bringing her into Derbyshire, had been the means of uniting them." Jane Austen thus achieves narrative closure by solving all the conflicts created in her novel. The frivolous Lydia and nasty Wickham have an unhappy, deserved fate, marriage to each other; Mr. Bennet learns that he has been an unwise father; Darcy having learned to understand his pride and Elizabeth to overcome her prejudices are ready to live happily ever after. There is nothing more to say, because in this story nothing more can happen to these characters.

Tiepolo, Rudolf Wittkower writes, "is in every sense the last link in a long chain."[1] Just as an individual dies, a tradition can also end. If the absolute beginning of a history is hard to include in a narrative, the final ending of a story of *human* history is impossible to tell. But more parochial histories can tell of the end of some *subject*. The Venetian republic fell in 1797, and though events still

happen in that city, they are now part of the story of the Italian nation. Some historical endings are matters of degree. If Sienese painting did not last into the sixteenth century, and the Venetian tradition seemingly ended with Guardi, Canaletto, and Tiepolo, the fact that painters continue to work in those cities is not an argument against that claim. This painting is too undistinguished or too weakly linked with the tradition to continue it. One great artist worked in modern Bologna, but he did not continue the tradition of the Carracci; Morandi's art has little in common with theirs.

Even in discussion of individuals, the notion of an ending is complex. Matisse was glorious in old age, but Chagall and Marquet ceased to develop interestingly; the men lived on, but the artists did not. When the *subject* of an art history narrative is a fictional entity, what is involved in speaking of the end of such a figure? In the next to last paragraph of her *Passages in Modern Sculpture*, Rosalind Krauss describes contemporary sculpture that involves experiences of spatial motion: "And with these images of passage, the transformation of sculpture—from a static, idealized medium to a temporal and material one—that had begun with Rodin is fully achieved."[2] Her book begins with Rodin and concludes with Robert Smithson, her elegant narrative linking their art; what Rodin began, Smithson finished, and so her history appropriately ends.

For Gombrich, the history of naturalism ends in cubism; for Greenberg, many readers concluded, modernism ends with the creation of minimal art, works that emphasize their literal flatness and rectangularity. So read, the two give different answers to the question, "When did painting end?" But are their claims inconsistent? Gombrich tells us when making and matching ends; Greenberg, in this interpretation, when the modernist tradition was finished. Because these accounts describe different *subjects*, there need be no real disagreement.

This inconclusive conclusion seems unsatisfactory. Here is an analogy indicating why. Imagine a professor whose daughter presents her with a moral dilemma.[3] This able student needs to pass philosophy to get into medical school. She has been unable to study, but knows an effective, safe method of cheating. Her mother says, "As a faculty member, I deplore cheating; as a tuition-paying parent, I urge you to cheat." In merely describing her two roles, she really fails to solve her daughter's dilemma. Analogously, to give two answers to my question, "When did painting end?" is to give no answer at all.

For this study of American art criticism, Gombrich's analysis may seem irrelevant. Today most critics take for granted Pollock's importance, so Gombrich's opinions are not important for them; indeed, today Greenberg too has become a figure whose views cease to inspire active debate. Because Gombrich and Greenberg share many assumptions about how to write art history narratives, however, we may better comprehend Greenberg's account by understanding Gombrich's analysis of the end of the tradition of naturalism.

Since the end of the naturalistic tradition is discussed in chapter eight of *Art and Illusion*, what is said in the three chapters that follow? Just as the book's beginning with two chapters before Gombrich gets to the Pygmalion fantasy indicates the complexity of his starting point, so his puzzling conclusion qualifies his claim that Constable and the impressionists mark the end of the tradition of naturalism. Gombrich says, "There is such a thing as real visual discovery, and there is a way of testing it."[4] He indicates, though, that this test is complex. Renaissance masters did not paint landscapes except as background scenes, so how can we fairly compare Raphael as naturalist to Constable or Pissarro? Nineteenth-century art showed, we may grant, that "the elements of the visual experience could be taken to pieces and put together again to the point of illusion"; but if we "can, and almost must, interpret Constable's paintings in terms of a possible visible world," that is perhaps because he paints not madonnas but landscapes such as Wivenhoe Park that we can actually see.

After discussing the end of naturalism, Gombrich turns to a history of caricature and the suggestion that such expressive making and matching provides a precedent for abstract art. "All or most" modern art thus "tries to represent the world of the mind"; as Constable depicts trees and water, Mondrian represents feelings.[5] The parallel is infelicitous, both because it treats emotions as things within the mind that Mondrian can represent and because it implies that Mondrian really continues the tradition of making and matching. Not surprisingly, Gombrich does not develop this idea. Rather, he then suggests that just as Constable's images accurately *represent* nature, they also *express* his feelings about nature. Loving slimy posts and old mills, he "forged himself a language that is both truthful and poetic, that makes it possible to fulfill the patron's demand for accuracy and his own urge for poetry." In the conclusion,

Gombrich neatly returns to the starting point of *Art and Illusion, Wivenhoe Park*; but what has this seeming digression to do with his main theme, the discussion of naturalism? Here it is useful to discuss at some length his theory of image interpretation.

Consider two related questions. First, what function is served by the last two chapters of *Art and Illusion*? Second, how is Gombrich's theory of expression relevant to his theory of naturalism? To answer them, we must examine Gombrich's general thesis about image interpretation. None of Gombrich's critics has indicated what is most interesting about this thesis, developed in *Art and Illusion* and in a number of other essays: the radical distinction between interpretation of texts and of pictures. Examining the thesis explains the otherwise puzzling accounts of the end of naturalism and points to some of Gombrich's major disagreements with Greenberg.

For Gombrich, interpreting pictures is like the interpretation that goes on in everyday perception. This initially obvious seeming claim has surprising implications. Looking out my window, I see a fuzzy shape on a far lawn that either is my sheepdog, Alfredo, or is not. If it is he, either he is one hundred yards away or at some other distance. In general, everything I see is at a definite distance and has a determinant identity. It is only my momentary inability to interpret my perceptions that occasionally disconcerts me. I move and realize that I do see Alfredo; the perception does not remain ambiguous. A picture, by contrast, may depict forms with multiple meanings and indeterminant positions in relation to me; as Rosalind Krauss says, a depicted rabbit-duck may stand for neither rabbit nor duck, but ambiguity.[6]

Perception orients me in relation to the world and alerts me to dangers. Stepping into a dark theater, I feel anxious before I can find my footing; in a more primitive situation such an experience could involve real dangers. Failing to see an approaching wild beast could be dangerous. Given Gombrich's use of a biological framework, it is unsurprising that anxieties are associated with visual perception.

> My contention that our visual world is much less definite and stable than it is often supposed to be ... is likely to arouse not only skepticism but even resistance. ... Our aim will always be to see a stable world since we know the physical world to be stable. Where this stability fails us ... we may easily panic.[7]

By contrast, after he resolved a personal crisis, a mandala with self-evident order provided Gombrich with an appropriate visual symbol of emotional stability.[8] If illusionistic art provides a way of achieving "psychological poise and rationality," and so the capacity to keep "the powers of passion and of unreason at bay," that is because making and matching involves an experimental or rational attitude toward the world.[9] I test my perceptions as a scientist tests theories. Notwithstanding his objection to Hegelian art histories, which read social history in pictures, this is why Gombrich is critical of the regression implicit in the modern fascination with primitivism. Giving up rational control of images is antiscientific and so may be a potentially dangerous symptom of irrationalism.

The achievement of nineteenth-century naturalism was the creation of images that are unambiguous; the cubists' development of inherently ambiguous depictions marks a breakdown of this "system of control." Gombrich's account of Dali is suggestive here. Freud said, "It would indeed be very interesting to explore the origins of such painting analytically"; is this not exactly what Gombrich has done?[10] He asks why caricature arose so late in the history of naturalism.[11] Only after the magical-seeming techniques of making and matching had been mastered were artists ready to use these skills in playful ways. The surrealists' play with visual ambiguity is amusing, not threatening, because it occurs after the complete mastery of naturalism.

A theory of the interpretation of representational images need not make such claims. Contrast, for example, Fry's formalist approach. For him, seeing pictures aesthetically requires taking an attitude rarely assumed in practical life; hence he does not share Gombrich's belief that interpreting pictures involves a certain inherent anxiety. Only when picture interpretation is assimilated to perception in general can Gombrich's problem arise. If unable to understand a novel, I seek alternative readings of key passages; if uncertain how to interpret a painting, I look at it, Gombrich says, as if I were standing before some real scene. Reading and seeing thus call for inherently different kinds of interpretation. Because knowing my position in the world depends upon my interpreting what I see, it is no wonder that my momentary inability to disambiguate perception of a painting is disorienting.

However we understand the interpretation of images, in any case, the history of naturalism has ended. When a *subject* ceases to exist, we can

ask why this has happened. One argument in *Art and Illusion* is that naturalism ended when realistic representations became so perfect as to be unaesthetic; another, that it ended because artists realized that even the best possible image would always remain only a mere picture. That Gombrich makes both these seemingly inconsistent claims may merely reflect the fact that the ending of so complex a tradition was over-determined.

Some histories narrate stories of *subjects* that have ceased to exist; others, however, tell of still-existing *subjects*. Unlike a history of Eastern European Jewry, a story of Zionism describes an ongoing entity; and so, whether the latter history concludes by summing up the problems that have been solved or presents worries about Israel's future, in either case the choice of ending will determine in part the structure of the analysis. It would be wrong to say that Greenberg believes that modernism has ended. On the contrary, if "the norm of the picture's enclosing space was loosened, then tightened, then loosened once again . . . by successive generations of modernist painters," then the most plausible prediction is that this process might continue indefinitely.[12] Yet in retrospect, it is easy to see why his theory was misinterpreted to imply that the end of art was at hand. If modernism shows that the further the limiting "conditions with which a marked-up surface must comply in order to be experienced as a picture . . . are pushed the more explicitly they have to be observed"; if "the irreducible essence of pictorial art consists in but two constitutive conventions or norms: flatness and the delimitation of flatness," then one might reasonably infer that by 1960 the history of modernism was almost over.

Donald Judd spoke of the need to avoid creating a system of parts; Frank Stella said that "any painting is an object." Although Greenberg did not champion their work, surely they were influenced by his suggestion that a blank canvas "already exists as a picture."[13] Concluding "that the most original and furthest-out art of the last hundred years always arrived looking at first as though it parted company with everything previously known as art" was, Greenberg now says, an error, but this interpretation of *Art and Culture* was not implausible. If Pollock was important because he went beyond Picasso, the next important step beyond Pollock would seem to be to end the history of painting. Had the work of the early modernist Russian avant-garde been better known in

the West three decades ago, it would have been obvious that this was not a novel idea. As it was, the chiliastic claims of the minimalists seemed highly original.

Today, looking back, this misreading of Greenberg calls attention to a real problem inherent in his account of modernism. A modernist picture, he says, makes us explicitly aware of the norms that an old master work observes implicitly. But how can we determine whether a picture exemplifies the properties it possesses? Greenberg himself has recently recognized this problem. Being told that postmodernist art was art "that was no longer self-critical" made him realize "how inadequate that was as a covering definition of Modernist art."[4] How could "self-critical art be told from art that wasn't self-critical?" Modernist painting, he had written, "calls more attention to the immediate physical qualities of painting" while it "still assumes that its identity as a picture shuts out awareness of its identity as an object."[5] Calling attention to flatness while shutting out our awareness that a work is a flat object involves a complex mental balancing act; the picture *is* a physical object that does not *appear* to be a mere physical object.

Future connoisseurs, Greenberg suggests, "may be more sensitive than we to the imaginative dimensions and overtone of the literal."[6] They may see the old masters differently than we do. We may apply his point also to modernism. Long familiarity with literality in visual art may lead future connoisseurs to focus on the illusionistic depths in abstract expressionism. They may see modernist paintings differently than we do and also believe that Greenberg described those works as they appeared in the twentieth century; for them, understanding his view of modernism will be as difficult as it is today to learn to interpret Manet's image of the Folies-Bergère. If the statement "Pollock calls attention to flatness and shuts out awareness of literal flatness" is true in 1950 and false in 2050, however, what is the status of Greenberg's analysis?

That question is hard to answer, so it is not surprising that the conclusion of *Art and Culture* is as complex and ambiguous as the ending of *Art and Illusion*. Greenberg's closing essays, the discussions of Brecht's Stalinism and Kafka's Jewishness, have received little attention from art critics because they seem unconnected to his analysis of painting. His account of Kafka qualifies his earlier use of an art history narrative that borrowed Marxist ideas. Marx was an assimilated Jew, a revisionist

interpreter of Hegel. For Hegel, the implicit stands to the explicit as the Old Testament does to the New; Christ makes explicit what was for the Jews merely implicit. Hence, in Christ's era the Jews are living fossils; they have lived beyond their time, failing to grasp that history has passed them by. For an art critic, using Hegelian and Marxist ideas need not, of course, require accepting these claims. But what Kafka's art offers, Greenberg says, is a critique of this vision of history.

"Kafka, the Jew of Prague, was more loyal to his experience" than Marx; it "presented the Gentile world and Gentile history as a trap for the likes of him...And how right he was." For the believing Jew, the passing events of Gentile history no more belong to genuine history than what happens in black Africa constitutes part of Hegel's history; those events involve "no dealings with the divine." The emancipated Jew is in a complex position, both "suffocated outside" history and continuing "to fear it, at bottom, just as much and even more than the Orthodox Jew." Those emancipated Jews, the actual history of Eastern Europe shows, have no place in the Gentile world, and this fact makes Kafka's art prophetic. "And when did a Jew ever come to terms with art without falsifying himself somehow. Does not art always make one forget what is literally happening to oneself as a certain person in a certain world?"[17] Kafka's Jewishness is shown in his refusal to tell stories of development. He writes not historical narratives, but texts describing "ongoing states such as can have no beginning or ending, but only middles." This concern with history is very different from Gombrich's account of the end of naturalism and his consequent worries about the interpretation of visually ambiguous images.

Kafka's texts are verbal equivalents to Pollock's paintings, which dissolve "the pictorial into sheer texture...into an accumulation of repetitions," thus answering to "something profound in contemporary sensibility." In placing those works in a story with a beginning, middle, and ending, the narrative in *Art and Culture* sometimes uses Marxist codewords: cubist space "is an expropriated property detached from everything not itself"; cubism inherits Cézanne's problem, "but—as Marx would say—only by destroying it."[18] But another phrase of Greenberg's suggests a different, more Kafkaesque image of this process. In modernism, "the world was stripped of its surface, of its skin, and the skin was spread flat on the flatness of the picture plane"; maybe the

dialectic that created modernism was not altogether a happy development. So, instead of happily looking forward with the minimalists to the end of art, we might rather ask whether their optimism about historical endings was justified. Perhaps Kafka's "In the Penal Colony" is an apt allegory about the trials and tribulations of modernism.

As I noted earlier, neither the minimalists' chiliastic views nor my own reading of the Kafka essay recreates Greenberg's own intended view of modernism, which he has discussed in more recent essays. What is important historically is that when his theorizing became influential in the early 1960s, it lent itself to the minimalists' interpretation. Here again, a contrast with the debate about Gombrich's claims is revealing. No art historian is more famous, but his theory of naturalism has hardly been debated by his fellow art historians.[19] A book proposing an interesting new interpretation of Giorgione generates debate, but present-day art historians are unconcerned with the grand tradition of speculative art history, which Gombrich continues and criticizes. By contrast, Greenberg's analysis of abstract expressionism was controversial. The history of this debate is well known, and its logic obvious enough that only a brief sketch need be offered.[20]

Greenberg's view of Stuart Davis interests only specialists; this artist is a relatively minor figure. His view of the abstract expressionists was important, however, both for its own sake and because the viewpoint taken on them determines how more recent art will be understood. As long as the PLO struggles, debates about Zionism and historically more distant issues such as Muslim history and orientalism relate to present-day politics. There is no Norman Liberation Front, and so discussion of eleventh-century English history is academic; how we understand the events of that century has no apparent relevance to present-day English politics.

As the power of Greenberg's genealogies became evident, he acquired disciples who borrowed his framework while taking issue with some of its details. In the 1960s his positive views of Morris Louis, Kenneth Noland, Jules Olitski, and the sculptor Anthony Caro quickly became widely accepted. Looking back, it is easy to see why this situation could not last.

In active intellectual life, after the importance of any major theory is recognized, it is commented on, popularized, and then rather quickly put

aside. In philosophy, for example, Wittgenstein's later work was a great influence in the 1950s; many articles referred to him, whole books were written on some of his aphorisms, and his commentators engaged in internecine debates. After a certain time, his ideas had been absorbed, and what might readily be said about them had, it seemed, been said; further accounts were either mere repetitions, historical exegesis, or brilliant reinterpretations.

In art criticism, the work of a writer who becomes famous poses complex problems. Someone who admires only a few aging artists, like Harold Rosenberg, who continued into the 1970s comparing younger masters unfavorably to Barnett Newman and de Kooning, soon becomes of historical interest only. If a critic does admire new work, however, we may conclude that his theories lack substance. Good criticism is almost always exclusive. Greenberg, Leo Steinberg, and Michael Fried influenced taste; it is left to textbook writers to produce accounts in which these critics' enthusiasms—Pollock, Jasper Johns, Frank Stella,—and also pop art, op art, minimalism, photorealism, performance art, conceptual art, and neo-expressionism are discussed.

I emphasize here the impersonal aspects of the response to Greenberg. His taste, some critics complained, was narrow; but this is to misunderstand his role and not to take seriously his theory of modernism. Pop art, like surrealism, was innovative in its use of content; minimalism sought to create literal art. Certainly there is no reason that a critic like Greenberg, who wrote about educating himself in public, might not change his theories. Admiration for pop art and minimalism is however only possible for someone who gives up Greenberg's theory of modernism. Because that theory was one source of Greenberg's well-deserved authority, for him to admire this art would have been like the archbishop of Paris becoming a Buddhist. Furthermore, since those movements were discussed by critics who championed them in opposition to Greenberg, one function he served was to be the critic with whom everyone could disagree. Ultimately, such reactive criticism is only of limited interest; criticism of the master, however severe, merely underlines his importance as master. In artwriting, as sometimes in art itself, once a problem has been posed and solved, there is not much to be gained from variations on that theme. What Greenberg's followers demonstrated, ironically, was not his strength, but that his narratives are problematic.

Consider, for example, one Greenbergian art history narrative, Jack Flam's recent John Walker catalogue, whose well-presented argument exhibits all-too-evident borrowing from Greenberg (see fig. 9.)[21] Analytical cubism, he argues, opened two avenues: the one taken by Pollock and "the combination of intensely realized surface with non-denominative and yet object-containing empirical space." If the latter "seemed to be merely an historical dead end," Flam claims that now Walker has given it life; so he works out a series of comparisons between Walker and Manet, Matisse and Picasso. To complain that this argument is fatally close to Greenberg's may seem strange. If Greenberg's theory of modernism is convincing, why not borrow it? But when Greenberg says that, Pollock worked from analytical cubism and Flam amends that argument to say that there are two ways to pick up from analytical cubism—Pollock's *and* Walker's—we realize that analytical cubism has as many successors as there are artwriters to describe the visual similarities.

This problem, inherent in Greenberg's genealogies, may be understood by contrasting Gombrich's historical narratives. The theory of making and matching tells how an artist transforms an inherited motif. Michelangelo learns from the poses in Signorelli's *Last Judgment*; Rubens quotes from Renaissance masters; Caravaggio's *St. John the Baptist* ironically borrows from Michelangelo: the history of naturalism is the story of such appropriations. By contrast, to link Pollock or Walker to analytical cubism is to make a much more general parallel; their works do not look similar, but represent space in related ways.

This difference between Greenberg's and Gombrich's histories points to another. Compared with an account of inherited schemata, a genealogy offers only a very weak explanation of how new work is involved in solving inherited problems. Reynolds borrowed from Michelangelo, and in tracing that borrowing we learn how he took a Michelangelo image and used it in his society portraits without implying that he was Michelangelo's artistic equal.[22] By contrast, to link Pollock's and Walker's shallow space to Picasso's tells us less about the appearance of their work while implying a quality judgment. If there are only two ways to solve the problems posed by Picasso in 1912, and Pollock found one and Walker only recently the other, it is plausible to place Walker in the same class as Pollock.

When Greenberg's genealogies were widely imitated, their ultimate

9. John Walker, *Labyrinth III*, 1979.
(Tate Gallery, London)

arbitrariness became recognized. If *Art and Culture* does not describe *the* story of modernism, but merely one of many ways of narrating that history, the result is to call into question its style of argument. Again, the differences with the theory of making and matching are important. Iconographers argue about the source of Caravaggio's images, but these disputes, which often are difficult to settle, do not undermine confidence in the methodology of art history. We can agree that old master art involves making and matching even while we disagree about the source of any given image. By contrast, the capacity to construct alternative genealogies suggests that they are ultimately arbitrary ways of describing artworks.

I have focused attention on Greenberg's art historical narratives while placing less emphasis upon a perhaps more important point: his taste. If we think that the importance of Pollock and his fellow abstract expressionists is obvious, then Greenberg's genealogy becomes merely a heuristic tool, a way of explaining this judgment. As we saw in the previous chapter, though, Greenberg's account of taste is not satisfactory. Once we recognize that a genealogy may also be constructed for Walker, then Greenberg's histories no longer support his judgments of taste.

Here the contrast with narrative necessity in literature is illuminating. The traditional novelist, like the narrative art historian, shows that one event inevitably leads to another. Darcy must, we think, marry Elizabeth; and satisfying narrative closure is created by achieving that goal. But the history of modernism may be told many ways, and even while I admire Greenberg's brilliant telling of that story, I recognize that the story may be told differently. In other accounts, different painters will play roles, and the painters Greenberg discusses will have different roles. Because his genealogies, whatever his intentions, give aesthetic values to the work of his favored artists, recognizing that the story of modernism can be told differently undermines the plausibility of Greenberg's account. To put this conclusion in the vocabulary of the Overture, if multiple interpretations of modernism are produced by critics with differing interests, Greenberg's account seems less convincing. Had the abstract expressionists not become so famous, this problem would never have arisen. Only when the artworld came to value their masterpieces highly and to seek the next generation of great American painters, did the revealed rhetorical aspect of art history narratives become a real problem.

54

There are interesting parallels between the generation of artists who succeeded the abstract expressionists and the generation of post-Greenbergian critics. Just as de Kooning's imitators in the late 1950s soon seemed unimportant compared with Johns and Rauschenberg, whose work radically rejected the assumptions of abstract expressionism, the more important new critics were not Greenberg's imitators, but those artwriters who rethought the problems of criticism in a more radical way. My present analysis permits an abstract formulation of their dilemma: given that a historical narrative is ultimately an arbitrary way of identifying new work, how is it possible to describe abstract art without appeal to such genealogies? Understanding how this problem was solved in practice is the goal of the next chapter.

3 The Presentness of Art

As I explicated Greenberg's art history narrative by discussion of Gombrich's similarly structured account, so now I will analyze Michael Fried's discussion of the presentness of modernist art by discussing the conceptually similar views of Adrian Stokes. To contrast Fried and Greenberg may seem surprising, for Fried expresses, repeatedly, the greatest admiration for Greenberg. Yet unlike many lesser critics who took issue with Greenberg in minor ways while accepting his general working assumptions, Fried adopted from the start a radically different approach. His account of the presentness of art deals with the problems inherent in art history narratives. Because Fried is a deeply original thinker, one whose real originality has not been understood by his many critics, it is useful to focus on his artwriting strategies. Stokes, like Fried, also sought an alternative to the art history narrative; unlike Fried, he explains in detail why he adopts this approach and how it may be defended. For this

reason, his important, relatively obscure work here receives extended discussion.

An art history narrative tells how what comes early in art's history leads to what comes later. Since any text must have a beginning, middle, and end, what alternative modes of artwriting are possible? Perhaps Stokes's early books would have seemed less exotic than they did had the great tradition of travel literature—the books about Italy by Goethe, Taine, Ruskin, and Burckhardt—not ended, their work replaced only by the humble, if indispensable, Blue Guides and Touring Club Italiano guides. Gombrich and Greenberg discuss artworks in their historical order; the travel writer discusses art in the order in which it is seen. Entering Santa Maria Gloriosa dei Frari, Venice, with Lorenzetti's *Venice and Its Lagoon* in hand, I notice Titian's *Pesaro Madonna* on the left; pass through the choir to look at the earlier Titian on the high altar; see the still earlier Vivarini and Donatello to the right of that altar; and exit past a nineteenth-century tomb by Canova's pupils to observe the late Gothic facade.[1] This experience, typical of the viewing of Italian art *in situ*, will seem startling to the museum goer, who expects to find art arranged in chronological order; in most museums, one walks from the rooms holding pre-Giottoesque work to the gallery of postmodernists. Still, even the museum goer will recognize that we see Titian's high altar painting better framed, as he intended, by the choir, not placed in the museum to which it was temporarily removed in the nineteenth century.[2]

Travel literature is a relic of the grand tour that once every English gentleman was expected to make; and Adrian Stokes (1902–72) is the last great figure of that tradition. Though he wrote about modern art, Stokes's most distinguished work is his account of early Renaissance art. For my purposes, what is most interesting about his writing is his highly original thought about how the experience of the traveler suggests a way of composing artwriting texts. Analysis of these books takes us far from the art of the 1960s of interest to Fried; but, as we will see, Stokes's account provides a highly suggestive way of explicating Fried's analysis.

Stokes's interest in the self-sufficient, self-explanatory artwork reflects a fantasy of many early modernist writers. For Rilke, Rodin's sculpture aims to "refer to nothing which lays beyond it."[3] For Pound, an image "is real because we know it directly"; Gaudier-Brzeska could, Pound

believed, read Chinese ideograms without knowing that language because they are transparently meaningful images.[4] For Wyndham Lewis, a musical work is inferior to a statue, "always there in its entirety before you."[5] Such an artwork need not be interpreted, because it contains "within itself all that is relevant to itself." The greatest art is in a double sense timeless; we see all at once the meaning of works from historically distant cultures. For this reason, the Tempio Malatestiana in Rimini, then well known because it was discussed in a popular historical novel by Edward Hutton, fascinated both Stokes and Ezra Pound (see fig. 10). "There is no description of the *Tempio* in accordance with good Vorticist logic; one art does not attempt what another can do better, and the meaning of the *Tempio* as been fully explicated on the spot by Agostino di Duccio, [its sculptor] with his chisel."[6]

Stokes's view is similar. Because Pound reviewed Stokes's first two important books, *The Quattro Cento* (1932) and *Stones of Rimini* (1934), some Pound scholars treat them as commentaries on his cantos.[7] Pound's celebration of Sigismondo, the protofascist builder of the Tempio, was not Stokes's theme, however; and Pound's fascination with the Tempio's incorporating of "cultural layers from various periods (the Gothic church, the Renaissance shell, the Byzantine marbles), as [he] does in *The Cantos*" was not Stokes's concern.[8] Rather, Stokes begins with the very traditional contrast of carving and modeling: the carver cuts away excess material, the modeler builds up his work.[9] For him that opposition defines aesthetic value; the carver has an authentic feeling for materials, unlike the turn of the century modelers, who sent small clay models to Italy to be scaled up and cut in stone.[10]

The carving sculptor creates on his stone's surface images showing the history of that material. That is, the temporal process in which that stone was created is exhibited, translating time into space. Stone is organic matter and water solidified slowly; it is a substance that "suggests concreted Time."[11] The images in the Tempio depicting Sigismondo and his love, Isotta, relate them to the stone's history. "The ideas of influence and attraction, and Isotta's pervasive magic, stimulated in the sculptor . . . (fantasies) of fecund moisture in stone, of glimmering forms seen under water, of suctional forces congealed as shapes on the surface of the marble." *Stones of Rimini* is a tripartite narrative. The parts are "Stone and Water," a lengthy account of geology and the place of stone in

10. Agostino di Duccio, *Mars*, Tempio
Malatestiano, Rimini (Alinari/Art Resource,
New York)

Mediterranean life; "Stone and Clay," the contrast between carving and modeling; "Stone, Water and Stars," an analysis of the work of Agostino. It concludes with a seemingly fantastical description of a great storm, which in August 1442, engulfed the building, wherein Stokes describes the sculpture's meaning as precisely as possible.

> The mysteries of ocean and of earth . . . are forging the new element which shall the better sustain the offspring of dust and water, the living form, their offspring of a now-remembered marriage. Venus comes reborn out of the further sea into the new element. Doves descend to give her greeting. As she touches land she disappears. . . . Nothing remains to the outer senses, all is music now, imperceptible to the ear, loud in the blood.

In an earlier passage Stokes imagined sea life repossessing Venice: "Salmon jump a fondamenta, sea-snakes crawl up the sheer sides of every campanile, parti-coloured cuttle-fish staining the pavement black squirm to reach the shoals stranded upon Rialto." Here too fantasy reveals the meaning of carved stone by telling of its relation to life and water.

"In the little chapel left of the altar is a lavabo with fantastic creatures, by the workshop of Donatello"(see fig. 11).[12] *The Blue Guide* has a page and a half on San Lorenzo, Florence, but only this sentence about the carved work that Stokes describes most elaborately. Water and ceremonies connected with birth attract him, so his account is lengthy.[13] "Beneath the lip of the cup where scorching, water sifting and rime have long been encrustated, as if left to golden communion with the love-chalice after the banquest has been drained," the "marine splendours have descended upon urn and crested cup . . . marble embraced to re-membrance of primeval beginnings in lime dropped by countless animals." Stokes sees the story of that stone used, appropriately, to celebrate life. The balance of the dragons' wings is intricate: "the right-hand one must reach higher than the left, but inasmuch as the right one, as well as making the connection with the eagle's left-upward stress, is the means of carrying on that stress in a right-downward form, it must also reach down lower than the left-hand wing."

Pateresque in its ruminations, this prose reveals a very un-Pateresque sensibility. For Pater, Giorgione's painting summarizes the history of European art; according to Stokes, this lavabo is a self-sufficient work.

11. Verrocchio (?), Lavabo, Old Sacristy,
San Lorenzo, Florence (Alinari/Art Resource,
New York)

Even if we know nothing about the artist, the meaning of his carving is transparent.

What was unoriginal in Stokes was his fascination with the early Renaissance. Many turn-of-the-century writers admired this period; John Symonds, for example, found the Tempio reminiscent of Botticelli and Burne-Jones, and of early Italian compositions for voice, which "surpass in suavity of tone and grade of movement all that music in her full-blown vigour has produced."[4] Alternatively, what was original in Stokes was his theory of the medium of relief sculpture; his account justified his belief that the meaning of a carved work is self-evident. Stokes's neologism "quattro cento" refers to art, whether from the quattrocento or other centuries, where "time is transposed into the forms of space as something instant and revealed."[5] The meaning of a quattro cento work is self-evident to sensitive viewers even if they do not know its art historical context.

This claim denies everything that Gombrich and others have said about interpretation; why did Stokes believe that it was defensible? Let us return to the contrast between seeing artworks and seeing the world. Things in the world are at some distance from me, and I see them from one viewpoint; as I move, hidden objects will come into view. My vantage point is thus always partial, what is present now defining a horizon beyond which I know that more exists. By contrast, a painting shows me a world I cannot see more of. I am not at some distance from figures depicted in the pigment, nor can I see what is beyond the frame or behind a depicted tree. In this sense, as Sartre said, a painting is like a mental image; it does not provide one point of view, but shows a depicted scene as if giving a view on another world.[6] Sometimes different views of the world may be hard to connect; what I see when looking through my window and when I am outdoors looking at that window may seem to be disjoint perceptions. For Stokes, art promises a world entirely accessible to the eye in which everything is visible at once, with no such succession of viewpoints even possible.

Rightly reminding us of the quasi-religious implications of this doctrine, deconstructionsts replace such Stokesian self-sufficient signs with symbols having meaning only as elements in a system. Their procedure is relevant here, for even as Stokes, our cicerone, points to the carved stone, he teaches about the carved/modeled opposition using his system

of examples. Like any binary opposition, his distinction classifies all objects under consideration into two categories. We identify the greater carved works by contrasting them to art with rhythm or tension, which shows failure to love stone. If we need such examples, if carving is understood only by opposition to modeling, though, then the claim that the carved work is self-sufficient is deconstructed. The carved work may transpose time into space, but its identity is known only in relation to the symbol system we learn by using *The Quattro Cento* as our travel guide.

For Gombrich, we see what a naturalistic picture depicts when we know its conventions; for Stokes, the quattro cento work is self-explanatory. A symbol, Gombrich says, is ambiguous until "viewed in context."[17] That an element could be taken out of context does not lead him to accept the deconstructionists' suggestion that it may therefore have no determinant meaning. Rather, successful images are those that can be disambiguated. Sometimes, certainly, we need to know the context. The detail in a Manet appears ambiguous until placed in the whole picture; stepping back from a late Titian makes the painterly brushstrokes fall into place; a sketch for *Wivenhoe Park* prompts us to see tiny details in the painting.

Gombrich's faith in the determinancy of context depends in part upon his link between picture interpretation and perception in general. Since the young Stokes thinks of seeing carved works as unlike viewing the world, for him the problem is radically different. Unlike Gombrich, he cannot appeal to a model in which perception involves successful testing of hypotheses. In fact, he disagrees radically with other interpreters of the Tempio. Edgar Wind sees in it the "musical animation of matter"; Jean Seznec, pagan sentiments of love and pride; John Pope-Hennessy, anticipations of Botticelli and Leonardo; and Charles Seymour, "the conscious recreation of a Neo-Attic style."[18] These art historians treat the relief sculptures as akin to paintings, windows through which we look to see depicted forms. For Stokes, carving instead brings to the material's surface images of its history.

As given here, this theory of carving applies only to sculpture; *Colour and Form* (1937) extended it to painting. The original theory of carving united two notions: the carver loves stone, and the carved work is transparently meaningful. Now these notions are separated. Only metaphor-

ically speaking does a carved painting "essentially illuminate a certain space"; now identifying love of materials is more complex.[19] Traditional aesthetics subordinates color to line. Color stands for emotion, line for order; color makes outlined forms more readily identifiable; color is only a property of surfaces, a mere secondary quality.[20] But for quattrocento artists green and blue were properties of green and blue *things*, not just qualities of their surfaces.[21] Ruskin hinted that this ideal might be revived: "As color is the type of love, it resembles it in all its modes of operation; and in practical work of human hands, it sustains charges of worthiness precisely like those of human sexual life."[22] Color shows, we might speculatively suggest, what sexuality also identifies, that point where "the meeting of mind and body is strikingly, if mysteriously, effected."[23] Line outlines form, and so usually represents, but color is (almost) always literal. Red pigment both is red and is used to represent red things.

The carving/modeling contrast now becomes for Stokes a contrast between surface color and film color. *Surface color* is color of depicted surfaces themselves; *film color*, color apparently unattached to such depicted forms. For Piero della Francesca, "forms are familiars. No form accepts sacrifice to the emphasis of another."[24] By contrast, film color reveals tension and rhythm; the depicted forms are linked in seemingly arbitrary ways. Carving color, Stokes believed, is synthesized instantaneously, an idea he drew from F. H. Bradley's theory of identity-in-difference: A is identical with B if A and B both differ and in some respect are identical. Analogously, carving color links different things in a seemingly inevitable unity.[25] Carved shapes appear rooted in one another, so that synthesis is less the finding anew of color relations than an awareness that the perceived forms appear already interrelated. We see one shape "as a form with roots in another . . . from which it grows and whose opposite nature it displays under the dramatic guise of rooted affinity."[26]

This is an antiformalist theory. Relations of depicted forms are akin to relations of natural things of the same colors. Hence, it is easy for Stokes to draw examples from the perception of nature and now, as was not the case earlier, the link between seeing pictures and perception in general is developed in his work. The trees in the portico of St. Martin's in the Fields show the potential fruitfulness of the stone: "Such green calls forth its complementary colour, a purplish red as if summer warmth were stored there."[27] Regarding a red letter box on a leafy street, "the

extended young green enjoyed a constant reciprocity with this squared patch of saturated red as being both the earth which fed the green thus spread, and as being the birthplace to which it might return." In painting, "something of the harmony of the original white canvas should be restored in the finished painting." In these words Greenberg praises a work which thus appears to be "the result of the successful resolution of a difficult struggle."[28] For Stokes, rather, this effect is forced; ideally, color relations should look inevitable. In a Brueghel, for example, the peasant's blue shirt "shaped from his folded arms is an extraction of the blue from the green-blue milky sea, whitened and fleeced from association with his sheep."[29]

It is hard to imagine artwriting more unlike present-day art history, and it is easy to see what is questionable in Stokes's account of art's presentness. Like Pater, Stokes offers a vision that it is hard to imagine emulating. So it is all the more surprising that Michael Fried, who to my knowledge never mentions Stokes, appeals to a similar theory of art.

Fried's contrast between theatrical art, which he dislikes, and the great modernist, antitheatrical works is complex; though much commented on, it remains puzzling. The real aim of his contrast is a desire that modernism achieve an equivalent to old master composition. When, for example, the follower of Poussin created that formal arrangement that Fry admired, he placed the depicted figures so that from wherever they are viewed, that appear in the same positions. This, of course, is true of any representation; as Gombrich notes, illusionistic depictions appear unchanged as the viewer moves.[30] But some artists of the sixties attempted to abolish such composition.

A minimalist places a box in a gallery, and spectators can take up as many viewpoints on it as on any physical object. Poussin's formal relations are internal to his work, but the minimalist makes me, the spectator, one element in his artwork. If the artist's goal is to compose by creating relations, then an incorporation of the spectator ought to seem undesirable. Anti-theatrical modernists, the artists Fried admires, create visually unambiguous images. If Morris Louis "did not want the veil configuration to be seen purely and simply as a physical object"; if Stella used irregular shapes "to prevent the eye from instantly perceiving the shape of the support as a single entity"; if Anthony Caro's two-piece *Prairie* appears as one unit—then the artwork as perceived is not the physical object.[31]

Any physical object appears different from various viewpoints, and so potentially is a theatrical artwork; but if "*at every moment the work itself is wholly manifest*," then that *work* cannot be a physical object.[32] Like the carved art Stokes admired, such "continuous and entire presentness" is experienced "as a kind of instantaneousness."

The suggestion that an artwork is not identical with any physical object is familiar to aestheticians. According to one traditional view, the artwork as such possesses only the qualities that are immediately visible.[33] The marks on the back of a painting, for example, are not aesthetic qualities of that work. Danto's aesthetic radically reinterprets this claim. Fried is not developing this theory, however. As he indicates, it was only in the context of the minimalist movement that the claim that the artwork is *just* a physical object became important to critics. If a Poussin painting is a physical object, obviously it is a special sort of physical object. The minimalists claimed that absolutely ordinary things could be artworks. A sequence of plates on the floor, an arrangement of lumber, the New Jersey Turnpike viewed at night could be artworks. It is important to see exactly what was novel about this claim. Following a long tradition, Fry says that anything may be viewed aesthetically; for example, I may concentrate on the formal relations I perceive when walking down a street. The minimalists' original claim was that the end of modernism led to the making of artworks that are just ordinary objects, stuff we might find anywhere. Here, as we have seen, they were perhaps interpreting Greenberg's theory.

Fried, like Stokes, makes a radical distinction between everyday perception and the experience of art. His account is best understood by returning to Gombrich's theory of interpretation. Constable's landscapes made Fuseli call for his raincoat and umbrella; a depicted nude is arousing because it calls up remembered experiences.[34] I am not hinting that I imagine making love to the depicted lady, nor that the pleasure of viewing landscapes requires fantasies of a picnic, but only noting (following Gombrich) how response to depicted figures presupposes some trace of similar ideas. This will happen, Stokes and Fried imply, unless the artwork achieves what I call presentness. "There may be nothing in the world which is purely objective, no object...which appears exactly the same from every conceivable point of view, which is as it is independently of all modes of observation, an object truly in itself."[35] Maybe artworks

can be such objects. For Gombrich, when I put an artwork in one context, I am aware that other features might appear in another context. If a work could have so self-evident a meaning as to appear the same in any context whatsoever, we could escape this dilemma. Any interpretation could only point to the qualities always present in that work.

The carved work is about its materials; the antitheatrical work is visually unambiguous. For Stokes, the carved work is unambiguous because it reveals the qualities of its materials; for Fried, modernist works are unambiguous because they are *not* material things. Ironically, they reach the same goal by these opposing arguments. Their denying that we need look outside the work itself to determine its context seems paradoxical. Normally, we casually take for granted much background information which, if pressed, we could make explicit. What Stokes and Fried deny, and Danto and Gombrich assert, is that we really need such information. "Why should it be worth my while," Stokes asks, "to transpose into terms of drama what is immediate and objective to the eye?"[36] If we can *see* the work's meaning, why write about it?

As stated, this claim is hard to argue with. Thus, it is best understood by considering how Stokes and Fried compose their texts. The advantage of art history texts, we have seen, is that they easily slip individual works into a narrative, implying that we can best interpret an artwork by placing it in a historical context. What alternative literary structures are available to Fried and Stokes? We can learn much about the strengths and limitations of Fried's texts by first discussing Stokes's account.

I earlier compared Stokes's books to travel guides, but that is not an entirely apt comparison. He is not just giving us a guide, but also evaluating what we see. *The Quattro Cento* is built around the opposition of Verona and Florence, wherein, "Verona" (or, really, "Venice") stands for carving and "Florence" for modeling. The book degenerates, almost, into a catalogue of examples barely linked by his narrative framework, as the section titles reveal: "Jesi"; "Venice"; "South opposed to east and north"; "Plastic and music"; "Roman architecture and the quattro cento"; "Genoa"; "Representational and non-representational art"; "Oriental and northern art in Italy"; "Verrocchio's lavabo"; and so forth.[37]

If one relevant strategy is suggested by the travel guide, another appears in the autobiography. For a man who found himself traveling in Italy,

these were related approaches. Stokes's model is less Pater's more than Jamesianly obscure *The Child in the House* than chapter 9 part 9 of Ruskin's *Modern Painters*, "The Two Boyhoods." Ruskin's opposition of Turner and Giorgione stands for London/Venice and also past/present; similarly, in Stokes's *Inside Out* (1947) and *Smooth and Rough* (1951), the London of his Edwardian childhood is opposed to the Italy where he discovered carved art. He identifies with Cézanne, another troubled youth, whose development from youthful romantic to mature classicist Stokes believed paralleled his own. His fascination with the carver giving "birth" to the stone was reinterpreted by him after the birth of his son, who became identified for Stokes with the house where he lived.[38] The sexual implications of the carving/modeling contrast are rethought as we learn why Stokes valued the quattro cento. The child who feared hidden spaces in the London parks, places where something menacing might be secreted, found in Italy "an open and naked world. I could not then fear for the hidden, for what might be hidden inside me and those I loved." If the carver gives birth to his stone, to "push this fantasy further, the sculptor's attendant statuary are her lovers and sons rather than her daughters or a mere projection of herself."[39] In unpublished material, Stokes notes his erotic pleasure in boyish sculpted figures; the most personal of artwriters, he describes his own development to explain the value he gives to carving.

The perfect stillness of carving stands, for Stokes, for both life and death. In his first and last writings, Stokes identifies aesthetic contemplation with death. Were the world to end soon, we could "enjoy our equality with old buildings. They hold no more mysterious secrets," for "all perfection is close to death."[40] His brother, a geologist, was killed in the World War I, so Stokes naturally associated stone with death, and was fascinated by the idea of escape from the destructive forces of time. This was not an altogether personal association. Wyndham Lewis wrote, "deadness is the first condition for art. With the statue its lines and masses are its soul, no restless inflammable ego is imagined for its interior: it has *no inside*."[41] Though his aesthetic is very different, Stokes repeats this last point, praising the Greeks for "their emphasis upon the exterior (though it is really no such thing because they did not thus seek to hide an interior...)."[42] The carving aesthetic is thus linked to a fear of what might be hidden, but now the significance of that fear is acknowledged.

This autobiographical detail explains much about Stokes's aesthetic judgments. Still, one dilemma remains. Carving is made meaningful for him because it is placed within a story of personal development, a temporal framework. Sometimes Stokes's later work is said to demonstrate how his view of art became more catholic. Compare, for example, his two accounts of Michelangelo:

> The stone is spent . . . in attaining colossal shapes, joyless, writhing supreme . . . reserve, exploited by Quattro Cento artists as a reserve of power . . . has been broken down. (1932)
>
> By means of the articulated nude, he . . . contrived a touchable and heroic universe, a touchable homogeneous condition, the outcome of conflict. (1955)[43]

Certainly Stokes's estimate of modeling became more positive, but to treat him as a man whose taste merely broadened trivializes that development. The real problem is that again the artwork is placed within a temporal framework: Instead of an art history narrative, that framework is now the story of Stokes's development. So his original aim, demonstrating the atemporal quality of the carved work, has been compromised; ultimately we can understand the work only by learning Stokes's life history. Stokes's frankness in facing this dilemma is most admirable. His early books contain beautiful writing, but his deepest insight was that they were incomplete without his autobiographical narratives.

Some art historians have interesting lives, but it is hard to think of one whose autobiography could be as revealing about his or her work as is Stokes's. Modern day professional art historians aim to be impersonal, and Stokes—who stands, as Meyer Schapiro has said, to art history as do the pre-Socratics to philosophy—remains outside that tradition. He is closer to Pater and Ruskin, and for interesting reasons; his "anxiety of influence" led him to make some surprisingly misleading claims about their work. Quattro cento architecture, he writes, "gives the lie to Pater's dictum about all art approximating to the condition of music."[44] But Pater's most famous sentence, "all art constantly aspires towards the condition of music," means rather that ideally art achieves a perfect unity of form and content, like that of music without words.[45] Pater does not claim that music is perfect because it is a temporal, nonspatial art. Stokes himself recognizes this obvious point when he later finds in Giorgione's

carving-painting the "fusion of form and content . . . that Pater considered justly to be close to music."[46] The author of *Stones of Rimini* was dangerously close to the powerful influence of Ruskin, so Stokes stakes out his independent position by claiming both that Venice is better understood in Rimini and that the real subject of his book is Venice. Only later does he write *Venice* (1945). He calls Ruskin "a tortured unappeased visionary, entranced by the utterly good, imprisoned without warning by an unutterable bad," and argues that Ruskin's moralizing led him "into the most glaring inconsistencies."[47] These judgments surely apply also to Stokes's own early writings and to his argument that contemporary art's limitations reflect the failure of the modern city "to provide the more intimate architectural pleasures once available in lovely streets," an obvious echo of Ruskin's view of Renaissance Venice.

To understand Stokes's account of art's presentness we need to know about his childhood memories, his brother's fate, and the birth of his son. To say this is not to criticize his work, though it does show why his original ideal of "carving" was confusing. In the previous chapter, I argued that Gombrich's theory of interpretation, which seems so much less personal, also is ultimately based upon a fantasy about vision. Whereas Gombrich's analysis, however, whatever its subjective roots, relates to the theorizing of other art historians, the same is not true of Stokes's account. Though admired by a small circle, his is not the sort of artwriting that can serve today as a model for others.

Fried, too, has not had many followers, but his work has been widely influential. Just as Greenberg's judgments about modernism are more controversial than Gombrich's account of the old masters, so Fried's highly debatable judgments of art of the 1960s caused more controversy than Stokes's discussion of quattrocento sculpture. Fried admired only a few artists, so critics with different tastes took issue with his account. What is most remarkable about Fried is his happily arrogant self-confidence, which perhaps made his relation to Greenberg easier than those of his contemporaries. He is one of those rare writers who was himself almost from when he started to publish. Baudelaire describes such a lucky person: "In short, what he is now, he was at the very beginning. Thanks to the energy that is in him, he will stay like that to the end. Just as he has not progressed, he will not grow old."[48]

Fried wrote, "One is always ill at ease disagreeing with Greenberg on

visual grounds."[49] In truth, he seems not at all ill at ease. Compared with *Art and Culture*, his texts on criticism have relatively undeveloped or, at least, short-range historical references. As Greenberg derived Pollock from analytical cubism, so Fried links Morris Louis and other artists of the 1960s to Pollock. The two key concepts in his account of presentness are nonrepresentational line and deductive structure.

Pollock's aim, Fried asserts, was not just to create a shallow space, but to use line that is freed "not only from its function of representing objects in the world, but also from its task of describing or bounding shapes."[50] A closed line marks a represented "inside" apart from its "outside"; but in Pollock's swirls of line, every given area is both *inside* one adjacent line and *outside* another. Pollock created nonfigural line compositions; Morris Louis used color in an equivalent way. His less successful works use color "as though they represent real objects juxtaposed almost Cubistically in something like traditional space"; his great paintings create "an extraordinary illusion . . . not of bodies in space, nor of space alone, but of . . . modes of matter, modes of substance, modes of corporeality."[51] It may seem strange for Fried to say that he disagrees with Greenberg's account of Pollock on "visual grounds"; their accounts are not obviously incompatible interpretations. While Greenberg's very brief published analysis of Louis treats him as a figure within modernism, though, Fried—who certainly thinks that Louis continues that tradition—implies that Louis differs from Pollock as much as does Pollock from the analytical cubists.

The concept of deductive structure is more complex. Greenberg discusses how Mondrian and Barnett Newman compose in relation to the stretcher. His analysis echoes Woelfflin's contrast between classical old master composition that works with the frame and those baroque compositions that refuse explicitly to acknowledge that frame.[52] In developing this point, Fried says that an abstract painting may echo an irregular-shaped frame inside the picture or oppose literal to depicted shape to create illusionism of edge, equivalent to modernist and old master illusionism in depth. In Stella's *Moultonboro III* (1966), for example (see fig. 12), "the shape of the support is an irregular polygon formed by superimposing a triangle and a square, the first apparently having come slanting down from the upper right to wedge itself deeply into the second."[53] The actual shape of this painting contrasts with its apparent

12. Frank Stella, *Moultonboro III*, 1966.
(Photo courtesy of Leo Castelli Gallery,
New York)

shape. Similarly, although we know that Caro's *Prairie* is a two-piece sculpture with three horizontal bars on one piece and one bar on the other, we see the four bars as marking one plane.[54] These relationships, "which make a different kind of sense to the mind and to the eye," thus compel "us to believe what we see rather than what we know." Like Stella, Caro creates nonrepresentational artworks that seemingly deny that they are physical objects.

The difference between this account of modernism and Greenberg's, Fried argues, is that although Greenberg *can* be read, as I have noted, as asserting "that modernism proceeds by discarding inessential conventions in pursuit of a timeless constitutive core," Fried cannot.[55] One is always ill at ease disagreeing with Fried on textual grounds, but here he has not defined the difference between himself and Greenberg in the most happy way. The essence of painting, Fried asserts, "changes continually in response to the vital work of the recent past." If, however, by 1966 modernism had eliminated deep space, any hints of represented forms, brushwork, and the illusionism of depth, what could come next? I grant that this question may merely reveal my lack of imagination, but it is easy to feel that by 1966 few moves were left to the painter. In fact, of the artists then admired by Fried, only Stella remains of interest to younger artists today; this is because gestural brushwork and spatial illusionism reentered his art with a vengeance. Fried himself has not continued to publish criticism, but today writes art history. Whatever his personal reasons for doing so, it has contributed to his reputation. He refuses to repeat himself, so now is for critics as much a figure of the distant past as Greenberg.

In part, this change is like the change in Greenberg's status. Fried became famous as the champion of Noland, Stella, Olitski, and Caro. Once his judgment of them became accepted, there was a search for other artists worth writing about. Artwriters interested in minimalism, conceptual art, or, in the late 1970s, the revival of abstract painting and neo-expressionism had little use for Fried's texts. Fashions in artwriting change quickly, but what is special about the change in Fried's status is that it revealed some real problems inherent in his theorizing. Here, again, a comparison with Stokes's theory of art's presentness is illuminating.

Often in Fried's texts there is a striking contrast between a description of the literal qualities of an artwork and its expressive qualities:

The primacy of literal shape [for Olitski] is such that even a slight departure from verticality . . . makes itself felt with an intensity of expression I, for one, find astonishing.

It is as though [with Louis] tautness and flatness *themselves* billow in the unfurleds, in a wind whose source and very nature remain wholly mysterious.

If the central concept for understanding Caro's art is that of the body, . . . for Noland's it is personal identity.[56]

Obviously any interpretation may be debated. Still, there is a difference in kind between arguing about the place of the mirror in *A Bar at the Folies-Bergère* and debating with Fried. Consider, for example, Richard Hennessy's recent revisionist account of Stella, which describes his early work differently than does Fried.[57] "His paintings are stunning, numbing, deadening. . . . Since all the forms exist either on the surface or behind it, nothing advances toward us." He agrees with Fried that Stella learned from Pollock, while disagreeing entirely about the interest of the resulting work. Like Greenberg's art history narrative, Hennessy's text implies that we can judge early Stella by placing his work in a historical context; but even viewers who disagree with Hennessy and accept Fried's claims will have difficulty explaining how to justify Fried's interpretations.

This problem is inherent in interpretations of recent art. To interpret *A Bar at the Folies-Bergère* or the *Tempest* is, in part, to identify their content. Interpreters agree on one level about what these paintings by Manet and Giorgione depict while disagreeing about the political or art historical meanings of that content. By contrast, it is harder for Fried to explain how Noland's chevrons and circles are "about" personal identity. This problem can be exemplified when we contrast two interpretations of Jasper Johns's *Flag*. For Greenberg, it is a work "interested in in the literary irony that results from representing flat and artificial configurations"; for Leo Steinberg, "Johns' subjects are whole entities seen from no particular angle."[58] Though Greenberg, unlike Steinberg, does not admire this work, these interpretations do not obviously conflict, so it is difficult to know what more to say about this dispute, which in part involves a dispute about taste.

This point is one reason that so much writing about abstraction is modeled on Greenberg's genealogies. To place an abstract painting in

historical narrative is a very useful way to explain its visual qualities. By focusing on the presentness of art, Fried makes it more difficult to understand his descriptions, and it is not clear what he can say to anyone who debates with him. He wrote, "I am angered and stunned with frustration" about what other critics said about the artists he admired.[59] Where a less confident person would come to doubt his own claims if there was so much disagreement with those judgments, Fried concludes that he is right and his critics, i.e. almost everyone else, wrong.

Were Fried's favored artists still universally admired and his vision of modernism generally accepted, there would be a certain objectivity to his judgments. As it is, his claims come to seem merely private enthusiasms. This dilemma is inherent in the theory of art's presentness. When Stokes points to the meaning of Agostino's reliefs, he describes the history of stone shown in these carvings. Even if I think his analysis is subjective, his autobiography permits me to understand his judgments. By comparison, Fried's statements are gnomic. When he compares the Louis to a curtain, he allegorizes it in a somewhat literal way, even while saying that it is not a physical object. When he describes "the utter pervasiveness—the virtual universality" of the theatrical sensibility, I read him as reformulating Stokes's carving ideology.[60] "Presentness is grace" because normally we cannot see a world entirely open to the eye; but Fried's words are elliptical. My need to read them in relation to Stokes's discussion only emphasizes how much more fully Stokes motivates his account.

Here, too, the contrast with Greenberg's genealogies is revealing. Though highly controversial, they are relatively easy to understand; that Picasso is Pollock's precursor is, we have seen, a suggestive visual comparison. Such visual comparisons are useful because even if we cannot easily identify the similarities in so many words, we can visually compare the two works; this is, of course, one reason that art history is so conveniently taught using two slide projectors. By detaching a work from any such context, Fried makes its meaning harder to grasp. He would have us understand a painting in isolation, but it is not obvious that we possess any clear vocabulary to identify the features to which he points.

It is significant that Fried's account of Caro is his analysis least vulnerable to this objection. To see Caro as using "*our* uprightness, frontality, axiality, groundedness and symmetry" in some large works or to

compare his small table sculptures to "Chardin's depiction of utensils with handles directed towards the beholder" is relatively easy.[61] Because these sculptures are three-dimensional objects, it is not hard to relate this account of their expressive qualities to a description of the physical objects that constitute these sculptures. What Fried says about the paintings of Olitski and Stella is harder to understand.

Asserting that Pollock takes up from analytical cubism is a request for the viewer to look into him or herself for comparisons; saying that a Stella demands "to be experienced in (its) . . . terrific immediacy and directness, as of a gesture or cry" is more puzzling.[62] Fried wants us to see that work's meaning. One feels blind if one cannot see it as he does and ignorant if one cannot explain it to others who are blind. Ultimately, of course, all any artwriter can do is point; sometimes, still, that act of pointing can be motivated. "Look at that," I say, pointing; and you know from the context that I point to my Turkish kelim on the floor, not the dust in the air, the dirt under that carpet, or the mess in my basement. Pointing is always context-dependent, and if ordinarily its contexts need not be spelled out, that is because in everyday life their meaning is apparent. Fried wants the meaning of modernist art to be as self-evident as the gesture of pointing, but because these artworks are not like my gesture, embedded in some life world, it is hard to understand his act of pointing.

I have made a sharp distinction between Greenberg's genealogies and Fried's concern with presentness. That dramatic, didactically useful contrast may be misleading; often Fried does construct an art historical narrative. *Three American Painters*, for example, opens with a defense of formalism, continues with a discussion of Pollock, and then devotes successive sections to Noland, Olitski, and Stella. Given that narrative structure, it is unavoidable that Noland seems the most traditional of these three Americans, the one closest to Pollock, and Stella the most advanced. Indeed, Fried begins discussion of Noland by asserting, "Olitski's paintings demand to be seen and discussed first of all in terms of color, and Stella's in terms of structure; in Noland's paintings neither color nor structure seems to come first."[63] This is a complex starting point. "Stella is the youngest," and so "perhaps his reliance on exclusively formal concerns" is "no mere coincidence." Certainly it is no coincidence that Stella, coming last in Fried's text, goes farthest beyond Pollock.

Because the discussion of Stella leads to an analysis of the Dadaist opposition "to the notion of *value* or *quality* in art," it would be logical to imagine that Dada goes one step beyond Stella. Fried undercuts this implied temporal thrust of his narrative, though, by strongly denying that going one step further is to understand modernism.

A discursive account takes time to develop its argument; pointing can be understood all at once. If the presentness of modernist works is shown by the fact that we understand them all at once, then the difficulty for the artwriter is to construct a narrative whose temporal structure does not undermine the claims of his theorizing. Even if I think that I grasp a text's argument all at once, I still realize this only gradually. If I really believe that the structure of texts is irrelevant to their argument, using them to teach readers to see becomes difficult.

"There are . . . things that cannot be put into words. *They make themselves manifest. They are what is mystical*"—but looking back on his early philosophy, Wittgenstein came to believe that he failed to take account of the public ways that language use is governed.[64] A similar objection can apply to Fried's doctrine of presentness. His compelling account is hard to explain in words that others can understand.

What have we learned from Stokes and Fried? Their attempt to abolish the art history narrative ultimately is doomed to failure. This failure is shown by Stokes's recognition that his early texts were comprehensible only when placed in the context provided by his later autobiographies. In Fried's case it is shown by the fact that his widely admired writing failed, unlike Greenberg's, to attract imitators. "We should try to unpack the notion of theatricality. . . . it is too dense and too confusing."[65] Here Rosalind Krauss speaks for many of us. What was most valuable in Stokes's work was his attempt to provide an alternative to the limitations of art history narratives. In now recognizing that his approach also is ultimately limited, we need not go back to such narratives. Rather, following the historical development of artwriting itself, we must see how the post-Friedian structuralist focus on the artworld system provides a strategy for artwriting that transcends the limitations of both historical narratives and the theory of the presentness of art. To this effort I now turn.

4 The Art System

The trouble with Greenberg's genealogies, I argued earlier, stems from the fact that they make the individual modernist work meaningful by placing it within a historical sequence. Chapter 3 showed that the ultimate limitation of Fried's account is that it leaves the meaning of the individual work unexplained. These problems with painting were reflected in the actual artworld situation of the 1970s. In 1975, *Artforum* published a "special painting issue." The cover reproduced a famous photograph of Pollock making a painting, and in the major article various painters were questioned about the prospects of their art. The article asserted, "It appears that painting has ceased to be the dominant artistic medium for the moment."[1] The implication, many respondents noted, was that painting was dead. Pollock's work was in the museums, but he seemed almost as historically distant as the old masters; and many articles and reviews were openly hostile to the very idea of painting. In that era of political crisis, many critics desired that art

contribute to the revolution; for them, traditional easel painting seemed hopelessly compromised by its links to capitalism. The artists whom Greenberg and Fried admired had become successful producers of commodities, and many younger critics rejected this conception of art.

This viewpoint was shared by only a small group of New York critics; it did not lead to the closing of art schools nor to an end to the art market. Most artworld activity proceeded independently and probably in ignorance of this debate. As the history of modernism shows, however, often an important change in sensibility initially is the product of the work of a small group. Only a few early artwriters understood cubism and in the 1940s Pollock was ridiculed or dismissed by most critics, so the importance of this viewpoint is not to be measured by the fact that only a limited number of critics accepted it. Leaving aside the political issues, these critics had worked through the dialectic described in the first three chapters of this book. Their felt dissatisfaction with these modes of artwriting implied a real uncertainty about the validity of any ongoing tradition of painting.

Given this impasse, what was needed was a new way of thinking about artmaking. In this, the analysis of photography and a semiotic theory of visual images played a constructive role. The account that I will now present is woven from a theory of representation given recently by Norman Bryson and an account of photography developed by Rosalind Krauss; these accounts were developed separately and serve quite different goals. But Bryson's and Krauss's shared concerns reflect their common interest in structuralism and poststructuralism, major influences on critics of this period, which led to a rejection of the traditional art historical narrative.

Compared with the work of Greenberg and Fried, these theories remain somewhat sketchy. This need not concern us greatly; because the semiotic theory of art is original, it has been difficult to work it out in detail. Gombrich's and Greenberg's accounts draw on a long tradition of art historical narratives; the semiotic theoriticians are trying to do something new.

Since its invention, photography has often been treated as a rival to painting. Therefore, it is surprising that this book has come this far without mentioning photography. *Art and Illusion* nowhere links the birth of photography to the end of the naturalistic tradition; Greenberg's

analysis of modernism says nothing about the relation between self-conscious attention to the properties of the medium of painting and the invention of photography; Fried's account does not contrast paintings that achieve presentness to photographs. It cannot be wholly accidental, however, that the changes in painting coincide with the invention of photography.[2]

What does photography tell us about painting? Constable's *Wivenhoe Park* looks like Wivenhoe Park because he, a skilled naturalist, painted his scene while working in Wivenhoe Park. Such a painting of some actually existing place succeeds when it captures that place's appearance. Many naturalistic pictures, though, depict things the artists could not see, such as a crucifixion by Giotto or an Annunciation by Leonardo. More complex still are symbolic images. God is often shown as a balding elder; since he is not a man, these representations use conventional symbolism. "A painting may *represent* an object of the visible world, a woman holding a balance, or a lion. It may also *symbolize* an idea . . . the woman with the balance will symbolize Justice, the lion Courage or the British Empire."[3] In this passage Gombrich reminds us that the representation/symbol distinction is in part arbitrary. God does not look like the old man depicted by Allori in his *Trinity* (fig. 13), but even Constable's naturalistic masterpiece looks like what it represents only for the viewer who approaches it knowing Constable's conventions.

Photographs represent in a different way. My passport portrait shows me because it was made by exposing film in my presence; such an image exhibits "marks or traces of a particular cause" of "that thing to which" it refers.[4] This causal connection is a necessary but not sufficient condition for such representation; a photograph where the film was exposed for one hour or taken with a distorting lens would not show my appearance. Photographs might be compared with the line drawing made by the Corinthian maid. Just as she can depict her boyfriend only by positioning him so that he creates a recognizable profile image, so a photographer represents me only when his camera is properly arranged. Perhaps standards for acceptable images depend upon those defined earlier by painted portraits. Even so, there is a difference in kind between how a photograph and a painting refer to me. The painting identifies me because it uses pictorial conventions; the photograph is of me because it is causally connected to my presence before the exposed film.

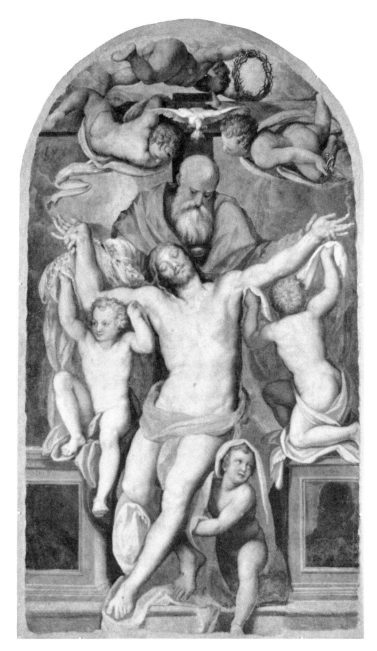

13. Alessandro Allori, *Trinity*, Cappella di
San Luca, Santissima Annunziata, Florence.
(Scala/Art Resource, New York)

Nineteenth-century critics asked whether photography could rival painting in capturing the appearance of depicted things. This analysis allows for that possibility, but points to an inherent difference in the ways that photographs and paintings refer. Looking at a painting, I can always ask, "Did this scene exist, or did the painter invent it?" Viewing a photograph, I see "the *necessarily* real thing which has been placed before the lens, without which there would be no photograph."[5] The photograph attests "that what I see has indeed existed." Unlike a painting, it "bears an indexical relation to its object," where "indexes establish their meaning along the axis of a physical relationship to their referents."[6]

As long as we allow Gombrich's claim that illusionistic pictures have some natural relationship to what they depict, the above analysis adds nothing new. Painting and photographing are different ways of making naturalistic images. The key additional claim is that illusionistic paintings do *not* have this special relation to reality. Though Gombrich himself often has "stressed the conventional element in many modes of representation," what is special, he argues, about a painting like Constable's is that "we can, and almost must, interpret...in terms of a possible visible world....to those who can read the code, it would...give no false information."[7] Given the problems, many noted by Gombrich himself, with his equation of naturalism with illusionism, we might seek an alternative account of pictorial naturalism. Norman Bryson does so, defining pictorial naturalism by using a theory developed by literary critics.

We think *Pride and Prejudice* a more naturalistic work than a Beckett novel, and we explain this intuition by a theory of literary realism. Such realism is produced by the multiplication of details not essential merely to describing the action; we learn not just what the characters do, but how they are dressed and what objects surround them. "And Abraham rose up early in the morning, and saddled his ass, and took two of his young men with him, and Isaac his son, and clave the wood for the burnt offering, and rose up, and went into the place of which God had told him." As Erich Auerbach notes, Gen. 22.3 gives no details about the landscape or the servants' attire. "A journey is made, because God has designated the place where the sacrifice is to be performed; but we are told nothing about the journey except that it took three days."[8] Drawing on his comparison with the naturalism of the *Odyssey*, suppose I rewrite Genesis in a more naturalistic style:

And Abraham rose early in the morning.

It was seven, and he was thirsty and hungry; and so he ate. He saddled his ass,

choosing for this momentous occasion a finely worked leather saddle and took two of his young men with him,

Peter, a homely but honest lad, and brave Kasimir. Peter was plainly dressed, but Kasimir wrote a brightly colored overcoat.

and so on. This multiplication of details makes the scene seem more naturalistic by supplying information that does not add to the list of essential actions.

Bryson proposes similarly, that we contrast the Duccio and Giotto depictions of Christ betrayed by Judas. Giotto's is more naturalistic because it "conveys far more information concerning the exact disposition in space . . . far more detail of facial expression, drapery, bodily posture, light conditions."[9] Nelson Goodman's critique of theories of pictorial naturalism offers a concept useful here: one image is relatively replete compared with another if more of its features are aesthetically relevant. Imagine, for example, a Hokusai drawing of a mountain and a visually identical graph from a fetal monitor.[10] In the graph, all that counts is the relative vertical height of the line; in the Hokusai, the texture of the paper, the thickness of line, and color all are of aesthetic significance. A similar comparison may be made using the different images of Christ betrayed. Giotto's relatively replete picture is more naturalistic, not because it is more lifelike but because it conveys more information; so we may define naturalism without reference to Gombrich's account.

This (quickly sketched) argument blurs important distinctions. That the semiotic theory remains crude need not bother us; as I have indicated, much of the sophistication of Gombrich's analysis, which this theory ultimately aims to rival, is due to Gombrich's skillful use of a long tradition dating from Ruskin, Vasari, and Alberti. Still, we must consider some problems seemingly inherent in the semiotic theory.[11]

The comparison of two versions of Gen. 22.3 and of two paintings of Christ Betrayed by Judas assumes that we can contrast two symbols with identical content but more and less detailed descriptions of that content; but such a form content distinction is problematic in both verbal and visual arts. I treat Gen. 22.3 as an annal that I can supplement, but

14. Agostino di Duccio, *The Kiss of Judas*.
(Alinari/Art Resource, New York)

15. Giotto, *The Kiss of Judas.*
(Alinari/Art Resource, New York)

I can do this only if I adopt a controversial theory of narratives.[12] Raymond Queneau's *Exercises in Style* gives seventy-nine versions of the same story, a trivial incident on a Paris bus. We know that these are different tellings of the same story because Queneau so constructs them. Lacking similar knowledge, what would it mean to assert that a Norwegian or Nigerian folktale in which a man killed his father, slept with his mother, and lived happily ever after was a version of the story of Oedipus? Identifying "the story," which may be told differently, is possible only if we have one source for different versions, like the waltz by Diabelli on which Beethoven composed variations. Even thinking of variations as containing the same events or the same melody may be problematic; certainly my version of Genesis includes events not found in the authorized version.

Thinking of two different paintings as depicting Christ's betrayal is still more problematic. Bryson correctly notes that a painter must interpret, but wrongly concludes that the semiotic theory shows that Giotto necessarily does so in more detail. Suppose I agree for the sake of argument that Giotto does show more detail. Compare the works:

> Duccio's *Kiss of Judas*: Judas kisses Christ.
> Giotto's *Kiss of Judas*: Judas kisses Christ, who is facing him; a
> soldier is behind.

Following Meyer Schapiro, I contrast an earlier version of this scene to Giotto's vision "of the fateful encounter of two men who look into each other's eyes."[13] How can I describe the two paintings so as not to beg the issue? Suppose I write the same descriptions differently:

> Duccio's *Kiss of Judas*: Judas kisses Christ; there is no soldier behind.
> Giotto's *Kiss of Judas*: Judas kisses Christ.

This seems a perverse analysis, since Giotto's important innovation consisted of adding the soldier. How though can the semiotician make this point without implicitly appealing to Gombrich's theory of naturalism?

Here differences between texts and pictures are important. We can agree that "Judas kisses Christ" is a simpler description than "Judas kisses Christ, looking him in the eye; a soldier stands behind." The second text incorporates the first and adds more details, but translating visual into verbal symbols is not simple. Giotto, we may say, shows a more

complex figure grouping. Does it follow that he gives us more information? The Duccio picture gives one arrangement of figures, and Giotto's another; to identify Giotto's picture as the one giving more information supposes some natural standard of comparison. Because the aim is to replace Gombrich's account, the semiotician's analysis cannot appeal to a simple intuitive visual comparison. Goodman's concept of relative repleteness indicates this problem. We know that color, thickness of line, and image size in the fetal monitor graph are irrelevant; we cannot analogously conclude a priori that Duccio's failure to include features that Giotto does show indicates that the earlier picture therefore contains less information.

Neither Goodman's treatise, *Languages of Art*, nor Bryson's books give a clearly acceptable semiotic theory of images; as their critics have repeatedly noted, they do not really succeed in demonstrating that Gombrich's intuitively more plausible account is wrong, though they do show problems in his analysis. Debate about the semiotic theory will surely proceed. Meanwhile, though, the working critic still needs some alternative, however incompletely developed, to Gombrich's and Greenberg's accounts. Whatever the ultimate verdict of philosophers, the semiotic theory seems a suggestive way of thinking about contemporary art.

We may sketch such as account by following Rosalind Krauss, who observes that it was no accident that the structuralist theories of linguistics originated at the same time as art history. "The founding principles of art history . . . are similar to the set of acts that initiated modernism as an esthetic ideal. Both convert diachrony into synchrony. . . . [both] take successions of raw historical phenomena and transform them into formal systems."[4] Such images are only conventionally related to what they represent; each element in a system has meaning in relation to the available alternatives. If the only colors of traffic lights are green, yellow, and red, those colors signify "go," "go with caution," and "stop," not because there is any natural connection between green and forward motion but by convention. Krauss's art historical example of such coded alternatives is Woelfflin's opposition of the classical to the baroque; the classical work has meaning "only in relation to . . . not being Baroque."

Woelfflin describes the historical evolution from the classical to the baroque; had the Turks conquered Rome in 1550 and preserved classical art, there would have been no baroque. Yet, we could today still interpret

classical art; so how can the classical have meaning only in opposition to the baroque? In his critique of Woelfflin, Gombrich makes a related point: "It is legitimate . . . to compare . . . Caravaggio with Raphael, for Caravaggio knew Raphael's works. . . . But when we read the comparison the other way round and contrast the Raphael with the Caravaggio we are on more dangerous ground. [Raphael] cannot have rejected what he never knew."[5] Gombrich is right to conclude that the earlier artist's intentions are thus disregarded, but wrong to conclude that a structuralist reading of Woelfflin is mistaken for this reason. We are now abandoning the art historical narrative and describing the system of artworks in an ahistorical way. Because photography marks the end of the history of painting, we are examining a closed system of objects.

This last point is important. Gombrich argues that painting ended in cubism, Greenberg that it continues in modernism. Krauss's view must be distinguished from both. A *subject* may cease to exist either if it exhausts all its own resources or when it is destroyed by some external force. For Gombrich and Greenberg, the existence of the outside society is the necessary precondition for art's relatively autonomous development; for Krauss, the invention of photograph provokes a break in art's history. Unlike an old master who uses inherited schemata to continue a tradition, Manet makes "painting's relationship to its sources self-consciously problematic."[6] The easy availability of many mechanically reproduced images transforms painting and at the same time helps create art history. "It is not so much a fortunate coincidence as a product of specific cultural conditions, in which the foundations of modern art history and those of modern art were laid down together."[7] For Greenberg, Manet is the first modernist and so both breaks with and continues the old master traditions. If his work marks, however, the beginning of the end of a tradition, then it is more appropriate to identify him as the first postmodernist. Krauss's account implies that Greenberg's view of Manet is all too similar to Gombrich's; though Greenberg and Gombrich disagree about the meaning of Manet's quotations, what they share is the mistaken belief that there was a tradition for him to continue.

The nature of this radically new relationship between painting and photography only became clear, Krauss implies, in the 1960s. We find then unmistakable evidence for the development of postmodernism. Con-

sider, for example, the work of Robert Rauschenberg and Frank Stella. Rauschenberg's collages incorporate photographs and also objects such as clocks, chairs, and ladders into a picture plane, which thus becomes radically different from an Albertian "window." Any flat documentary surface that tabulates information is a relevant analogue of his picture plane—radically different from the transparent projection plane with its optical correspondence to man's visual field."[18] On that flat bed, the quoted image ceases to be the starting point for making and matching; the collage is very different from those cubist collages that, according to Greenberg, continue the modernist tradition by flattening the picture plane until "the only place left for a three-dimensional illusion is in front of, upon, the surface."[19] Photography thus enables Rauschenberg to break with the past.

Stella does not use photographs, but for Krauss his equivalent break with modernism involves a turn from the artwork as a place for "the transcription of an artist's inner emotions"—as gestural abstract expressionist brushwork was expressive—to the use of "a language that belongs . . . to the world rather than to the private, originating capacity (of Stella) to invent shapes."[20] Meyer Schapiro earlier described the abstract expressionist's strokes, "signs of the artist's active presence," as attempts to "manifest his liberty in this striking way"; and as Schapiro recognized early, that sort of self-expression could be repeated and codified.[21] Because great paintings are valuable, they easily become objects "of speculation, confusing the values of art." In rejecting this sort of expression, Krauss argues, Stella echoes Wittgenstein's rejection of private language, "a language in which meaning is determined by the uniqueness of an individual's internal experience."

A new technology of image-production calls for new art. The refusal of a nineteenth-century politician to deal with industrialization would mark him as a reactionary; the same can be said of artists, dealers, collectors, and museums who fail to use such technology. Before photography, all images were handmade, so the special value attached to an original was justified. To continue today to make such images shows a deliberate blindness, which can only be explained by analysis of an objectively irrational art market. If this argument is correct, then as the Octobrists—as I will call the writers associated with the journal Krauss

coedits, *October*—admit, ironically Rauschenberg and Stella have failed to grasp it. Rauschenberg seems an admirer of, not the deconstructor of, the museum; Stella's recent art brings back that expressive brushwork which earlier it seemed his mission to abolish.

How ought photography to transform the museum? Reproductions make art from all cultures easily accessible, so artwriting and the teaching of art history are heavily dependent upon photography. Perhaps the museum has become impossible: "The fiction is that a repeated metonymic displacement of fragment for totality, object to label, series of objects to series of labels, can still produce a representation which is somehow adequate to a nonlinguistic universe."[22] When art collecting was centered on the High Renaissance, when every gentleman knew the fixed rules of taste, then the structure of the museum was self-evidently meaningful. When, however, we collect Manet, his once sconed academic contemporaries, and also tribal carvings, Gothic sculpture, icons, photographs, and ready-mades, then the museum ceases to have a coherent organization.

Is this argument correct? Even stated loosely (and I am unsure about how to make it more precise) it seems to misunderstand museums. The implicit assumption is that if our practices fail to have justification, they are incoherent. Yet a Rauschenberg can exist alongside the works depicted in his collages, and a Salon painting near a Manet, even if the beliefs of these artists contradict one another. Paintings are not propositions, so juxtaposition of such works is not like entertaining mutually incompatible beliefs. A rich Communist who believes both in equality and that he deserves the family chateau lives a life of contradictions. A museum director who juxtaposes her Rauschenberg with a Manet and with old master works does not, and even if no single theory coherently represents all the works, that need not show that such a collection is somehow unintelligible. Detaching an altar from a church, a carpet from a mosque, and a fresco from Pompei and then juxtaposing them with a Rauschenberg takes the older artifacts out of context; but thinking of that ensemble as incoherent treats our collecting practices in an over-rationalistic way.

Is today continuing to make paintings reactionary, as the Octobrists imply? That claim also is hard to judge. If the parallel between Stella's public code and Wittgenstein's discussion of private languages inspired

some artists, this was only because they misread Wittgenstein. He argued against using a language in which only the person who experiences a pain could refer to that pain; he was not arguing that we can, should, or ought to turn away from such talk about feelings. In any case, Krauss's contrast between abstract expressionist expression of feelings and Stella's code is altogether inadequate if we take seriously Stella's recent recollections about his early works. The title of *Arundel Castle* refers to a slum apartment where Stella worked as house painter, a building named after the West Sussex castle that Constable painted just before he died (see fig. 16).[23] Stella worked for a painter who "got many jobs in slum districts where the courts were forcing landlords to repaint." The titles, color, and technique of his early seemingly impersonal works are as revealing as de Kooning's fantasies about women are about his abstract expressionist art.

A politician who blocks the ERA is a reactionary; the role of a painter who today works in the style of the Chagall of 1910 is more complex. Such borrowings are artistically reactionary only if we believe that art history is goal oriented. The chiliastic interpretation of Greenberg is really the Octobrist position. Is it correct that in neo-expressionism "gestural delineation, high contrast color, and heavy impasto are immediate (unmediated, noncoded) representations of the artist's desire"?[24] Krauss has criticized the fantasy that an "abstract image" can play "directly on the viewer's sensations," a view Gombrich too criticizes when he rejects the claim that "the artist broadcasts his message in the hope of reaching a mind that will vibrate in unison with his own."[25] It would be strange if today artists who self-consciously quote earlier styles believed that they could achieve unmediated expression. A more interesting objection to such borrowings is that they ask us to compare these young artists to their self-proclaimed precursors; that comparison may only remind us of the superiority of the older masters.

The Octobrists insist that if they have demonstrated that art's history has ended, painters ought not to continue to paint. Like any claim that the world is not as it ought to be, like a leftist assertion that since capitalism is riddled with contradictions it should cease to exist, this analysis is very vulnerable to the objection that it is merely prescriptive. The Utopian socialist, Marx said, constructs a theory by which to judge reality, and then condemns reality for failing to fit that standard. If

16. Frank Stella, *Arundel Castle*, 1959.
(Hirshhorn Museum and Sculpture Garden,
Smithsonian Institution)

Rauschenberg's collages are in the museum, then that institution is finished. Rauschenberg's art is in the museum. Therefore the museum is finished, QED. Only a philosopher would conclude that, faced with the choice of rejecting this first premise or judging that the conclusion is false, the former is more plausible. Craig Owens asserts that a painter who makes interchangeable paintings, frames holding blank canvases, thereby shows how "in exchange all works of art are reduced to equivalence" and thus finds exposed "the contradictions of cultural production in a market economy."[26] Because he is an editor of a journal whose very existence presupposes that artworks are something over and above such commodities, the real contradiction here is his unhappy place in a market economy that he, for good enough reasons, dislikes.

To the extent that the Octobrists make political claims, these gifted artwriters seem still caught up in the dated leftist politics of the 1960s. Then it seemed reasonable to conclude that art's history was closed; today this vision of artwriting seems only an interpretation of Greenberg's account. For only when we really believe that each movement must advance if art is not to perish does the notion of art's history concluding in the endgame moves approved by the Octobrists make sense. Krauss raises this issue when, noting that "grids serve as a paradigm or model for the anti-developmental, the anti-narrative, the anti-historical," she rightly points out the danger that use of the structuralist grid may merely rearrange "the sequential features of a story ... to form a spatial organization."[27] Ironically, the artwriter whose view is most similar in this respect to hers is Gombrich; for him too, as we saw in chapter 2, the tradition really has ended.

Because I thus am critical of the Octobrists claims, I should explain why their argument is genuinely interesting. The discussion of art's politics is important, and these writers' claims are highly sophisticated. Compare the simple analysis offered by a well-known critic, Donald Kuspit. The Octobrists describe changes in methods of art production; Kuspit, like some old-fashioned Marxists, is primarily interested in the political content of art. Consider, for example, his account of Leon Golub (see fig. 17).

Abstract expressionists used large paintings; but Barnett Newman's were subjective and idealistic while Golub is "militantly anti-transcendental."[28] Golub shows us "written large, made blatantly public" figures,

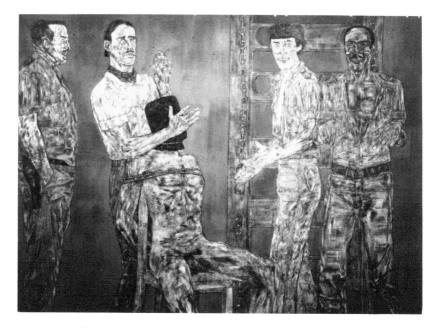

17. Leon Golub, *Interrogations II*, 1980–81,
acrylic on canvas, 10′ × 14′. (Gift of the
Society for Contemporary Art Committee
on 20th Century Paintings and Sculpture,
© The Art Institute of Chicago, all rights
reserved. Courtesy The Art Institute of
Chicago)

seared, worn, battered in their world-historical roles"; these "self-images of the artist" are "finally about private, heroic survival as an artist." Compared with Renaissance paintings of mercenaries, they teach us "how far towards raw violence society has moved to maintain its power over the individual." Today, making such pictures is "the only alternative to helplessness."

In part, Kuspit offers a genealogy. Like Newman, Golub uses color fields; like pop artists, his imagery derives from popular culture; like Goya, he shows torture. But Kuspit treats Golub also as a political thinker. Some paintings by Goya and David are politically powerful because they comment accurately on events of the time; by contrast, Kuspit makes Golub seem a remarkably jejune thinker. Is more raw violence employed today than in the Renaissance? Sigismondo Malatesta, the mercenary leader whose wars paid for the Tempio, would be astonished to know that. How can we all be equally responsible for the wickedness of modern mercenaries? To identify the failure of most of us to protest the acts of murderers is to trivialize the moral dilemma. How is Golub's art, "meant to intervene in the world as only art can," an alternative to helplessness?[29] Representations of Zionist or Palestinian violence would cause protest even in Soho. But because few artworld people are promercenary, Golub's paintings are as controversial as a Broadway play asserting that the Holocaust was a bad thing. There is no reason an artist should not take up a good cause, but bad faith is obvious in pretending that Golub's images are really controversial.

I am, I grant, being literal-minded in spelling out the triviality of Kuspit's claims, but that is called for by his insistence that Golub is a political thinker. He says that critics like Fried, who reject his analysis, are "fascists," and he believes that the critic "functions as the mediator for a full-fledged artistic meaning, where such meaning is understood to make the art responsible to world history rather than simply art history."[30] In plain words, the critic may make implausible claims without worrying about their truth.

Unlike Kuspit, the Octobrists make intelligent claims about art's politics, but because, as they well recognize, the society of which they are so critical has a remarkable capacity to absorb critical art, the political significance of such art is unclear. Hal Foster, for example, makes an elaborate distinction between reactionary neo-expressionist art and the

critical work he admires, which recalls "a repressed source or marginal sign-system in such a way as to disturb or displace the given institutional history of an art or discipline."[31] Even if we accept his analysis, however, in our artworld these critical artists, like their reactionary rivals, appear in prestigious exhibitions, are discussed in the art journals, and exhibit with the best dealers. Indeed, the more Foster writes about critical art, the more he contributes to this situation; in a more subtle way than Kuspit, he too promotes the artists he admires. Literature, film and music are popular media, so there radical works may become widely known; but paintings are commodities, so Golub's works and those of other established critical artists now belong to powerful collectors and museums.

In the next chapter I analyze the art market and the critics' role in it. Here I note only that this weakness in the Octobrist analysis perhaps reflects their failure to work out a semiotic theory of premodernist art. Krauss says that for Gombrich pictures provide "an analogue of the absolute immediacy of the world to vision"; hence, she argues, he must reject any account that "denies immediacy to the image, interposing between viewer and picture . . . the mediations of a code."[32] Bryson writes that in Gombrich's analysis "there is little evident awareness of the canvas as a place of and for the production of meaning. . . . The realist image disguises or conceals its status as a site of production; and in the absence of any visible productive work from within, meaning is felt as penetrating the image from an imaginary space outside it."[33] These are one-dimensional readings of Gombrich. Although Gombrich does imply that images are transparent, he also writes much about their codes. *Wivenhoe Park*, he says, is truthful "to those *who can read the code. . . .* "[34] It is wrong to say that he has little awareness of how meaning is produced on the canvas; on the contrary, he is obsessed with this question. He indicates, for example, how a pencil sketch for Constable's painting "may even alert us to a more detailed interpretation of the final picture itself."

Just as Stokes's misreadings of Pater and Ruskin provided a productive way of defining his position, so these misinterpretations of Gombrich by these subtle readers define the semiotic theory in opposition to *Art and Illusion*. In saying this, I do not deny that Gombrich's account is problematic; on the contrary, his attempt to assert both that illusionistic images are transparent and that they use codes has puzzled even his

sympathetic commentators. Krauss and Bryson give good arguments against the former position, but do not adequately analyze the peculiar, puzzling synthesis that constitutes Gombrich's real viewpoint.

Of the post-Friedian critics, Krauss is the figure most worth arguing with, but, like Fried, she has turned to art history and now seems more a figure of the past than an active influence on critics. My reconstruction of her arguments is obviously some distance removed from the present concerns of working critics. Still, as with Greenberg and Fried, such a philosophical account ought to capture the intuitions felt by practicing artwriters. To put her claim in so many words, the photograph's direct relation to reality makes traditional painting obsolete; and all art can do now is to demonstrate this result repeatedly. A critic who thinks that there are new artworks worth discussing will not find Krauss's account a promising starting point.

Still, the ideal of artwriting that depends neither upon the art historical narrative nor upon the theory of presentness is fascinating. Michel Foucault's history without *subject*—with "neither an individual subject, nor some kind of collective consciousness, nor a transcendental subjectivity"—provides one possible model.[35] What is puzzling about such an analysis, Danto has noted, is that "traditionally it was felt to be a metaphysical necessity that some unchanging substance must endure through a change, it being otherwise a misnomer to speak of change at all."[36] Greenberg, for example, uses such a *subject*; modernism makes explicit qualities that were merely implicit in old master art. Like a woman who realizes in her mature life as a feminist qualities that were merely implicit in her girlhood, this *subject's* development merely unfolds in time the essence that it always possessed; but change can occur, Foucault is saying, without there being any thing that changes. How could we write, he asked, a narrative in which there is no such developing *subject*? How could we write, Joseph Masheck asks, an account of art in which there is no such *subject*?

In the mid 1970s, painting "had been made to seem irresponsibly indulgent, if not wimpy, like, say, the cultivation of bonsai trees."[37] The influential chiliastic reading of Greenberg and the belief that artists should move outside the studio, so as not to make commodities, made serious discussion of painting difficult. Harold Rosenberg's account of action painting, which praised artists of the forties for turning away from the

hopeless goal of changing the world to "acting" on canvas, was reinterpreted; maybe such artists had shirked their responsibilities. In retrospect, the belief that artists could make serious radical work accessible to large audiences seems hopelessly ambitious. Even during the French revolution, David hardly achieved that goal. None of the artworld radicals of the 1960s had any real success in dismantling the art market, which was in any case happy enough to support its most prominent opponents. The artworld split into two camps, "one concerned with ideas, ironies and concepts...the other in shameless pursuit of visual delection."[38] The consensus about the limitations of Greenberg's narratives did not mean that any new account was available to be put in its place.

Just as *Art and Illusion* has a false beginning, so does this chapter. Having worked through the fascinating but problematic semiotic theories, I return to my opening question: if we seek an analysis of painting that is neither a historical narrative nor a theory of art's presentness, how may we proceed? Masheck's strategy is to draw parallels between contemporary painting and icons and crucifixes from the Byzantine tradition. If we thus relate recent art to works from a very different culture, we may escape the limitation of theories that derive abstract painting from earlier naturalistic works. Masheck's goal is neither to assert that the abstract artists of our time are influenced by the Byzantines nor to imply that abstract art is inevitably spiritual; rather, he seeks a model for abstraction that does not define its identity by appeal to a historical narrative. This also was the goal of the semiotic theoreticians, but where they proceeded in large part by abstract argumentation, Masheck offers a series of examples whose significance I will summarize.

For Alberti, as for Gombrich and Greenberg, the painting is a window; the modernist work is created, Greenberg says, by flattening the vista seen through that window. Whether, with Gombrich, we see abstract paintings as unreadable, ambiguous patterns or, with Greenberg, as the end product of the process of flattening that vista, in either case they have "meaning as a 'trace' of the figurative image which has been progressively eliminated."[39] This approach appears even in sophisticated artwriting. For example, Meyer Schapiro compares Mondrian's "division of the lateral bays by shorter horizontal bars that bound rectangular spaces of distinctly contrasted areas and proportions" with a Bonnard

cityscape.[40] His complex text both denies "that Mondrian's work is a stylized reduction of his vision of an actual scene" and asserts that it utilizes "certain relationships of form already conceived in figurative art."

Suppose, rather, we deconstruct Alberti's window and treat its components, the shaped frame and the flat surface, not as fragments of a now destroyed whole, but as autonomously meaningful materials whose use in pre-Renaissance painting and recent abstract art defines an alternative artistic tradition. "The stretched canvas supported by a rectangular wooden armature is only one of the conventional formats of Western painting."[41] Shaped surfaces, such as the crucifix and the icon—the hard-core painting on a surface which appears to be "an intransigent plane"— are alternatives; so the ways that Byzantine artwriters thought about these media are relevant to painting today.

Again, consider photographs. I earlier introduced two ideas: that a photograph captures the appearance of what it depicts, and that a photograph is causually connected with its subject. In the former sense, a photograph of Wivenhoe Park rivals Constable's painting; in the later, that photograph is like an icon. "On Byzantine assumptions," an icon of a saint "has him 'in' it...as a bottle of Burgundy has Pommard in *it*," that image capturing his essence without showing his appearance. [42] So understood, what for Gombrich are the weaknesses of icons were for the Byzantines positive qualities.[43] They do not depict individuals; there is no desire to capture mere physical likenesses. There are no light sources; no shadows exist in the spiritual world. There is no life study, and so no making and matching; an icon is copied from earlier icons. Progress is unimportant; a more naturalistic image is not better. The architecture is "irrational," and inverse perspective may be used. An icon can reverse left and right, implying that the viewer's standpoint is within the space defined by the work; we are not looking through a window, but seeing a scene that could exist in our space.

The nature of such images was discussed in the Byzantine debates about iconoclasm. Because we are made in God's image, and Christ himself took human form—so some creative interpreters of Gen. 1.27 proposed—maybe icons showing sacred figures are permissible. In the section of *Phenomenology of Mind* entitled "Revealed Religion," Hegel argues that sacred pictures reveal the limits of strictly visual thinking. A

painting depicting Christ is an inadequate symbol for a Being who can only properly be described in words. Hegel treats the image as a thing revealing the appearance of what it shows, but the icon makers describe the relation of image to source differently.

American artists today are not interested in painting icons nor in making sacred art; how is the invocation of this historically distant tradition relevant to their work? Consider an example, the grids in Sean Scully's paintings of the late 1970s and early 1980s. As Masheck notes, grids have a complex history.[44] They are used in Renaissance art to mark the projection of three dimensions onto two; in fifth-century Ravenna mosaics to show the squares of cloth of billowing ship sails; by Jasper Johns in his *Flag*, where "a field of horizontal stripes is interrupted by a rectangular zone, the 'field' of the stars," thus combining "iconographic obviousness with an artistic anonymity."[45] A grid suggests, furthermore, endless repetition, broken perhaps at those places where lines intersect. This last observation suggested to me a related way of thinking about Scully's art of the 1980s.[46]

For a colorist, the problem with a grid arises at the points where verticals and horizontals cross: either the lines pass through one another, dematerializing the color, or they cross over one another, yielding a shallow woven pattern. Often, as we saw in the previous chapter, color is merely a secondary quality, what fills in the spaces defined by line. But an older tradition, to which Scully returns, was interested in the literal qualities of colored things. Alberti wrote, "Red is the color of fire, blue of the air, green of the water, and gray and ash of the earth."[47] When Scully lifted vertical stripes and placed them alongside horizontals, the crossing points of the grid lines in the resulting diptych are moved to the hard-to-see edge where verticals meet horizontals (see fig. 18). The literary text, Barthes wrote, "always has two edges."[48] What "pleasure wants is the site of a loss, the seam, the cut, the dissolve which seizes the subject in the midst of bliss." Scully's internal edges provide the visual equivalent to the break in the text, a result we might understand by contrasting Matisse's use of represented grids. In many works of the 1920s and 1930s he painted grids of fabrics, wallpapers, and garments; Scully shows his stripes in direct, frontal compositions. No longer do we see images of an ideal world; rather, these color panels—like those of an icon painter—stand within the real space that we viewers also occupy.

18. Sean Scully, *Maestà*, 1983, oil on canvas,
8′ × 10′. (Collection Edward R. Broida Trust,
Los Angeles)

This analysis cites precedents and makes visual comparisons without constructing a genealogy for Scully. Noting the affinities of Scully's stripes to the work of Mondrian, Johns, and some mosaic artists, Masheck seeks "to draw on the memory bank of culture to claim for contemporary artists the traditions to which they...contribute."[49] His narrative, in which there is no *subject* whose development we can trace, is inherently harder to follow than a historical analysis or even an account of presentness. Compared with Greenberg and Fried, Masheck offers many examples, giving no explicit thesis that can be stated in so many words. He aims to tell a story without *subject*, dramatic beginning, or definite conclusion; such a text, perplexing for the reader who is accustomed to a strong narrative line, makes sense if we give up the belief that artwriting needs such a structure.

Masheck's essay "Pictures of Art," the mid-essay of his five-part "Iconicity" series, exemplifies these procedures. Such pictures within pictures are discussed also by conventional art historians. "The smaller work is not only a distinct field with its own scale and imagery...it is also a means of dividing the surface or extending the illusory space of the larger work in which it occurs and of deepening its content through visual or iconographic analogies."[50] We may thus treat the space of such a painting as a unity and focus on how the picture within the picture "alludes to the constructional aspect of picture-making, and to the finished product as a rectangular field subdivided unequally into rectangles, in a whole system of rectangles held in relational check."[51] We might, though, also consider pictures within pictures as images of an implied studio space. In one such painting, for example, Matisse squares off "the top of the easel...to make it agree" with "the actual canvas we are looking at," which situates "the activity of painting comfortably within the rectangle of the picture."[52] The vast blank white walls of the modern gallery gets the viewer to see individual works differently than did eighteenth- and nineteenth-century salons, where the visually busy ensemble functioned like a single composition composed of many individual works. We need tunnel vision, Greenberg says, to focus on individual works in such a setting. Gombrich, in a connected observation, notes that, in frescoes, "multiple vistas carry within them the seeds of their own destruction"; for Renaissance painters, subdividing a wall to show images from

different historical moments ultimately seemed an unsatisfactory procedure.[53]

Yet once we follow Masheck in giving up the identification of a picture with a window, then Greenberg's and Gombrich's analysis may seem less convincing. Observing the relationships of pictures on a wall, we see that any isolated rectangle "relates to, and qualifies, the rectangular wall."[54] Fried assumes that because the rectangular frame is the norm, Stella's departure from that shape created a kind of illusionism. Masheck both notes that this norm is found only in a relatively parochial range of examples and finds Fried's worries about the ontological status of the artwork somewhat unreal. Fried, like Greenberg, insists that the artwork's identity is defined by the fact that it is *not* a mere physical object; for the icon makers and some contemporary painters, this claim is irrelevant to how they think of art. Perhaps Stella's shaped works were less an entirely novel development than part of an ongoing tradition. "We tend to take for granted the regular margin and frame," but use of these is only one possible alternative.[55]

Thus, modern concerns with composition inside and around the painting are "partly an extension of the tradition of compositional balance that stems from the Renaissance emphasis on the relationships existing between depicted things in an also depicted space"; but they also involve a "distinction that goes back to Byzantium, between art as decoration, where the eye is intended to wander, even aimlessly, and art as an object of fixed apprehension."[56] Just as in the discussion of Scully's stripes, in analyzing pictures within pictures, Masheck gathers together a large number of visual references to old master, early modernist, and contemporary works. Greenberg and Fried focus attention on a few individual paintings: Greenberg's great essay on Cézanne mentions only one individual picture, a very well-known Seurat; Fried's essays on Stella, Noland, and Olitski are illustrated only with their art. By contrast, Masheck's very visually erudite account requires many illustrations, so is much more difficult to summarize.

Some philosophical texts raise related problems. Descartes's *Meditations* tells a story in which the central figure first doubts everything, then grasps two self-evident truths, and finally recovers all the once-lost knowledge. The leading themes are clearly signaled, and the general thesis is

demonstrated by many examples. By comparison, Wittgenstein's *Philosophical Investigations* is much more loosely organized. A commentator who divides part 1 into three sections—an account of reference; a discussion of rules, and the "private language argument"—imposes a controversial order. Wittgenstein gathers examples while refusing to generalize about them, so commentators who extract a thesis from his book are inevitably involved in a different argumentation than are interpreters of Descartes. If style and content in philosophy cannot be separated, then describing Wittgenstein's "thesis" in so many words falsifies his account.

Imposing a plot structure on a text always involves interpretation, but unless a text could thus be represented, we could not even think about it. Because all representations, visual and verbal, capture only selected features of what they refer to, to think of interpretation as a kind of falsification condemns us commentators to absolute silence. How can I interpret Wittgenstein's text except by selecting, summarizing, and interpreting? Applied to artwriting, these general concerns are particularly pressing. When art history narratives treat individual works as manifestations of some general thesis about art, they tend to make us think of those individual works as only items demonstrating some theory. This is one reason why chapter 3 turned from such narratives to the theory of art's presence. Now we can see that the minimalist glorification of the artwork's literality only negated the more traditional claim, made by both Greenberg and Fried, that artworks are nonphysical objects. For Masheck, such an undialectical negation is itself all too close to the viewpoint it negates. Hard-core paintings are neither vehicles for the presentation of ideas about art nor just things; they are physical objects that also manifest some conception of painting.[57]

At the risk of contradicting myself here, I state Masheck's thesis in so many words to present his position in relation to the theories I have discussed earlier. Gombrich interprets images as if they show real scenes, while seeing in cubism the end of the naturalistic tradition. Greenberg thinks of time as allowing both development and a potential menace; modernism preserves and negates the past. Stokes's notion of carving envisages a lost utopia in which time's menace is negated. (As Ruskin

dated the fall of Venice from the moment when artisans no longer did authentic, self-expressive labor, so Stokes dates the fall from the appearance of modeling.) For Fried, utopia is manifested today, in antitheatrical modernist works. For Krauss, photography plays the role that alienated labor played for Ruskin; we live in a false, posthistorical time, unable to recognize that the Fall has occurred. Whether art thus ends in cubism, or modernism begins with Manet, or carving dates from the early Renaissance, or postmodernism begins in the 1960s, in any case we have a break in tradition; and these different views of time are reflected in these artwriters' narrative strategies. Gombrich tells of the closing off of the tradition of naturalism; Greenberg writes genealogies; Stokes and Fried describe the artwork's presentness; Krauss discusses a recently closed tradition.

Masheck's view of old master art is highly personal. It was "a failure as holy art, unfruitful as art."[58] Some nineteenth-century artists sought to return to the time before Raphael; Masheck is a pre-pre-Raphaelite. Paradoxically, his view of history makes him an optimist about the present. If art today neither continues the modernist tradition, nor defeats theatricality by achieving presentness, nor is postmodernist, then its future is open. Instead of thinking of the past as a dead weight on present-day artists, we can instead see tradition as a resource that now can be drawn upon.

The writer most relevant to the artworld of the early 1980s is not an artwriter, but the literary critic Harold Bloom. His account of the anxiety of influence and belatedness defines the dominant mood of the time. Bloom is interested in how an artist creates himself or herself by wrestling with mighty precursors; in his Oedipalized interpretation of history, de Kooning became great by wrestling with Picasso, and Johns found himself by checkmating de Kooning.[59] Originality often involves struggle, and most artists and artwriters probably begin by imitating some master. What is important now, however, is that tradition seems an overpowering weight. Certainly Gorky felt Picasso's power, but at least for him such a father figure was far away; when de Kooning and Johns are our old masters and younger artists are already long famous, then the oppressive weight of art's history can be overwhelming.

The problem with painting...is that by now all the possible significant variations on neat/messy, thick/thin, big / little, simple/complex, or circle/square have been done. You've got your basic Mondrian, basic Frankenthaler, basic Pollock, basic Reinhardt, basic Kline, and basic Pousette-Dart.[60]

I predict that in another decade this feeling will seem to be as dated as John Stuart Mill's Victorian worry that all imaginable music had been composed. What from the historical perspective can seem a frighteningly heavy burden can for a thinker like Masheck, who concentrates on the art system, appear a rich array of possibilities.

Speculating about the meanings of Thornton Willis's trapezoidal forms, Masheck finds them reminiscent of icons and portraits, and evocative of the fin, rudder, vane, and sail; "an act of imagination need not amount to using the artwork as raw material for the aimless projection of fantasy."[61] He adds, "It's not that Willis's form 'means' anything you want it to, but that it seems meaningful." Imagine, Barthes asked, "an aesthetic based entirely on the pleasure of the consumer; the consequences would be huge...."[62] Such is Masheck's visual aesthetic.

Masheck's work is radically original and highly suggestive. Still, my judgment of its importance is eccentric in a way that my views of Greenberg, Fried, and even Krauss are not. Few younger critics share the latters' taste, but they have written themselves into the history of artwriting. By contrast, Masheck's work remains a relatively marginal influence. Here we return to the point discussed in the Overture, the function of artwriting within the art market. Philosophers construct abstract arguments whose relation to life outside philosophy is tenuous; by comparison, artwriters have success only when their arguments achieve a certain worldly recognition. Zola's championship of Manet was vindicated by history; Fry convinced the English establishment of Cézanne's importance; Greenberg, and not Pollock's hostile critics, had his judgment validated by the test of time. Artwriters succeed, it seems, only when the artworld accepts their taste.

We may learn something about that artworld by extending an idea implicit in this chapter. The artworld system, the Octobrists and Masheck say in their different ways, is the corpus of artworks, past and present. Since artwriting functions within an art market, however, that system

really should include not only artworks, but also the art market in which they are bought and sold. Reference to the art market here may seem strange; what have art dealers to do with how we think of art and how we write about it? As Danto's thesis reminds us, though, artworks are identifiable only by being placed in an institutional context. My discussion merely extends his thesis in a natural way. Artworks are identifiable in relation to artwriting, and artwriting is understandable only when we grasp its position in the art market. Only an account of this larger art-world system can explain how we identify and interpret individual artworks. Let us now analyze that system.

5 Art Fashion

In the 1980s, no single critic or critical approach has achieved the authority that Greenberg once had. As the present-day artworld admits a plurality of artistic styles, so it also supports various forms of artwriting. Some critics are inspired by Marxist sociology, others by poststructuralism, some write autobiographical criticism, and still others are frankly eclectic or are mere journalists. To understand this situation, consider the role of criticism in today's artworld. Many contemporary Marxist critics discuss the expression of ideologies in art, an interesting though not central Marxist topic. A real Marxist, I propose, would describe the system of artworld production; leaving aside any merely partisan political claims, I outline such an account.

Much of *Artwriting* has prepared us for such an analysis. The Overture and chapter 2 showed how Berenson and Greenberg worked in earlier art markets; the Octobrists, that the creation of new technology changed how we think of handmade images; Mash-

eck, the importance of the system of artworks. So, if here I momentarily take up some sociological questions, this does not signal a turn away from my earlier arguments. Rather, now, as before, I seek an account that both does justice to the function of artwriters' argumentation and explains the role of that argumentation within the artworld system. A full sociological analysis would describe the roles of artists, dealers, collectors, and critics; I will say only enough about the makers, sellers, and owners of art to introduce my account of the role of contemporary artwriters.

Like any artifacts made in capitalist society, artworks are distributed by a marketing system. Artmaking is an old-fashioned industry, its labor performed by isolated individuals in small shops as with all manufacturing before the industrial revolution. The creation of a division of labor both made manufacturing much more efficient and created alienated laborers; no longer could the individual think of the finished artifact as his or her individual product. Part of the charm and many of the miseries of the contemporary artist's life arise from this archaic system. We value art because it is handmade and think of the artist as an unalienated laborer; but because such a manufacturing system is inefficient, artworks are expensive to produce, and so relatively few people can afford to purchase them. Even a little knowledge of earlier capitalist societies reveals how art once played more of a role in middle-class life than it does today. In the 1470s in Florence, there were forty-two members of the painters' guild and eighty-three silk-weaving firms, seventy butchers, and sixty-six spice merchants; this shows "the great and constant demand for decorative works to enrich the life-style of the bourgeois-patrician population."[1] In Vermeer's Delft, "perhaps two-thirds of the population lived in households possessing paintings. . . . as many as forty to fifty thousand paintings hung in the city's four-thousand-odd houses."[2] By contrast, how little original art do our middle classes own! Today, serious paintings are often too large to display easily except in a museum. The abstract expressionists painted on such a scale partly because there was no market for their art in any case; today, in an ironical reversal, most ambitious painters *must* work on this scale, making art that therefore aspires to be so displayed.

To help us understand our art market, I will make some very rough calculations and present three theses supported by my analysis of recent

artwriting. These are: (1) The present-day function of artwriting is to advertise art; (2) unlike art history, art criticism has not been able to establish its place within the university; (3) this artwriting remains largely unaware of its essentially rhetorical dimensions.

Our art market is centered in Manhattan. Even were great art shown in Pittsburgh, it would become known in the artworld only if it were written about in the New York journals. Such a concentrated artworld creates a critical mass of people who talk to one another and to dealers and collectors; because these people are concentrated in Manhattan, that is probably the best place for a young artist to live. But because Manhattan studios are very expensive compared with those in provincial cities, most artists find daily life difficult, and few can support themselves from their work. If the cost of a studio and art supplies is at least a few tens of thousands of dollars per year, and an artist sells out a one-person show every year, then each painting will cost a few thousand dollars to manufacture. Most artists would think themselves lucky to sell out a one-person show every year; also, because desired styles change, works salable now may be in little demand in five years.

Of course, an artist may work outside the gallery system or in other cities; he or she might teach. When artists support themselves by other jobs, artmaking itself becomes an expensive hobby. More art teachers produce more graduates, some of whom in turn will seek to become artists. Philosophy is a purely academic profession; philosophers do not produce commodities, but their teaching and research are thought to be valuable, so there are some university jobs for them. Many people think all students should learn something about philosophy. By contrast, art teachers teach a trade. Because practicing that trade is difficult, the training of so many art majors for a career in which very few of them can succeed seems irrational. If these students believe that the artist is an unalienated worker, unlike the factory worker or the executive, their beliefs are not consistent with the realities of the contemporary art market. This grotesque imbalance between supply and demand reflects both a lack of awareness of this market on the part of art students and a failure of our society to identify any real need served by art. Unlike quattrocento Florence or Vermeer's Delft, our society does not support a large market in serious bourgeois art.

Artists make the works that dealers distribute. Successful dealers often

attract resentment, perhaps because artists are thought to be creative and dealers merely businessmen. Yet the essential role of the dealer is to provide a selection mechanism. There are tens of thousands of artists in Manhattan; without such a system, how could their work be displayed? In the past, the salon provided a chance for people to see current work; today, galleries are dispersed public spaces in which one can see what attracts attention. Were art sold without middlemen, it would be both cheaper and harder to find; the dealer, particularly if his or her reputation is established, can pick what seems interesting. The April 1984 *Gallery Guide* lists over two hundred galleries in downtown Manhattan and even more uptown; such an unselective listing is exhausting to use. Even someone who devoted all his or her time to visiting galleries would have difficulty seeing everything that is displayed. Thus it is natural that most attention is concentrated on a relatively few well-known dealers.

Most such dealers are in high-rent districts, and their monthly costs of rent, publicity, and staff are tens of thousands of dollars. Therefore, showing the work of not-yet-established artists is either a gamble, based on the expectation that they might achieve success, or a practice supported by the sales of better known work. Certainly, it would be nice if the market permitted many lesser known artists to achieve enough sales to support themselves; but dealers alone cannot create such a market.

In commercial galleries, the work even of unknown artists costs a few thousand dollars; artists with reputations command five-figure prices. Collectors therefore are either people with considerable means, or museums and corporations. The question of how much an artwork should cost itself is interesting; compared with cars, vacations abroad, and other middle-class "necessities," paintings are not very expensive. And of course much collecting, which is hard to trace, goes on outside or on the margins of the gallery system. Even people with some interest in art may not think of themselves as collectors, which is too bad, because the art market would work differently if many such people did purchase what they liked. Buying a painting because it is an attractive, handmade object need be no different from purchasing any home decoration; and artists collectively would be better off if art was thought of in such a way. As it is, art is often an investment, and when work is very expensive, collectors naturally hope that it will appreciate in value.

Many critics would prefer public patronage, but whether such a system

would function better than the present one or even differently is hard to determine. In the present art market, rich collectors buy as they choose; what others think of their choices is, all things being equal, irrelevant. Of course, all things are *not* equal; the collection of expensive contemporary paintings depends in part upon corporate and individual tax write-offs. Judging the equity of such an arrangement is difficult. The tax benefits rich collectors obtain may be balanced against the pleasure of looking at art in public collections, a calculation irrelevant, alas, to the larger public, which remains hostile to contemporary art. Were distribution of art controlled by public patronage, curators and critics might determine how funds would be spent. If those choices were made independently of public opinion, then we would merely have an extension of the present system.

My description is not intended either to assert or to deny that such a market is fair. In the art market, unlike the larger society, questions of distributive justice are of marginal relevance. Artworks are not necessities, and so their fair price, presumably, is what someone will pay for them. Many critics think this art market is a bad thing. Craig Owens believes it important "to counteract the division of artistic labor in a society that restricts the artist to the manufacture of luxury goods destined for the real agents of art-world appropriation."[3] I agree that it is too bad that artworks are luxuries, but reject the suggestion that there is something inherently wrong in treating art as a commodity. What the Octobrists desire, of course, is the end of the creation of all commodities. However we judge that desire, it is hard to see how the art market itself creates injustices, though it certainly reflects larger inequalities. Only people with substantial surplus income can purchase art, but the worst thing that can be said about the art market is that such people spend money on art that otherwise would go for other luxury goods. An openly blasphemous painting could not be an altarpiece, a sufficiently unflattering portrait would not be sold; but because in our culture artworks seemingly serve a purely decorative function, whatever the artists' intentions, there is no reason that all art, "radical" art included, cannot hang in museums and even in corporate headquarters.

In the past, such questions about how to fund the arts were unimportant. The patrons of Bernini, Borromini, and Caravaggio usually did not care what the masses thought. Even in a bourgeois democracy, many

policy decisions are made without effective public participation. Because expenditures on art are proportionally so small, it seems perverse to concentrate on a discussion of how art is funded. Recently, there has been debate about federal funding that provides stipends of $15,000 for each of six critics a year; when passion is aroused by such sums, it is easy to see that this is a sensitive issue, but hard to think coherently about it.[4]

Allocation of funding in physics requires technical knowledge, but education is a concern, potentially, for every citizen. Should art funding be discussed only by experts, or is it a matter for public debate? This seemingly simple question is not easy to answer. Much Marxist literature describes the masses' desires as the product of false consciousness; advertisers convince us to buy things that we ought to recognize are rubbish. Greenberg's distinction between modernist art and kitsch makes a related point.[5] The masses seek relaxation, and the artworld demands challenging art; hence, not surprisingly, those masses dislike serious art. For anyone who thinks that aesthetic judgments are a product of an unmediated relation of viewer to work, this present discussion will seem irrelevant. Perhaps in an unalienated society, everyone will choose genuinely good work. Stokes's account of carving involves such an ideal; and it is not hard to agree that our society is not very good at satisfying our real needs. What is harder to justify is the claim that today genuine tastes are identifiable. In dealing with a phenomenon so culturally bound as art, it is hard, as we have seen, to construct a convincing, noncircular account of taste. Like everyone who cares about art, I certainly have strong tastes; but asserting that others would agree with my taste, could they but see properly, seems overly optimistic.

What role is played by the artwriter in this system of art manufacturing and distribution? Here a historical perspective is valuable. Berenson's connoisseurship guaranteed the value of works sold by dealers who paid him for his attributions; Greenberg's genealogies drew attention to a select group of artists. They were experts with good eyes, skilled at identifying artistic excellence. In the present-day art market, it is no longer plausible to think of critics as experts of this kind. Since there is consensus neither about what artworks are valuable nor about how to describe art, such a view of the critic's role is no longer convincing.

This change in the role of artwriting is reflected in the changes in

artworld journalism over the past four decades. Many of Greenberg's articles appeared in the *Nation*, a journal, then as now, primarily concerned with politics; it has few gallery advertisements and illustrations. Fried's essays appeared in *Artforum*, which was in the 1960s and is today filled with advertisements for dealers selling the work discussed by him and other critics. Because commercial journals need to pay for color plates and an editorial staff, obviously it is difficult to keep criticism independent of advertising. Though critical reviews do appear, an editor who alienated enough galleries would soon be in an untenable position.

In the 1950s, *Artnews* covered the contemporary scene and old master art as well; with the expansion of the art market, four major commercial journals now devote most of their attention to work by living artists. Just as the gallery system provides one selection system, so these journals supply another. Because all four journals combined review only a few dozen different shows each month and they mostly publish articles about well-known artists, most work exhibited even in Manhattan is never written about. Two facts about these journals are important here. First, there is an inverse correlation between the difficulty of their writing and the size of their audiences. Second, they all eventually discuss the same artists.

Artforum mostly contains esoteric, highly polished prose; it assumes a knowledge of contemporary literary and sociological theories. *Artnews*, a frankly popular journal, is written in language a reader of *Time* would not find difficult; unlike *Artforum*, it contains much glossy advertising by dealers in "Wild West" painting, Erte and Dali lithographs, and other work not taken seriously in the artworld. *Art in America* occupies a middle position. In prose usually more understandable than *Artforum*'s, it discusses some esoteric issues while also containing popularizing essays; like *Artnews*, it contains much advertising for kitsch. *Arts* combines a scholarly interest in the history of modernism with discussion of contemporary art; allowing its writers more freedom than the other journals, it publishes more accounts of not-yet-famous figures than the other journals combined.

Given that these four journals are written for different audiences, it is interesting that the successful artist who is reviewed in *Artforum* or *Arts* one year will almost certainly be featured in *Artnews* a year or two later. In part, this swift movement reflects an art market in which esoteric

work that draws attention is soon shown in prestigious galleries and purchased by museums. For artwriters, this means that there is a need to popularize such work. Because much recent art is comprehensible only against the background of some theorizing, even *Artnews* needs to find a way to describe original work.

Consider five texts from these four journals about a recently much-discussed young artist, David Salle (fig. 19): Ross Bleckner's "Transcendent Anti-Fetishism" (*Artforum*); Robert Pincus-Witten's article in *Arts*; Donald Kuspit's review in *Art in America*; an article in *Art in America* by Peter Schjeldahl; and the *Artnews* account.

Bleckner discusses a number of artists, relating their work to his theory that artists create transitional objects, things through which an individual "negotiates its reality through particular desires, a libidinal cathexis, and not a descriptive coding."[6] As the following quotation suggests, his is a very abstract analysis of symbols: "Our production indicates a going toward something else; it signifies the dynamic relation of something with the outside without codifying that relation. We get out of ourselves by going into ourselves and evoking the dialectical tension of this symbolic discourse." This text could only make sense to a reader familiar with Ricoeur, Lacan, and Deleuze; even so, because these authors are not very concerned with visual art, it is hard to explain Salle's paintings in their vocabulary.

Pincus-Witten's account is really gossip for those in the know plus an elliptical account of Salle's art. Unlike Bleckner, he both talks about theory and implies that these concerns are not to be taken too seriously: "The appropriation of image, the current despoliation of art and culture, always invokes the specter of specific interpretability. If only one can find the key. Once it was provided by psychoanalysis. Such procedures seem frightfully outmoded today."[7]

Donald Kuspit's review reflects a now extensive debate. "Salle's message is that there is no longer any inner necessity for criticality, no longer any point to straining all one's sense in the hope of some special illumination."[8] Bleckner's psychoanalytic analysis has been dropped in favor of a narrower account of the significance of the works; if Salle "offers us an explicitly conformist art," are we to admire him for doing so, or does he reconfirm the Octobrist vision of the end of art?

Schjeldahl's lavishly illustrated article skillfully popularizes these ar-

19. David Salle, *Tennyson*, 1983, oil and acrylic
on canvas, 78″ × 117″. (Photo: Dorothy
Zeidman. Courtesy Leo Castelli Gallery,
New York)

guments.[9] Conservatives think Salle is a bad painter; radicals, that he is insufficiently critical; feminists believe him a sexist. Schjeldahl, rejecting all these views, asks us to look more closely at Salle's image quotations. Viewers may react "as if these denatured representations (representations of representations) were somehow indistinguishable from people in daily life." This theory fails to distinguish Salle from an old master who makes and matches; and it does not explain how he differs from Manet or Rauschenberg. At least, however, we can understand why his images produce such varied responses.

This essay is technical compared with the *Artnews* account, which begins and ends with a frank celebration of David Salle the celebrity. We learn how his loft is decorated, about his current prices, and the story of his boyhood in Tulsa, life in college, and New York career. In the midst of this account of a pop star, however, there is an analysis of his work. Salle "layers and combines; like words on a palimpsest" his images beg to be interpreted. Without going into technical details, the effect of these images is described: "Paintings, like stories, have always been 'read' by the aroused; to look at a painting is to acknowledge desire—for wholeness, for pattern and completion, for some sense of meaning.... What Salle does...is make the viewer aware of his or her own complicity." Even a reader with little knowledge of contemporary art can understand why such paintings are widely discussed.

The poststructuralists, from whom this writer borrows, denied that an artist's life could explain his or her work. We might wonder, therefore, why learning about Salle's life is relevant to understanding his art. Salle explains his work with a funny anecdote: "My wife smoked a lot. I just saw her smoking one day, and it hit me.... I wanted to see the other images through the images of a woman smoking. I painted her quick from life, holding the canvas in my hand."[10] Like an account of van Gogh in a pulp biography, this story is comic; still, perhaps it is no more fictional than the images that Salle constructs.

The plausibility of all these accounts is limited. Reynolds advised students to appropriate old master images, as he himself did in portraits; Gombrich's notion of making and matching is a restatement of that principle. Suggesting that such a practice is characteristic of critical art, as Kuspit says, or that Salle's critics fail to recognize that his images are just images, as Schjeldahl argues, are implausible claims. Even if I disagree

with Clark, Wollheim, and the other Manet-interpreters, I can see that they are engaged in a real debate. By contrast, the difficulty with these accounts of Salle is that we lack some way of describing his images that allows for competing interpretations. Compared with Manet's interpreters, these artwriters do not really argue with each other; it is hard to explain what Bleckner or Schjeldahl clearly assert that Pincus-Witten and Kuspit deny.

That the time lag between a discussion of Salle in *Artforum* and a cover article on him in *Artnews* is short is nothing new; Pollock was discussed in *Life* in the late 1940s and early 1950s. What *is* new is both the intensity of the concern with contemporary art and the general awareness that such publicity is linked to the art market. Pollock became famous but remained poor; Salle is financially successful.

Art historians seek a uniquely correct interpretation that matches the artist's intentions; these art critics really do not. Either Pontormo shows a deposition in the Santa Felicita Altarpiece or he does not; either *A Bar at the Folies-Bergère* is intended to have the viewer identify with the man depicted in the mirror or it is not. Art historians think of these problems as having a uniquely correct solution. By contrast, Salle's critics provide accounts that are harder to debate. This distinction between art history and art criticism is important. The professionalization of art history, which permitted it to become a university subject, depended upon agreement about standards of acceptable argumentation. In any discipline that achieves such a status, a dividing line is set up between experts and laypersons. The doctor and the faithhealer, the ordained priest and the prophet—institutions distinguish them by providing a system of certification. Ruskin and Pater were amateurs, working before art history created its licensing system; Stokes also was an amateur, which is one reason that professional art historians pay little attention to him. Connoisseurship, the study of iconography, and work in archives are topics in the art history curriculum in part because they are clearly relevant to artworks traditionally important for the historian, those from the Italian Renaissance. Woelfflin's formalism may be opposed to Warburg's social history of art and Panofsky's iconology, but these disagreements did not prevent professionalized art history from developing. What is excluded from the curriculum is writing like Pater's or Stokes's, which does not provide a model for professionals.

Such professionalization implies both that a discipline gives us knowledge and that it has an established place within society. Art history belongs in the university, while astrology does not. Debate about art history interpretations takes place within a framework in which disagreement is meaningful. There is some consensus about how to interpret Manet and Giorgione. By contrast, in art criticism such agreement is hard to achieve. This distinction does not simply reflect the fact that art critics deal with recent art. Pollock's art has now become a subject for art historians, so we learn something about the status of art criticism by understanding that development. I discussed Greenberg's geneology earlier. Now let us contrast a purely journalist account of Pollock with an art historian's discussion.

In 1951 *Artnews* published Robert Goodnough's article, "Pollock Paints a Picture."[11] Goodnough describes Pollock's studio and gives some account of Pollock's art; he is "not concerned with representing a preconceived idea, but rather with being involved in an experience of paint and canvas directly, without interference from the suggested forms and colors of existing subjects." Unlike Greenberg, Goodnough does not provide a genealogy; he discusses Pollock's pleasure in nature without suggesting that his work relates to traditional landscape painting. Although he emphasizes Pollock's seriousness, he really does not explain how that seriousness is manifested in Pollock's paintings.

William Rubin's 1967 *Artforum* articles are elaborate; they link Pollock to impressionism, cubism, and surrealism, and discuss precedents for the drip technique and Pollock's composition and sense of scale.[12] Pollock's art, he asserts, is both "firmly rooted in European traditions" and novel. His text is complex partly because he debates with both supporters (Greenberg, Fried, Harold Rosenberg, Sam Hunter, Lawrence Alloway, Meyer Schapiro, Frank O'Hara, and others) and critics of the artist. Taking for granted Pollock's importance, Rubin replaces Greenberg's partisan analysis with a highly academic account. Pollock is both a formal innovator—he goes beyond the impressionists, who were "hampered by their primary commitment to the visual field before them"— and a man whose art expresses his times: "Pollock accepts the challenges of molecularity and *prima facie* confusion of modern life and transcends them." Today this analysis seems dated, for Rubin uses unquestioningly theories that have now been much disputed. For example, Foucault and

Barthes have questioned the view that we can, as Rubin says, find "the unity in Pollock's diversity derived from the continuity of the terms of his interior dialogue and reflected (from) the *wholeness* of his being."

Still, Rubin's essays show that Pollock is as suitable a subject for a doctoral dissertation as Poussin. Therefore, why has writing about contemporary art not become a branch of art history? My answer to this interesting question appeals both to a discussion of the practical role of present-day critics and to an analysis of some texts by important ones.

Though it may be difficult to achieve success as an artist or art dealer, some do well and a few are exceptionally successful. By contrast, when critics are paid two-figure fees for reviews and a few hundred dollars for articles, writing criticism must be a part-time activity for people with other jobs. Interest in contemporary art does not enhance the reputation of an art historian. An otherwise equally marginal activity, creative writing, is supported in some English departments within universities. By contrast, art criticism occupies at best a minor place within art history departments, and art critics are generally thought to be journalists, clever writers whose work is not intellectually serious. Berenson received his commissions because there was a need for reliable attributions. In comparison, the marginal institutional role of present-day art critics reflects genuine uncertainty about the value of their work.

To understand why this is justified, let us contrast two texts published at the same time in the 1970s about the work of Brice Marden (fig. 20). In John Ashbery's work, the first paragraph moves from describing Marden's studio collection of art reproductions to asserting that now "the urgent articulations of Kafka, Dylan or Cézanne" are being reworked.[13] Jeremy Gilbert-Rolfe, however, takes nineteen dense paragraphs of art historical analysis to get to his personal view of Marden.[14] Ashbery's *Artnews* article reproduces four Marden paintings; Gilbert-Rolfe's *Artforum* piece, six paintings, five drawings, and comparative illustrations from Manet, Stella, and a Godard film. Ashbery carries his learning lightly; Gilbert-Rolfe has footnote references to Brecht, Merleau-Ponty, Mallarmé, and various literary critics. These differences mark a difference in kind between their claims. "All the pictures seem to be keeping a weather eye on Doomsday while asserting in various ways that there are important things still to be done"; like Goodnough's account of Pollock's interest in nature, Ashbery's description is safely vague. Marden is in-

20. Brice Marden, *Hydra I*, 84″ by 63″, oil,
wax/canvas, 1972. (Collection Albert and Vera
List, New York. Courtesy Mary Boone Gallery,
New York)

terested in art history; he admires Zubaran and somehow for Ashbery continues the Spanish tradition. By contrast, Gilbert-Rolfe has a definite thesis; Marden's art "has taken the dialectic implied in Cézanne's technique to be characteristic of the physical object." The French master divided the depicted landscape into color planes; Marden divides the canvas itself. Marden's work is thus opposed to Ellsworth Kelly's similar-appearing art. For Kelly, "color stands for an entirely conceptual and abstract space" as in more traditional art; for Marden "it denotes things and also brings them together." Marden's reluctance "to place ultimate faith in that which is merely known" marks him as a materialist, akin to Brecht and Godard.

In part, Gilbert-Rolfe constructs a genealogy for Marden and argues that his work has social significance. The leftist Luddite who replied that he had made up "a swanky pedigree" nastily oversimplified while pointing to a real problem; is not Gilbert-Rolfe's link between Marden and Cézanne highly arbitrary?[15] Unlike Rubin, Gilbert-Rolfe draws on poststructuralism: Marden is engaged in "a deconstruction of the sublime," because he finds it "not within monumental scale, but in the endlessly discoverable parameters of human size, the ultimately impenetrable space of the well known." Although his theorizing is up to date, even a sympathetic reader can easily question his claim that Marden is a politically radical artist. Brecht's and Godard's work was politically engaged; relating Marden's austere abstractions to their work and politics is not easy, and so, not surprisingly, more recent commentators on Marden adopt different approaches.

The differences in the vocabulary of Rubin and Gilbert-Rolfe should not obscure a certain similarity in their claims. As Pollock was said by Rubin to advance the concerns of analytical cubism and other modernist movements, so Marden is shown by Gilbert-Rolfe to take the concerns of Cézanne and Kelly one step further. Like the account of John Walker discussed in chapter 2, Gilbert-Rolfe's narrative mimics Greenberg's genealogies, and his beautifully written essay again indicates the problems inherent in such artwriting. (We need not work out a critical analysis of Gilbert-Rolfe's particular claims, for our earlier discussion of genealogies applies also to his work.) Ashbery's informative essay gives useful information without offering any serious argument. Yet once the strategies of a seemingly more sophisticated artwriter such as Gilbert-Rolfe

are questioned, it is unclear whether his complex text is really superior to such a journalistic account. It is such skepticiam about the claims of such criticism that, because it is widely felt today, makes the present-day role of the critic problematic. At present, it is Gilbert-Rolfe's theorizing, not Ashbery's essay, that seems the more dated.

This perhaps harsh judgment is the lesson to be learned from my account thus far. Bleckner and Gilbert-Rolfe, more learned than popular art writers, are not necessarily more convincing. Rubin's art historical analysis of Pollock has been replaced in the more serious journals by such writing, which seems more sophisticated; but the plausibility of these erudite accounts remains in doubt. That art critics have been self-critical and intellectually imaginative is greatly to their credit; theirs is a lively discipline because they have rejected Greenberg's genealogies, objected to Fried's account of art's presentness, and pointed to the problems in the Octobrist theorizing. Bleckner and Gilbert-Rolfe are challenging writers because they have created novel forms of artwriting. It is because they and other recent artwriters are self-critical that it is possible for me to write a philosophical reconstruction of their claims. We must also ask, though, what positive results have been achieved. What options are now open to the artwriter?

Again let us draw on a parallel with literature. *Pride and Prejudice* and *The Prime of Miss Jean Brodie* are fiction, and so usually judged not as accounts of the nineteenth-century gentry or of Edinburghians of the 1930s, but as stories. Could we think of artwriting in a similar way? Certainly there were in fact families like the Bennets and spinsters like Miss Brodie; similarly, an art critic can construct a plausible story about a featured artist. Still, to break down this dividing line between fact and fiction—between literature and artwriting—is a radical move, one whose consequences are complex. If Gilbert-Rolfe only provides a convincing story about Marden, how do we understand alternative accounts of the artist's work? We cannot, I think, treat Gilbert-Rolfe as merely a convincing storyteller; unlike Jane Austen or Muriel Spark, he describes a nonfictional *subject*. An artwriter, as we argued earlier, seeks to provide a true account.

Maybe the correct conclusion to be drawn is that ultimately art critics are just rhetoricians; they construct convincing-seeming texts but offer no real arguments. Unlike art historians, they have not achieved agree-

ment about standards of debate, so cannot give us knowledge about art. Perhaps, though, artmaking today can proceed without appeal to theories of art. After all, there is no developed philosophy of such activities as cooking and fashion, though they too can be theorized about. This parallel may tell us something important about today's painting.

Occasionally, I grant, writers about food or fashion claim to give theories. "What people do with food is an act that reveals how they constitute the world."[16] As Chinese cuisine and Confucian ethics show "rigid discipline," and French food and thought, "logic," so "what we find in the cooking of Italy is a serene relationship between man and the sources of his existence...." If American fashion shows off legs, that is because here "women started off on a more equal footing with men" than in Europe.[17] As artwriters explain changing styles of painting, so fashion writers discuss changes in dress. For example: "Within a year or two of the Crash men's suits were becoming darker and heavier, as if to shelter them from the wind and rain while waiting on bread lines.... Trousers tended to be wider...perhaps to counteract or disguise the owner's slump of discouragement."[18] John T. Molloy gives elaborate rules about dress. "To avoid looking like a gangster, always make sure that your shirt is *lighter* than your suit, and your tie *darker* than your shirt."[19] These conventions involve many social distinctions. For example: "If you're a black selling to white middle America, dress like a white. ...White salesman selling to antiestablishment blacks do better if they wear mustaches....Leisure suits are better than business suits, but no suit should be solid dark blue."

These are not serious theories, because fashion and perhaps food as well have only conventional meanings. In the late 1960s, for example, men's long hair signified opposition to the war and interest in drugs and short hair identified conservatives; some professors who preferred suits obeyed this code to identify their beliefs. For members of the American Progressive Laborites, short hair signified radical politics, so a certain semiotic skill was needed to distinguish these Maoists from GIs on leave. Today, long hair is merely an affectation or a sign of Einsteinian indifference to personal appearance, so just as Clark interprets *A Bar at the Folies-Bergère*, we who are middle aged need to explain to our students the old meaning of long hair.

Here parallels between aesthetic relativism and relativism about fash-

ion are suggestive. Laver's law says that a costume appears daring a year before its time; dowdy a year late; hideous ten years on; and romantic a century later.[20] Art fashion perhaps obeys a similar law. An Evelyn Waugh dialogue indicates why this seems disconcerting:

> "Is it Good Art?"
> "Well . . . I think it's a remarkable example of its period. Probably in eighty years it will be greatly admired."
> "But surely it can't be good twenty years ago and good in eighty years and not good now?"
> "Well, it may be *good* now. All I mean is that I don't happen to like it much."[21]

Perhaps changes in artistic taste have no deeper meaning than such changes in fashion; maybe what is acceptable just changes and laws explaining such change are highly arbitrary.

The most brilliant extended discussion of this dilemma is the Enlightenment masterpiece, *Rameau's Nephew*. Diderot opposes the nephew, who thinks that all that exist in society are roles defined by masks, to the philosopher, who seeks some truth outside appearances. Everyone takes up positions, the nephew asserts, because we all need and are needed by others. The beggar needs table scraps; the rich, support from the king; the king, help from his mistress and, perhaps, God. Because all human intercourse involves persuading others to serve our interests, disinterested behavior is a contradiction in terms. The philosopher is both condescending to and fascinated by the nephew. Even as he asserts that he is independent, we realize that he contradicts himself; without the nephew to study, he would know nothing of society.

Perhaps the nephew's position is inconsistent. If all that exists, as he asserts, is the taking up of positions, how can we speak of social reality? If there is nothing behind the masks we wear, how can we say that those masks hide anything? Marxists give one answer to these questions. What is objectionable for them is the philosopher's belief that a system of practice can be understood from the outside. Kojève compares the philosopher, the Cartesian who believes that objectivity is possible for the isolated thinker, to a "lunatic who believes that he is made out of glass. . . . we can assess his knowledge as lunacy or madness only because he is entirely alone in taking this knowledge for a truth. It is only by seeking

out ideas shared by others that we can be sure of not finding ourselves in the domain of lunacy."²² Like the political activist who demonstrates the accuracy of his or her social knowledge by successfully changing society, the nephew knows the rules of social life because he is engaged in that life. "It suffices to situate onself within 'real activity as such,' i.e. in the practical relation to the world . . . which entails no representation" in order to know that world.²³

Diderot's account aptly applies to our artworld, in which artists, dealers, collectors, and critics all take up positions. If artwriting is a form of rhetoric, then maybe its success and even its "truth" can be measured only by its power to convince artworld people. The general analysis of rhetoric is complex. Aristotle distinguishes between true claims and the persuasive presentations of false arguments: "To declare a thing to be universally true when it is not is most appropriate when working up feelings of horror and indignation. . . . The aptness of language is one thing that makes people believe in the truth of your story; their minds draw the false conclusion that you are to be trusted. . . ."²⁴ The more radical suggestion of *Rameau's Nephew* is that there may be no useful independent notion of truth; what is true is what is believed.

Fashion supplies a model for a world in which appearances are everything, and there is no reality behind those appearances. How I dress determines how people respond to me; their clothing, how I view them. Even if I reject the belief that younger professors, unlike bankers or hustlers, may go to work in faded blue jeans, my choice of conservative dress will be read in relation to that generally accepted code. Blue jeans signify "working dress" for the cowboy; "informal garb" for the broker; "dressing down" for the senior professor; and "provocation" or "absentmindedness" at a formal dinner. These codes, which everyone knows, even if they cannot put them in words, need no foundation because they are grounded in everyday behavior. John Molloy panhandled with and without a tie, making more than three times as much the first time; this experiment, worthy of Rameau's nephew, proved to him that a tie "can give off the right signals to keep you from being regarded as a no-class boob."²⁵

Just as Diderot's philosopher thinks that it is wrong to always take up positions, one fashion expert complains that it turns "life's most precious and fragile assets into marketable products of transient

worth."[26] We who have trouble matching our socks may think that she takes it so seriously because she does live in a world in which "fashion subverts ... definition of the self." Certainly, her moralistic comments imply that there is a contrast between appearance and reality, a distinction that the nephew's argument questions.

This may seem a highly conservative account; whatever is, it implies, therefore is right. Actually, the political implications are complicated. If today's system of practice has no justification beyond the fact that it is our practice, then a conservative cannot justify that system by appeal to tradition. Students in the 1980s dress differently from students in the 1960s, but this change shows neither a decline nor an advance in dress aesthetics, only that fashion has changed. Now let us apply this analysis to art. What the art market guarantees is that, though artwriters may disagree, at one level consensus will be achieved; treated as a commodity, an artwork has a determinant value. However strongly I disagree with current fashion, still I know that this is the present-day standard; analogously, however much I disagree with artworld fashion, I know that it shows a certain consensus.

In the art market we find the kind of agreement about contemporary art that is achieved for the old masters by the professionalization of art history. What the market in contemporary art provides, at least, is agreement about the value of an artwork. This initially seems a very strange parallel. What has agreement about prices to do with agreement in art history about standards of interpretation? The parallel becomes clearer if we return to our discussion of taste. According to the traditional view that we discussed in chapter 1, artworks are good or not, and the artwriter's goal is to point to their excellences or weaknesses. Were that view correct, it would be possible to say that a work is good, though not yet thought good, or, conversely, bad, though today generally thought good. This traditional view of taste makes a distinction between the artwork as it really is and the work as it is generally thought of; but *Rameau's Nephew* and the analogy with fashion seek to undermine this distinction.

The critic who offers a persuasive analysis redefines the consensus. If we think of Greenberg, Fried, and their successors as experts who saw art as it is and then got others to recognize that they were correct, their roles are very difficult to understand. Why were all of the artwriters who

disagreed with them so mistaken? Why are Greenberg, Fried, and the others still thought of as important artwriters today, when their theories are generally rejected? If we identify them as masterful rhetoricians, however, we may better understand both why they are important thinkers and what they achieved. By convincing others in the artworld to accept their claims, these artwriters made statements that became widely accepted and so became true.

Certainly, matters of fact are true independent of what is believed. Even if someday everyone believes that Stalin was absolutely benevolent and that a Rothschild conspiracy caused World War II, those beliefs would still be false. Accounts of contemporary artworks do not, however, involve such factual claims. That Pollock is the heir to analytical cubism; that Stella's deductive structure was an important formal invention; that Salle uses appropriated images in a new way; that Marden is a materialist who learned from Cézanne's landscapes: to say that these claims are true is a perhaps overly dramatic way of signaling that they are central to thinking about contemporary art.

In appealing to the models of fashion and food and to *Rameau's Nephew*, I seek a rational reconstruction of a puzzling social system. If we look at the arguments of contemporary artwriters, often their claims are hard to understand; but if we look at the function their texts serve, they reveal their meaning. An anthropologist faced with "natives" who tell him things that he finds strange seeks to interpret their remarks so as to make them intelligible. The Droze of Ethiopia told the anthropologist Dan Sperber that "the leopard is a Christian animal who observes the fasts of the Ethiopian Orthodox Church"; that statement, Sperber notes, must be made consistent with the fact that "a Droze is no less careful to guard his animals on fast days."[27] Leopards, like Christians, it seems, may not act consistently on their beliefs. "If apparently irrational beliefs falsely appear to be irrational, that is" because they are falsely taken "to be beliefs in the philosopher's sense, i.e. propositions accepted as false."[28] Present-day art critics may be understood as arguing for beliefs like these.

Seeking thus to make sense of what people say is a good, perhaps inescapable, practice.[29] Still, such sympathetic interpretation is consistent with the belief that some viewpoints are more interesting, convincing, or plausible than others. The very structure of this book, which focuses on

a few selected figures at the expense of other artwriters, some well known, implies such a judgment. To argue with a writer, as I practice such argumentation, is already to show respect for his or her views; most artwriting is too ephemeral, boring, or unoriginal to inspire argumentation. Just as only a few painters are genuinely original, only a few artwriters find interestingly novel ways of discussing art.

Visual artworks do not, Danto writes, just assert facts, but present them "in a way intended to transform the way in which an audience receives those facts."[30] This is why we think that we have reason to be suspicious of rhetoricians. Tell us the plain truth, we demand; do not use suasive language. This request presupposes that there is a contrast between telling the truth plainly and using rhetoric. Faced with Greenberg's genealogies, Fried's account of theatricality, Krauss's reading of the end of art's history, or Masheck's discussion of icons, we may want some plain account; but there are no plain descriptions available. Artwriting is always a form of rhetoric, so the real distinction is not between suasive and plain accounts, but between more and less successful exercises in rhetoric.

An interest in rhetoric is found in the writing of a number of recent critics, who are rightly suspicious of the claims of earlier artwriters. My account differs from theirs, though, both in its systematic historical analysis and in its demand that we also consider critically the rhetoric of such deconstructions of traditional rhetoric. Though most postmodernist art is based on suspicion about the power of images to represent truthfully—as Salle's commentators all say—critics writing about this art are all too prone to take for granted the capacity of their texts to do so.

Consider, for example, the critic-painter Thomas Lawson's "Last Exit: Painting."[31] How, he asks, can painting continue? If the Russian modernist-revolutionaries failed; if minimalism took Greenberg too literally; if the interest in radical action "remained only a posture, rarely developing into a deeper commitment to social change"; if neo-expressionism is smug—then what is to be done? Some false solutions are listed. Sherrie Levine and Schnabel are seen as opposites, her "appropriations" matched by his "misappropriations." A positive suggestion appears for Lawson, though, "paradoxically," in one other critic's earlier account. If, as that critic says, painting's function depends upon the "mythology of individuality," then Lawson finds himself able to use this claim to criticize this

myth. "For since painting is intimately concerned with illusion, what better vehicle for subversion?"

The paradox here is only apparent, for given the way Lawson poses his question, what we inevitably expect, and get, is some resolution to it. Painting, he asserts, traditionally mimes reality, so today it can be used to subvert beliefs about what is real. Lawson can now contrast all the would-be photographers, who are not as radical as they think themselves to be, with the most radical younger artists, those who "place critical esthetic activity at the center of the marketplace"—for example, himself.

Notwithstanding its critique of formalism, the strategies here are surprisingly like those of Greenberg's narratives. Begin with a seemingly insoluble problem; discuss its history; note ways that it cannot be resolved; then conclude with a solution. Just as Pollock goes beyond cubism, and Stella goes one step further, so Lawson now continues painting. That this claim is so easily generated by such a historical narrative is one reason to be as suspicious of it as Lawson is of visual representations. Even if we think that "our very liberty is at stake," the order of such a historical analysis generates pressure to produce a seemingly inevitable conclusion.

If the central focus of "Last Exit: Painting" is constructing a narrative about the end of modernism, Lawson's concern in "The Dark Side of the Bright Light" is how artists are represented.[32] He gives an illustrated history of media representations of Pollock, Warhol, and Mary Boone. If we are overloaded "with staggering amounts of information," order may be created by this historical sequence. Just as for Fried, Stella is the last figure in the sequence Pollock–Louis–Stella, so Mary Boone, an art dealer, is the last figure in Lawson's sequence. Fried gave a formal analysis of Stella's paintings; Lawson analyzes the architecture of Boone's gallery, which both makes her visible to the larger public and genuinely accessible only to serious collectors.

To note that Boone, unlike Pollock and Warhol, is not an artist, misses Lawson's central point. For him, what counts today is less what an artworld figure does than how he or she is represented. Photos show Pollock at work, Warhol posing in an airline advertisement, and Boone doing her toenails; and Lawson links them in his narrative. Lawson's fear that now "all forms of representation" become "inert" is a strange

worry to present in *Artforum*, few of whose readers know Pollock or Boone only as represented in *Life*. Still, his strategy provides a creative alternative to a more traditional account centered on the art of Pollock, Warhol, and some painter associated with Boone. Boone is "one last, brilliant" master of publicity techniques, just as in "Last Exit: Painting" Lawson is the last post-Salle painter, less because no clever publicist will come after her than because he, like every good writer, aims to make his conclusion inevitable, achieving narrative closure. Lawson and Krauss have different taste, but share the belief that the end is in sight, while disagreeing about when it will come. Both provide compelling narratives, but are seduced by their very success as narrators into confusing mere narrative necessity with facts about the world.

Today, the distinction between the more and less sophisticated art-writers is perhaps a distinction between those writers who recognize that a critique of representation in art is itself a textual representation, vulnerable to criticism, and those who do not. When, for example, Kate Linker asserts that now "signs no longer refer to a 'subjective or objective reality'" because "there is no reality left to re-present," I ask, how, if true, can this be said? What could the word "reality" refer to in her sentence?[33] Similarly, though Hal Foster says that Barbara Kruger and Jenny Holzer call "language into crisis," he aims to describe that crisis clearly in his text.[34] Foster contrasts everyday passive manipulation of signs with the practice of artists "that renders the viewer an active reader of messages," a practice he subtly undermines by explaining how these artists use their signs. Perhaps in such artists' work "neither photo nor text is privileged"; but in Foster's account, he, the critic, is privileged in his text, which tells in so many words how their images function. Analogously, in a critical review comparing Marden and a younger artist, David Reed, Foster radically distinguishes these two not dissimilar painters. "Marden reworks old forms in contemporary terms"; Reed uses "all the old 'splits'... all the rigid dualisms of our worn Cartesian tradition."[35] Yet Foster's very critique of Reed's binary oppositions itself depends upon the simplest possible rhetorical opposition, that of good and bad; and even as he tries to show Reed's failure by contrasting Marden's success, his text presupposes the same contrast that he criticizes Reed's paintings for relying upon.

Craig Owens's article "Representation, Appropriation & Power" is

another relevant example, because it discusses the issues mentioned in its title by borrowing texts from Foucault and Louis Marin to criticize orthodox art history.[36] Owens describes an art history conference at which these absent Frenchman were misrepresented by two art historians, Svetlana Alpers and Fried; by contrast, Leo Steinberg's "sensitivity to the viewer" validated the Frenchmen's claims. Owens reports Marin to say that "representation is . . . appropriation and is thereby constituted as an apparatus of power"; and Owens uses this text to argue that "postmodernist artists demonstrate that . . . 'reality' . . . is a fiction." Within Owens's text, Steinberg functions as a sympathetic American, who links the two absent Frenchmen and the two Americans who misunderstand poststructuralism. Earlier, Owens appropriates Derrida's account of Meyer Schapiro and Heidegger, which criticizes them for treating what paintings represent as a "stand-in or replacement for someone who would not otherwise appear"; but these words describe exactly his own procedure. Like the postmodernist art it analyzes, Owens's text thus illustrates how narrative is ideological, "the apparent absence of an author" ultimately a fiction; for the author who assembles all of these quotations, demonstrating that "representation is an inextricable part of social processes of domination and control," is of course Owens himself.

Because I criticize these critics for being inconsistent, it is interesting to see that another artwriter constructs narratives consistently acknowledging their own status as fictions. Presenting us with a new development, the return of the figure, Carter Ratcliff's "Stampede to the Figure" says that actually the figure "never went away"; if Caspar David Friedrich and Turner used the figure, so do Pollock and Newman.[37] "Figure" here refers to the artist's will, which dominates a real or pictorial space. Ratcliff cultivates the deliberate paradox, as when he concludes that today's figure painters are pertinent just because their claims are dubious. What, though, exactly does he mean by "will," and how does appealing to it tie together Delacroix, Baudelaire's view of China, subway graffiti, Baron Haussmann's Paris, Rothko's suffering, Richard Long's landscape walks? But I merely list some of the topics that Ratcliff elegantly weaves into his narrative. The answer, of course, is that "will" is such a flexible, all-purpose concept that it cannot, and is not meant to, be defined.

What enchanted him, he writes, is critics' use of utterly inappropriate language, which may have "the allure of sheer willfulness."[38] Equally, I

am enchanted by his willfulness. He resents formalism for providing "fictions, and poor ones at that"; when he adds, "our resentments lay a trap for us, persuading us to define ourselves in simple opposition to what we resent," I begin to understand why he is interested in the will. But faced with "the confusion, fragmentation, doubt of the moment," how can he write? What act of will holds his text together? His David Salle catalogue helps us answer these questions.[39] Ratcliff flirts with a historical narrative, but, as we would expect given his criticism of formalism, his genealogy is half-hearted. He admits, "Once again, Salle is not a storyteller." Nor, of course, is he. If Salle's representations fail to describe reality, perhaps a consistent narrative about them should mimic those failings. Ratcliff says, "We might ask how Salle himself manages to survive in the face of the anxieties and ambiguities he cultivates in his art?" and his answer, that Salle "begins every painting under pressure to devise a given of his own," also describes his own procedures.

Still, Ratcliff seems to be left frankly dependent not only upon what he calls fictions, but on sheer contradictions. Salle's paintings, he concludes, permit "us to entertain two vital fictions," and so "take on the air of the simple, the self-evident, the given." Because earlier we learned of Salle's complexity, and were told that "the given" is a fiction, this text, which so openly questions its own conclusions, seems problematic. Ratcliff has described "the fiction that art criticism is coherent discourse" and identified the critic as a needed magician. "We can't shield ourselves from [the critic's] power. Nor is there any reason to want to." Clearly he cannot shield himself, for here Ratcliff appeals to the very clichés he denounces. "Magical thinking is in league with the fragmentary nature of modern experience." He repeats a tired cliché, and then provides that too-familiar fictional device, the upbeat conclusion: the best critics exchange "magical enchantment for imaginative language of a more sophisticated kind." I prefer to believe what he wrote a decade ago; art criticism "is a fiction...its unverifiable judgments are neither right nor wrong, but useful, appropriate, moving or not."[40] If that is true, how do we understand Ratcliff's own analysis?

Gombrich asserts that just as we see the rabbit-duck either as rabbit or duck, but not both simultaneously, seeing a representation as depiction momentarily blocks our capacity to see it as mere pigment.[41] Analogously, does awareness of an artwriter's rhetoric temporarily block our critical

awareness of his or her claims, or can we enjoy a text even while aware that it is but one of many possible accounts of the artwork it represents? This question is hard to answer. In any case, I admire and have learned from Ratcliff's discussion, but *Artwriting* differs from his texts in the way that it discusses rhetoric. He writes a text while frequently calling attention to its rhetoric, thus reminding us that it is merely a verbal representation; I accomplish the same task by comparing alternative interpretations: Gombrich and Greenberg on beginnings and endings; Stokes and Fried on art's presentness; Krauss and Masheck on the art system. Here, too, I have adopted the same procedure, describing recent artwriters' rhetoric by contrasting Ratcliff's texts to mine. My view of artwriting is similar to Ratcliff's, but I present it in a differently structured narrative.

The present-day suspicion of artwriting, I have argued in this chapter, is a natural product of that tradition, which *Artwriting* has philosophically reconstructed. Still, as not only Carter Ratcliff's texts but also my invocation of *Rameau's Nephew* should remind us, one major problem remains to be discussed. I say that artwriting today is an exercise in suasion, and criticism no longer provides an objective viewpoint; but how can I consistently make these assertions? Like the nephew and Ratcliff, I come to a problem faced by any relativist. To assert, that "truth is relative to the standards of the present culture" is seemingly to make a statement itself claiming to be true; but then that statement seems self-contradictory. In complaining that Lawson, Linker, Foster, and Owens fail to take their own expressed concerns about truth in representation seriously, how can I myself avoid making merely rhetorical statements? How, in short, can my discussion of rhetoric itself be truthful? To this problem I devote one brief, last chapter.

6 The Rhetoric of *Artwriting*

To understand an artwriter's argument, we must analyze his or her narrative strategies. This has been the central theme of *Artwriting*. But because, "it is always a fair question to put, whether a theoretical work on history can apply its theories to itself," I will now judge my book by the standards it applies to other texts.[1] To be a successful historian of artwriting, I must state my claims in language consistent with my analysis of the rhetoric of criticism. This is not necessarily easy to do. I like Ian Hacking's suggestion that "our discoveries are 'objective,' simply because the styles of reasoning that we employ determine what counts as objectivity.... We cannot reason as to whether alternative systems of reasoning are better or worse than ours, because the propositions to which we reason get their sense only from the method of reasoning employed."[2] Yet what then is the status of Hacking's analysis? Is his statement itself objective by the standard of objectivity he proposes?

Each interesting new style of argumentation in artwriting, we have found, is linked to a discovery of new ways to narrate. Far from being merely a literary affectation, an artwriter's style is thus a sensitive indicator of how he or she will argue. In artwriting, as in all representations, verbal and visual, the content cannot be subtracted without remainder from the form of the presentation. All problems about *representing* in artworks thus are also problems about the *representation* of those works *in artwriters' texts*. To understand my strategies of representation, consider my answers to the three questions posed at the beginning of the Overture: How do we identify the artwork? How may we choose between conflicting interpretations? What is the relation of an interpretation to the interpreter's goals?

Chapter 1 discussed how beginning a historical narrative requires a choice of a *subject*. The closer we come to the present, the more controversial is my choice of critics discussed. Everyone agrees that Greenberg is a major figure and that Fried was important. The roles of Krauss and Masheck are more debatable; I discuss their work both because it is intrinsically important and because it permits me to narrate my history of criticism. Any historical representation is selective. As Greenberg concentrates on impressionism, cubism, and abstract expressionism, relegating futurism, expressionism, and surrealism to minor places in his story of modernism, I discuss only a select group of artwriters. Another history, which discussed Harold Rosenberg, Lucy Lippard, Hilton Kramer, and Robert Pincus-Witten, might also be convincing; its success could only be determined after it was worked out in as much detail as is my account.

Chapter 2 described how artwriters' texts achieve narrative closure. Like any history, mine aims to achieve closure by solving in its conclusion the problems raised in its opening chapters. A period in art's history is "closed" once its visual tradition has been fully developed. Similarly, I believe, a period of artwriting is now closed, so this is a good time to explain what has happened in this period. Recent criticism, I argue, has worked out the problems posed by Greenberg and his successors. My defense of this claim is supported by analysis of the arguments of recent critics and of their role in the art market. Another historian might hold quite a different view of the situation today. My aim has been to interpret

the texts I think important, and that means, as Greenberg has noted, that I seek to control them. I believe this to be the result of every interpretation, because this activity always involves selective emphasis. My interpretation of Greenberg in comparison to Gombrich and in contrast to Fried, for example, serves to permit construction of an account in which discussion of art history narratives leads to the theory of art's presentness. In another history, the relation of Greenberg to Fried might be understood quite differently.

This point about alternative interpretations is not a merely speculative observation. Were I rewriting this book now, I would give much more emphasis to Leo Steinberg. His most famous published works in art criticism are his critique of formalism and his essay on Jasper Johns; because I contrast Greenberg to Fried and say little about Johns, Steinberg's important and influential texts play a small role in *Artwriting*. Steinberg's focus on the spectator's relation to an artwork provides a possible framework for a quite different history of recent art criticism, an analysis that might link the ambiguous space of *A Bar at the Folies-Bergère* to the minimalists' creation of a *literal* relation of spectator to artwork.[3] Such an account would perhaps find more affinities between old master and contemporary art than does *Artwriting*; certainly it would interpret the rhetoric of recent critics differently.

Chapter 3 discussed the difficulties inherent in theories of art's presentness. Such accounts fail, I show, to provide a context for the works they describe. I provide a context for Fried's mysterious texts in two ways. Relating Fried to Stokes, I explicate the theory of art's presentness; and linking Fried to writers who discuss the artworld system in the next chapter, I show how Fried's theorizing itself can be placed in a historical context.

By discussing and criticizing two different theories of the artworld system, chapter 4 led to the account in chapter 5 of the model of art as fashion. In such an artworld, I argue, the truth of an artwriter's claims is measured by their persuasiveness. This standard applies also to *Artwriting* itself; this book is successful only in so far as it provides a persuasive history of criticism. If my narrative is skillful, chapter 5 provides a convincing conclusion. Thus, the thought may momentarily pass through the minds of readers, my own included, that I have told the story

of the end of art criticism. On reflection, however, we will recognize that only my narrative has ended.

We identify an artwork in relation to the artwriting describing that artifact; conflicting interpretations are always possible because criticism is an exercise in rhetoric. *The Transfiguration of the Commonplace* argued that artworks are unidentifiable except in relation to some theory of art. My concern with the artworld system extends this claim. An artwork, I assert, can only be understood relative to an interpretation, and an interpretation only understood relative to the present function of criticism. Even as I borrow from Danto, however, I offer a different view of artwriting. *The Transfiguration of the Commonplace* gives a general aesthetic theory; my more parochial concern is with recent artwriting. In art history, conflicting interpretations can be debated because there is consensus about how to argue; lacking the possibility of achieving such agreement, present-day art criticism is a different enterprise. Danto allows, of course, that all artwriting has a rhetorical dimension, but he does not envisage the artworld discussed in my fifth chapter. In part, maybe this is because his starting point was Warhol's Brillo boxes, exhibited in 1964. At that date, most art criticism was still journalism, and the market in contemporary art was not so highly developed.

Danto's discussion of the seven visually identical red squares provides a good model for understanding artwriting when conflicting interpretations can be debated, but recent criticism, I have argued, does not fit this model. This is why *Artwriting* has been so preoccupied with seeking a framework permitting an objective viewpoint on criticism today. The framework provided in chapter 5 is an equivalent to the art historians' consensus about methods of interpretation. One reason that recent art criticism is philosophically fascinating is that it poses complex dilemmas for the writer who would rationally reconstruct its history. The recent transformations of art criticism have been as rapid as the stylistic changes in art itself during this period, so a history of recent artwriting, as I have tried to show, can be as interesting as a discussion of the art such writing describes.

In the future, the way that this period of artwriting is understood will surely change radically. Then, it will be possible to describe late twentieth-century art more dispassionately. Just as Vasari could hardly anticipate the modern interpretations of Pontormo's Santa Felicita Altarpiece, it is

hard today even to speculate about the forms such artwriting will take. We may reasonably expect, however, that the future historians of our period will be interested in understanding how the novel artworks of this era were accompanied by the deeply original artwriting whose history I have here narrated.

Notes

ACKNOWLEDGMENTS

1. I use the word "artwriting" to refer to texts by both art critics and art historians. For precedents, see Walter Friedlaender, *Caravaggio Studies* (Princeton, 1955), p. xi, which speaks of "an art writer of the seventeenth century"; and Michael Fried, "Thomas Couture and the Theatricalization of Action in 19th-Century French Painting,"*Artforum* 8 (1970):46, which speaks of "evolution in nineteenth-century art writing." Unlike them, I make "artwriting" a single word.
2. Leo Steinberg "The Sexuality of Christ in Renaisssance Art and in Modern Oblivion," *October* 25 (1983):iii.

OVERTURE

1. Arthur C. Danto, *The Transfiguration of the Commonplace* (Cambridge, 1981), pp. 1–2. The general philosophical argument is discussed, with full references to Danto's work, in my "Derrida as Philosopher," *Metaphilosophy* 16. (1985):221–34.
2. S. J. Freedberg, *Painting in Italy 1500–1600* (Harmondsworth, 1971), pp. 122–23.
3. Leo Steinberg, "Pontormo's Capponi Chapel," *Art Bulletin* 58 (1974):385–97. John Shearman, *Pontormo's Altarpiece in S. Felicita* (Newcastle upon Tyne, 1971), pp. 10–11, offers another account that disputes Freedberg's.
4. Danto, *Transfiguration*, p. 175.
5. T. J. Clark, "The Bar at the Folies-Bergère," in *Popular Culture in France*, ed. J. Beautroy, M. Bertrand, and E. Gargan (Saratoga, 1977), pp. 223–253.
6. Richard Wollheim, *Art and Its Objects*, 2nd ed. (Cambridge, 1980), p. 197.

7. Leo Steinberg, "Pontormo's Alessandro de'Medici, or, I Only Have Eyes For You," *Art in America* 63 (1975): 64.

8. Anne Coffin Hanson, *Edouard Manet* (Philadelphia, 1966), p. 187.

9. George Mauner, *Manet, Peintre-Philosophe* (University Park, Penns., 1975), p. 162.

10. William Feaver, "What Makes Manet Modern?" *Artnews* 82 (1983): 54–57.

11. Françoise Cachin, Charles S. Moffett, and Michel Melot, *Manet: 1832–1883* (New York, 1983), p. 478.

12. Anne Coffin Hanson, *Manet and the Modern Tradition* (New York, 1977), pp. 204–5.

13. This observation could be supported by discussion of Manet's puzzling study for this picture; see Novelene Ross, *Manet's Bar at the Folies-Bergère and the Myths of Popular Illustration* (Ann Arbor, 1977), p. 9.

14. Guy Debord, *Society of the Spectacle*, (Detroit, 1983), sec. 3, sec. 4.

15. Richard Wollheim, "Babylon, Babylone," *Encounter* 18 (1962): 36.

16. T. J. Clark, *The Painting of Modern Life: Paris in the Art of Manet and His Followers* (New York, 1985), pp. 267–68.

17. G. W. F. Hegel, *Aesthetics*, trans. T. Malcolm Knox, 2 vols. (Oxford, 1975), 2: 801, 808, 812.

18. J. W. von Goethe, *Italian Journey: 1786–1788*, trans. W. H. Auden and E. Mayer (New York, 1968), p. 79; entry for October 8, 1786.

19. H. Taine, *Italy: Florence and Venice*, trans. J. Durand (New York, 1872), p. 218; Jakob Burckhardt, *The Cicerone: Or, Art Guide to Painting in Italy. For the Use of Travellers*, trans. A. J. Clough (London, 1873), p. 178: see also Théophile Gautier, *Italia* (Plan de La Tour, 1978), chaps. 17, 18, 19.

20. Walter Pater, *The Renaissance: Studies in Art and Poetry,* ed. D. L. Hill (Berkeley, Los Angeles, London, 1980), p. 108.

21. J. A. Crowe and G. B. Cavalcaselle, *A History of Painting in Northern Italy*, trans. T. Borenius, 6 vols. (London, 1912), 3: 1–57.

22. Bernard Berenson, *Italian Painters of the Renaissance* (London, 1960), p. 123. The 1897 edition of this essay, *The Venetian Painters of the Renaissance* (London, 1897) contains a preface on connoisseurship, the popularizing essay on Venetian art, and—the longest part of the book—a listing of works and their locations in private collections, public galleries, and churches.

23. Frank Jewett Mather, Jr., *Venetian Painters* (New York, 1936), pp. 170–208.

24. Arthur C. Danto, *Analytical Philosophy of History* (Cambridge, 1965), p. 235; the most important recent discussion appears in Michel Foucault's work. See Foucault, *The Order of Things: An Archeology of the Human Sciences* (New York, 1970), pp. xiii–xiv.

25. Roger Fry, *Cézanne: A Study of His Development* (New York, 1958), p. 87.

26. Johannes Wilde, *Venetian Art from Bellini to Titian* (Oxford, 1974), p.61.

27. Freedberg, *Painting in Italy*, pp. 79, 78.

28. Pater, *Renaissance*, p. 109.

29. Salvatore Settis, *La "tempesta" interpretata: Giorgione, i committenti, il soggetto* (Turin, 1978).

30. Deborah Howard, "Giorgione's *Tempesta* and Titian's *Assunta* in the Context of the Cambrai Wars," *Art History* 8 (September 1985): 271–89.

1. BEGINNINGS IN NARRATIVE ART HISTORY

1. See Hayden White, *Tropics of Discourse: Essays in Cultural Criticism* (Baltimore and London, 1978); and Hayden White, "The Value of Narrativity in the Representation of Reality," *Critical Inquiry* 7 (Autumn 1980): 23.

 My discussion of Clement Greenberg here and in the next chapter draws frequently on the title essay in Leo Steinberg, *Other Criteria: Confrontations with Twentieth-Century Art* (New York, 1972).

2. Michael Baxandall, *Giotto and the Orators* (Oxford, 1971), p. 75.

3. Vasari, *The Lives*, trans. Mrs. Foster, ed. E. H. Blashfield, E. W. Blashfield and A. S. Hopkins, 4 vols. (New York, 1896), 1:50; 4:365.

4. E. H. Gombrich, *Art and Illusion* (Princeton, 1961), p. 48.

5. E. H. Gombrich, *The Story of Art*, 11th ed. (London, 1960), p. 144. Thomas Puttfarken, *Roger de Piles' Theory of Art* (New Haven and London, 1985), pp. 89–90, offers an interesting example within a Gombrichian framework. If viewing "the history of European painting from the fourteenth to the nineteenth century as a period of continuous improvement of the means of visual illusion seems to be a very attractive idea," still he detects "at least one break in this development"; the change from Renaissance attempts "to give . . . an accurate description of every small detail" to Baroque reliance "on suggestion and the spectator's imagination. . . . " I would generalize this point: the number of breaks we find in that tradition depends upon the goals of our narrative.

6. Andre Grabar, *Christian Iconography: A Study of Its Origins* (Princeton, 1968), p. xli.

7. Otto Demus, *Byzantine Art and the West* (New York, 1970), p. 239.

8. H. Taine, *Italy*, pp. 134–35.

9. Gombrich, *Art and Illusion*, p. 144.

10. E. H. Gombrich, *Meditations on a Hobby Horse* (London, 1965), title essay, pp. 1–11.

11. E. H. Gombrich, *Means and Ends* (London, 1976), p. 32.

12. Gombrich, *Story of Art*, p. 147.

13. See Edgar Wind, *Art and Anarchy* (New York, 1969).

14. Gombrich, *Story of Art*, p. 159.

15. For a discussion of Gombrich's analysis, see David Carrier, "Gombrich on Art Historical Explanations," *Leonardo* 16 (1983): 91–96.

16. Norman K. Smith, *A Commentary to Kant's 'Critique of Pure Reason'* (London, 1922), p. 338.

17. See Carrier, "Gombrich on Art Historical Explanations."

18. For a fuller analysis, see David Carrier, "Meditations on a Portrait of Comrade Stalin," *Arts* 59 (October 1984): 100–102.

19. See Robert Rosenblum, *Transformations in Late Eighteenth Century Art* (Princeton, 1967).

20. Clement Greenberg, "Modernist Painting," in *The New Art*, ed. G. Battcock (New York, 1966), p. 102.

21. Gombrich, *Story of Art*, p. 388; E. H. Gombrich, *The Ideas of Progress and Their Impact on Art* (New York, 1971), p. 76.

22. Gombrich, *Art and Illusion*, pp. 283, 287.

23. Clement Greenberg, *Art and Culture* (Boston, 1961), pp. 44, 51.

24. Clement Greenberg, *Hofmann* (Paris, 1961), p. 40.

25. Gombrich, *Story of Art*, p. 312.

26. Greenberg, *Art and Culture*, (1972), p. 76. Here and in n. 29 I refer to footnotes added in the 1972 text; other citations are to the 1961 edition.

27. Clement Greenberg, "After Abstract Expressionism," *Art International* 6 (1962): 25–32; see also Clement Greenberg, "Letter to Editor," *Art/World* 8 (October 1983): 1–2.

28. Greenberg, *Art and Culture*, p. 171.

29. Greenberg, *Art and Culture* (1972), pp. 73, 6–7.

30. Baudelaire, *Selected Writings on Art and Artists*, trans. P. E. Charvet (Harmondsworth, 1972), p. 403.

31. Greenberg, *Art and Culture*, p. 136.

32. Leon Battista Alberti, *On Painting*, trans. J. R. Spencer, (New Haven and London, 1966), p. 56.

33. Roger Fry, "Some Questions in Esthetics," reprinted in *Transformations: Critical and Speculative Essays on Art* (Garden City; 1956), pp. 23–26.

34. Anthony Blunt, *Nicolas Poussin* (London and New York, 1967), p. 4.

35. Roger Fry, *Cézanne*, p. 75.

36. Greenberg, "Modernist Painting," p. 103.

37. Greenberg, *Art and Culture*, pp. 42, 71, 77.

38. Heinrich Woelfflin, *Principles of Art History*, trans. M. D. Hottinger (New York, n.d.), pp. 89–90.

39. Greenberg, *Art and Culture*, p. 154; for discussion, see Anthony Blunt, "Illusionistic Decoration in Central Italian Painting of the Renaissance," *Journal of the Royal Society of Art* (April 1959): 309–26; Clement Greenberg, "Surrealist Painting," *Nation* 159 (August 12, 1944): 192–93; (August 19, 1944): 219–220.

40. Greenberg, "Modernist Painting," p. 109; Clement Greenberg, "Detached Observations," *Arts* 51 (December 1976): 86.

41. Gombrich, *Story of Art*, pp. 450–51.

42. Gombrich, *Art and Illusion*, p. 267.

43. See Joe Shannon, ed., *R. B. Kitaj* (Washington, D.C., 1981); and David

Carrier, "Morandi at the Guggenheim, Lichtenstein at the Whitney, Kitaj at the Hirshhorn," *Artscribe* 33 (February 1982): 61–63.

44. Greenberg, *Art and Culture*, pp. 137–38.
45. Ibid., p. 153
46. See Ernest Samuels, *Bernard Berenson: The Making of a Connoisseur* (Cambridge, Mass., and London, 1979); Meyer Schapiro, "Mr. Berenson's Values," *Encounter* 16 (1961): 57–67; Meryle Secrest, *Being Bernard Berenson: A Biography* (New York, 1979).
47. Greenberg, *Hofmann*, p. 40.
48. Clement Greenberg, "Seminar One," *Arts* (November 1973): 44–46.
49. See my review of Anthony Savile, *The Test of Time* (Oxford, 1982), in *Journal of Philosophy* 71 (April 1984): 226–30.
50. Clement Greenberg, "Can taste be objective?" *Artnews* 72 (February 1973): 22–23, 92; see also Clement Greenberg, "Seminar Two," *Art International* 18 (Summer 1972): 72–74.
51. See Francis Haskell, *Rediscoveries in Art: Some Aspects of Taste, Fashion and Collecting in England and France* (Ithaca, 1976), pp. 182–83.
52. David Robertson, *Sir Charles Eastlake and the Victorian Art World* (Princeton, 1978), p. 156, 189, 195, 197.
53. Clement Greenberg, "Modern and Post-Modern," *Arts* 54 (February 1980): 66.
54. E. H. Gombrich, *Ideals and Idols* (Oxford, 1979), pp. 156, 128, 157.
55. See Clement Greenberg, "How Art Writing Earns Its Bad Name," *Encounter* 18 (1962): 66–71.
56. Here I simplify by imagining that only these two accounts are available. For another account, one self-consciously opposed to Greenberg's, see Robert Rosenblum, *Modern Painting and the Northern Romantic Tradition: Friedrich to Rothko* (London, 1975); for an analysis of early modernism that both focuses on different artists and uses the vocabulary of poststructuralism, see Jean Clay, *Modern Art: 1890–1918*, trans. A. Rosin (Secaucus, 1978).

2. ENDINGS IN NARRATIVE ART HISTORY

1. Rudolf Wittkower, *Art and Architecture in Italy 1600–1750* (Harmondsworth, 1973), p. 489.
2. Rosalind Krauss, *Passages in Modern Sculpture* (New York, 1977), pp. 282–83.
3. See Gerald A. Cohen, "Beliefs and Roles," in *The Philosophy of Mind*, ed. J. Glover (Oxford, 1976), pp. 53–66.
4. Gombrich, *Art and Illusion*, pp. 324, 329, 299.
5. Ibid., pp. 367–68, 388.
6. Rosalind Krauss, "Seeing as Believing," *Raritan* 2 (Fall 1982): 86.
7. E. H. Gombrich, "Mirror and Map: Theories of Pictorial Representation," *Philosophical Transactions Royal Society* B 270 (1975): 142.
8. E. H. Gombrich, *The Sense of Order* (Ithaca, 1979), p. 59.

9. Gombrich, *Art and Illusion*, p. 389.

10. E. H. Gombrich, "Freud's Aesthetics," *Encounter* 26 (January 1966): 30–40.

11. Ernst Kris, *Psychoanalytic Explorations in Art* (London, 1953), chap. 7, "The Principles of Caricature," written jointly with E. H. Gombrich; see also Michael Podro, "Art and Freud's Displacement of Aesthetics," in *Freud*, ed. J. Miller (Boston, 1972), 126–35.

12. Greenberg, "Modernist Painting," 105.

13. B. Glaser, "Questions to Stella and Judd," ed. L. Lippard, pp. 148–64, and Michael Fried, "Art and Objecthood," p. 123, both in G. Battcock, ed., *Minimal Art* (New York, 1968).

14. Greenberg, "Modern and Post-Modern," p. 66.

15. Greenberg, *Art and Culture*, p. 67.

16. Ibid., p. 137.

17. Ibid., pp. 266–73.

18. Ibid., pp. 156–57, 77, 98, 172.

19. His equation of naturalism with some form of illusion has, however, been discussed by philosophers. See Richard Wollheim, *On Art and the Mind* (London, 1973), chap. 13; and Arthur C. Danto, "E. H. Gombrich," *Grand Street* 2 (Winter 1983): 120–32.

20. See Prii Halasz, "Art Criticism (And Art History) in New York: The 1940s vs. the 1980s: Part Three: Clement Greenberg," *Arts* 57 (April 1983): 80–88; Stephen C. Foster, "Clement Greenberg: Formalism in the '40s and '50s," *Art Journal* 35 (Fall 1975): 20–24; Barbara M. Reise, "Greenberg and The Group: A Retrospective View," *Studio International* 175 (1968): 254–57, 314–16; F. Frascina, ed., *Pollock and After: The Critical Debate* (London, 1985); B. H. D. Buchloh, S. Guilbault, D. Solkin, eds., *Modernism and Modernity* (Halfiax, 1983). In Greenberg's published work, perhaps the change in his status is defined most clearly in his *Avant-garde Attitudes: New Art in the Sixties* (Sydney, 1969), p. 12: "the variety of nominally advanced art in the 60s shows itself to be largely superficial." This judgment has not stood the test of time.

21. Jack D. Flam, *John Walker* (Washington, D.C., 1982).

22. See E. H. Gombrich, "Reynolds's Theory and Practice of Imitation," reprinted in his *Norm and Form* (London, 1966), pp. 129–34; and Edgar Wind, "Charity: The Case History of a Pattern," *Journal of the Warburg Institute* 1 (1937–38): 322–30.

3. THE PRESENTNESS OF ART

1. Giulio Lorenzetti, *Venice and Its Lagoon*, trans. J. Guthrie (Trieste, 1975), pp. 588–601.

2. David Rosand, "Titian in the Frari," *Art Bulletin* 53 (1971): 196–213; Henry James, *Italian Hours* (New York, 1979), p. 25.

3. Rainer Maria Rilke, *Rodin*, trans. J. Lemont and H. Trausil (London, 1948), p. 19.

4. Ezra Pound, *Gaudier-Brzeska* (New York, 1970), p. 86.

5. Wyndham Lewis, *Time and Western Man* (Boston, 1970), p. 174.

6. Hugh Kenner, *The Pound Era* (Berkeley and Los Angeles, 1971), p. 428; the novel was Edward Hutton's *Sigismondo Pandolfo Malatesta: Lord of Rimini* (London, 1906).

7. Pound's reviews are reprinted in H. Zinnes, ed., *Ezra Pound and the Visual Arts* (New York, 1980).

8. On Pound's view, see Carroll F. Terrell, *A Companion to the Cantos of Ezra Pound* (Berkeley, Los Angeles, London, 1980), p. 45.

9. See Rudolf Wittkower, *Sculpture: Processes and Principles* (New York, 1977).

10. For the historical background, see Sidney Geist, *Brancusi: The Kiss* (New York, 1978), and Charles Harrison, *English Art and Modernism: 1900–1939* (London, 1981).

11. Adrian Stokes, *Stones of Rimini* (New York, 1969), pp. 40, 243, 102.

12. A. Macadam, ed., *Blue Guide: Northern Italy from the Alps to Rome* (London, 1978), p. 453.

13. Adrian Stokes, *The Quattro Cento* (New York, 1968), pp. 59–65.

14. John A. Symonds, *Sketches and Studies in Italy and Greece* (London, 1914), p. 31.

15. Stokes, *Quattro Cento*, p. 15.

16. Jean-Paul Sartre, *The Psychology of Imagination*, trans. B. Frechtman (New York, 1966), pp. 246–49.

17. Gombrich, *Art and Illusion*, pp. 270–71, 216–19. 195–200, 232–23.

18. Edgar Wind, *Pagan Mysteries in the Renaissance* (New York, 1968), p. 130; Jean Seznec, *The Survival of the Pagan Gods*, trans. B. F. Sessions (Princeton, 1972), p. 133; John Pope-Hennessy, *Italian Renaissance Sculpture* (London, 1958), pp. 83–89; Charles Seymour, Jr., *Sculpture in Italy: 1400–1500* (Baltimore, 1966), pp. 130–34. See also Charles Mitchell, "The Imagery of the Tempio Malatestiano," *Studi Romognali* 2 (1951):77–90.

19. Stokes, *Stones of Rimini*, p. 119.

20. See Anthony Blunt, *Art and Architecture in France 1500–1700* (Harmondsworth, 1973), pp. 361–62; Jean-Louis Schefer, "Split Colour/blur," *20th Century Studies* 15/16 (December 1976): 82–100; Samuel J. Edgerton, Jr., "Alberti's Colour Theory: A Medieval Bottle without Renaissance Wine," *Journal of the Warburg and Courtault Institutes* 32 (1969): 109–34.

21. See Michael Baxandall, *Painting and Experience in Fifteenth Century Italy* (Oxford, 1972), pp. 81–85.

22. John Ruskin, *Modern Painters*, 5 vols. (Boston, n.d.), 5: 402–3; I am borrowing here from Stephen Bann, "The Case for Stokes (and Pater)," *PN Review* 6 (1979): 6–9, and S. Bann, "Couleur, délire et langage: Ruskin et Stokes," *Documents sur 6/7/8* (September 1980): 64–69.

23. Wollheim, *On Art and the Mind*, p. 32.

24. Adrian Stokes, *The Critical Writings*, ed. L. Gowing, 3 vols. (London, 1978), 2: 196.

25. See Richard Wollheim, *F. H. Bradley* (Baltimore, 1969). Stokes discusses Bradley in his notebooks and in two early books not included in *Critical Writings*.

26. Stokes, *Critical Writings*, 2: 32, 28, 67.

27. Stokes, *Critical Writings*, 2: 28.

28. Clement Greenberg, review, *Nation*, October 9, 1943, p. 416; see also David Carrier, "Adrian Stokes and Recent American Painting," *PN Review 15 7* (1980):50–51.

29. Stokes, *Critical Writings* 2: 71.

30. E. H. Gombrich, "The 'What' and the 'How': Perspective Representation and the Phenomenal World," in *Logic & Art: Essays in Honor of Nelson Goodman*, ed. R. Rudner and I. Scheffler (Indianapolis and New York, 1972), pp. 129–49.

31. Michael Fried, *Morris Louis* (New York, 1970), p. 26; Michael Fried, "Shape as Form: Frank Stella's New Paintings," *Artforum* 5 (November 1966): 23; and Michael Fried, "Two Sculptures by Anthony Caro," reprinted in R. Whelan, C. Greenberg, M. Fried, J. Russell, P. Tuchman, *Anthony Caro* (Harmondsworth, 1974), pp. 95–102.

32. Fried, "Art and Objecthood," pp. 145–46.

33. See Wollheim, *Art and Its Objects*, pp. 11–16.

34. Gombrich, *Art and Illusion*, p. 385; for a discussion of erotic images, see David Carrier, "Berger on the Female Nude," *Studies in Visual Communication* 7 (Spring 1981): 78–84.

35. Alexander Nehamas, "Immanent and Transcendent Perspectivism in Nietzsche," *Nietzsche-Studien* 12 (1983): 480.

36. Stokes, *Stones of Rimini*, p. 171.

37. Compare Oscar Wilde's characterization of Pater's prose: "far more like a piece of mosaic than a passage in music" (R. Aldington, ed., *The Portable Oscar Wilde* [New York, 1946], p. 64).

38. Stokes, *Critical Writings*, 2: 223.

39. The link with Ruskin has been emphasized by Stephen Bann. See also Richard Wollheim, "Adrian Stokes: critic, painter, Poet," *PN Review 15 7* (1980): 31–37.

40. Adrian Stokes, *The Thread of Ariadne* (London, 1925), p. 53; Adrian Stokes, *A Game That Must be Lost* (Cheadle, Hulme, 1973), p. 71.

41. Wyndham Lewis, *Tarr* (Harmondsworth, 1982), p. 312; see also Fredric Jameson, *Fables of Aggression: Wyndham Lewis, The Modernist as Fascist* (Berkeley and Los Angeles 1979), p. 97 and Frank Kermode, *Romantic Image* (London, 1971), p. 148.

42. Adrian Stokes, *Sunrise in the West* (London, 1926), p. 167.

43. Stokes, *Critical Writings*, 3: 173; 2: 304.

44. Ibid., 1: 20.

45. Pater, *Renaissance*, p. 106.

46. Stokes, *Critical Writings*, 2:199.

47. Ibid., 3:173; 2:309.

48. Baudelaire, *Selected Writings*, p. 131; he is describing Ingres.

49. Michael Fried, *Three American Painters* (Cambridge, Mass., 1965), p. 52.

50. Ibid., p. 14.

51. Michael Fried, *Morris Louis: 1912–1962* (Boston, 1967), p. 19.

52. Greenberg, "After Abstract Expressionism," p. 29.

53. Fried, "Shape as Form," p. 23.

54. Fried, "Two Sculptures," p. 98.

55. Michael Fried, "How Modernism Works: A Response to T. J. Clark," *Critical Inquiry* 9 (September 1982): 224.

56. Fried, "Shape as Form," p. 21; Fried, *Morris Louis* (1970), p. 34; Michael Fried, *Anthony Caro* (London, 1969), p. 7.

57. Richard Hennessy, "The Man Who Forgot How to Paint," *Art in America* 72 (Summer 1984): 13–25. A related point appears in Michael Brenson, "Seeing Contemporary Art in Light of Michelangelo," *New York Times*, August 19, 1984, sec. H, p. 23: "Once Stella produced his Black paintings, abstract works without content and without traditional pictorial space, the artistic sense of an inherited system of conventions broke down." Brenson goes on to make the interesting suggestion that the old masters, the cubists, and Pollock define a tradition which is continued by Fairfield Porter and the postmodernists.

58. Greenberg, "After Abstract Expressionism," p. 36; Steinberg, *Other Criteria*, p. 35.

59. See his contribution to *Art Criticism in the Sixties* (New York, 1967); contrast the highly critical early account of Morris Louis in Amy Goldin, "Morris Louis: Thinking the Unwordable," *ArtNews* 67 (April 1968): 49, 67–69.

60. Fried, "Art and Objecthood," p. 147.

61. Michael Fried, "Anthony Caro's Table Sculptures," *Art* 51 (March 1977): 96–97.

62. Michael Fried, "Jules Olitski's New Paintings," *Artforum* 4 (November 1965): 37.

63. Fried, *Three American Painters*, pp. 24, 40, 47.

64. Ludwig Wittgenstein, *Tractatus Logico-Philosophicus*, trans. D. F. Pears and B. F. McGuinness (London, 1963), p. 151.

65. Krauss, *Passages in Modern Sculpture*, p. 204.

4. THE ART SYSTEM

1. *Artforum*, "Special Painting Issue," 14 (September 1975); see especially "Painters Reply," pp. 26–36.

2. But see Greenberg's discussion of photography in his "Four Photographers," *New York Review of Books*, January 23, 1964, p. 8. Photography is discussed

by Fried's friend Stanley Cavell; see his *The World Viewed: Reflections on the Ontology of Film* (New York, 1971).

3. E. G. Gombrich, *Symbolic Images: Studies in the Art of the Renaissance* (London, 1972), p. 126.

4. Rosalind Krauss, "Notes on the Index: Seventies Art in America," *October* 3 (Spring 1977): 70. See also Patrick Maynard, "The Secular Icon: Photography and the Functions of Images," *The Journal of Aesthetics and Art Criticism* 43 (Winter 1983): 155–69; Joel Snyder, "Documentation without Ontology," *Studies in Visual Communication* 10 (Winter 1984): 70–95; and Peter Galassi, *Before Photography: Painting and the Invention of Photography* (New York, 1981).

5. Roland Barthes, *Camera Lucida*, trans. R. Howard (New York, 1981), pp. 76, 82.

6. Krauss, "Notes on the Index," p. 75.

7. Gombrich, *Art and Illusion*, pp. 298–99.

8. Erich Auerbach, *Mimesis: The Representation of Reality in Western Literature*, trans. W. Trask (Garden City, 1957), p. 7.

9. Norman Bryson, *Vision and Painting: The Logic of the Gaze* (New Haven, 1983), pp. 56–57.

10. Nelson Goodman, *Languages of Art: An Approach to a Theory of Symbols* (Indianapolis and New York, 1968), p. 229.

11. For criticism, see Michael Podro, "Misconceived Alternatives," *Art History* 7 (June 1984): 243–47; for more on Bryson's account, see Norman Bryson with David Carrier, "An Introduction to the Semiotic Theory of Art," *Leonardo* 17 (1984): 288–94, and the replies by E. H. Gombrich, *Leonardo* 18 (1985): 126, and *Leonardo* 18 (1986): 212–13.

12. See David Carrier, "On Narratology," *Philosophy and Literature* 8 (April 1984): 32–42, and Alexander Nehamas, "Mythology: The Theory of Plot," in *Essays in Aesthetics: Perspectives on the Work of Monroe C. Beardsley*, ed. J. Fisher (Philadelphia, 1983), pp. 180–96.

13. Meyer Schapiro, *Words and Images: On the Literal and the Symbolic in the Illustration of a Text* (The Hague, Paris, 1973), pp. 45–47. Comparing the accounts in the four Gospels would make this argument still more complex.

14. Rosalind E. Krauss, "Re-Presenting Picasso," *Art in America* 68 (December 1980): 93.

15. Gombrich, *Norm and Form*, p. 90.

16. Douglas Crimp, "On the Museum's Ruins," in *The Anti-Aesthetic: Essays on Postmodern Culture*, ed. H. Foster (Port Townsend, 1983), p. 45.

17. See Theodore Reff, "Manet and Blanc's 'Histoire des Peintres'," *Burlington Magazine* 112 (July 1970): 458. On the importance of reproductions for the teaching of art history, see Travor Fawcett, "Visual Facts and the Nineteenth-Century Art Lecture," *Art History* 6 (December 1983): 442–59. On photography, see Joel Synder, "Benjamin on Reproducibility and Aura: A Read-

ing of 'The Work of Art in the Age of its Technical Reproducibility.' "
Philosophical Forum 15 (Fall-Winter 1983–84): 130–45.

18. This highly important, influential idea is due to Steinberg, *Other Criteria*, p. 88.
19. Greenberg, *Art and Culture*, p. 75.
20. Krauss, *Passages in Modern Sculpture*, p. 256.
21. Meyer Schapiro, *Modern Art: 19th and 20th Centuries* (New York, 1978), pp. 218, 222.
22. Eugenio Donato, "The Museum's Furnace: Notes Toward a Contextual Reading of Bouvard and Pecuchet," in *Textual Strategies: Perspectives in Post-Structuralist Criticism*, ed. J. V. Havari (Ithaca, 1979), p. 220. For a critical discussion, see Wollheim, *Art and Its Objects*, p. 175. See also Stephen Bann, *The Clothing of Clio* (Cambridge, 1984).
23. Brenda Richardson, *Frank Stella: The Black Paintings* (Baltimore, 1976), pp. 28–30.
24. Benjamin H. D. Buchloh, "Figures of Authority, Ciphers of Regression," *October* 16 (Spring 1981): 58.
25. Rosalind E. Krauss, "Reading Photographs as Text," in *Pollock Painting*, ed. B. Rose (New York, 1981); Gombrich, *Meditations on a Hobby Horse*, pp. 45–46.
26. Craig Owens, "Allan McCollum: Repetition and Difference," *Art in America*, 71 (September 1983): 132.
27. Rosalind E. Krauss, *The Originality of the Avant-Garde and Other Modernist Myths* (Cambridge, Mass., and London, 1985), p. 22.
28. Donald Kuspit, "Leon Golub's Murals of Mercenaries: Aggression, 'Ressentiment,' and the Artist's Will to Power," *Artforum* (May 1981): 52–57.
29. Donald Kuspit, "Ryman, Golub: Two Painters, Two Positions," *Art in America* 79 (July-August 1979): 89–90.
30. See Donald B. Kuspit, "Authoritarian Aesthetics and the Elusive Alternative," *Journal of Aesthetics and Art Criticism* 41 (Spring 1983): 271–88. Fried reports the epithet "fascistic" in his "How Modernism Works," p. 226; the same phrase has been applied to me by Kuspit in public debate. For a sophisticated, critical account of the philosophical tradition from which Kuspit borrows, see Raymond Geuss, *The Idea of a Critical Theory: Habermas and the Frankfurt School* (Cambridge, 1981). Donald B. Kuspit, "Civil War, Artist Contra Critic," *Artforum* (October, 1980): 53.
31. Hal Foster, *Recordings, Art, Spectacle, Cultural Politics* (Port Townsend, 1985), p. 123. As one Octobrist ruefully admits, "the strategy of appropriation becomes just another academic category—a thematic— through which the museum organizes its objects" (Douglas Crimp, "Appropriating Appropriation," in *Image Scavengers: Photography* ed. P. Marincola [Philadelphia, 1982], p. 34).
32. Krauss, "Seeing as Believing," p. 81.

33. Bryson, *Vision and Painting*, p. 55.

34. Gombrich, *Art and Illusion*, pp. 232–3, 299 (my italics).

35. Michel Foucault, *The Archaeology of Knowledge*, trans. A. M. Sheridan Smith (New York, 1976), p. 122.

36. Danto, *Analytical Philosophy of History*, p. 235.

37. Joseph Masheck, "A Toast to 55 Mercer," in *55 Mercer: 12 Years* (New York, 1982).

38. Joseph Masheck, "Painting Beyond Doubt: The New Work of Howard Buchwald," *Arts* 49 (March 1975): 53.

39. Stephen Bann, "Abstract Art—A Language?" *Towards a New Art* (London, 1980), p. 125.

40. Schapiro, *Modern Art*, pp. 244–45.

41. Joseph Masheck, *Historical Present: Essays of the 1970s* (Ann Arbor, 1984), pp. 143, 159.

42. Arthur Danto, "Nausea and Noesis: Some Philosophical Problems for Sartre," *October* 18 (Fall 1981): 11.

43. See L. Ouspensky and V. Lossky, *The Meaning of Icons* (Boston, 1969); Tamara Talbot Rice, *Russian Icons* (New York, 1963); K. Weitzman, M. Chatzidakis, S. Radojcic, *A Treasury of Icons* (New York, 1966); B. A. Uspensky, " 'Left' and 'Right' in Icon Painting," *Semiotica* 28 (1979): 33–39.

44. Masheck, *Historical Present*, "Scully's Stripes and Strokes," pp. 259–70.

45. Masheck, *Historical Present,* p. 221.

46. See David Carrier, *"Color in the Recent Work,"* *Sean Scully* (Pittsburgh, 1985), p. 22–27.

47. Alberti, *On Painting*, p. 50.

48. Roland Barthes, *The Pleasure of the Text*, trans. R. Miller (New York, 1975), pp. 6–7.

49. Masheck, *Historical Present*, p. 206.

50. Theodore Reff, "The Pictures within Cézanne's Pictures, *Arts* 53 (June 1979): 90; see also David Carrier, "On the Depiction of Figurative Representational Pictures within Pictures," *Leonardo* 12 (Summer 1979): 197–200.

51. Masheck, *Historical Present*, p. 173.

52. Lawrence Gowing, *Matisse* (New York, 1979), p. 135.

53. Gombrich, *Means and Ends*, p. 39.

54. Masheck, *Historical Present*, p. 187.

55. See Meyer Schapiro, "On Some Problems in the Semiotics of Visual Art," *Semiotica* I (1969): 226.

56. Masheck, *Historical Present*, pp. 171, 177.

57. Ibid., p. 283; see also Joseph Masheck, *Corpus Christi Church and Its Art: A Modern View* (New York, 1981).

58. Masheck, *Historical Present*, p. 223, quoting a theologian: "That is something that the ancient icon painters and Malevich and Reinhardt would all have understood, and that also pertains to painting now."

59. For discussion, see Joseph Masheck, "Observations on Harking Back (And

Forth)," *New Observations* 28 (1985): 10. He cites Matisse: "The young painter who cannot free himself from the influence of the preceding generation is in danger of being swalloped up," quoted in Pierre Schneider, *Matisse*, trans. M. Taylor and B. Romer (New York, 1984), p. 114. Masheck adds, "David Carrier had been telling me to read Bloom, but I probably had to come a certain distance by myself. . . . "

60. Peter Plagens, "The Academy of the Bad," *Art in America* 69 (November 1981): 59.

61. Masheck, *Historical Present*, pp. 251, 257.

62. Barthes, *Pleasure of the Text*, p. 59.

5. ART FASHION

1. Martin Wackernagel, *The World of the Florentine Renaissance Artist*, trans. A. Luchs (Princeton, 1981), pp. 300–301.

2. John Michael Montias, *Artists and Artisans in Delft: A Socio-Economic Study of the Seventeenth Century* (Princeton, 1982), p. 220. A very interesting discussion of collecting with full bibliography appears in Joseph Alsop, *The Rare Art Traditions* (New York, 1982). An account of the modern artworld appears in Howard S. Becker, *Art Worlds* (Berkeley, Los Angeles, London, 1982). On the sociology of contemporary art, see Carter Ratcliff, "The 'Art' of Chic," *Saturday Review*, April 8 1981, pp. 12–17.

3. Craig Owens, "Sherrie Levine at A & M Artworks," *Art in America*, 70 (Summer 1982): 148.

4. For the conservative view, see Hilton Kramer, "Criticism Endowed: Reflections on a Debacle," *New Criterion* 2 (November 1983): 1–5.

5. Greenberg, *Art and Culture*, pp. 3–21.

6. Ross Bleckner, "Transcendent Anti-Fetishism," *Artforum* 17 (March 1979): 50–55.

7. Reprinted in Pincus-Witten, *Entries (Maximalism)* (New York, 1983), pp. 54–60.

8. Donald B. Kuspit, "David Salle at Boone and Castelli," *Art in America* 70 (Summer 1982): 142.

9. Peter Schjeldahl, "The Real Salle," *Art in America* 72 (September 1984): 180–87.

10. Gerald Marzorati, "The Artful Dodger," *Artnews* 83 (Summer 1984): 46–55.

11. Robert Goodnough, "Pollock Paints a Picture," *Artnews* 50 (May 1951): 39–42, 60.

12. William Rubin, "Jackson Pollock and the Modern Tradition," *Artforum* 5 (February 1967):14–22; (March 1967):28–37: (May 1967):28–33. For discussion of the poststructuralist view with full references, see David Carrier, "Art without its artists?" *British Journal of Aesthetics* 22 (Summer 1982): 233–44.

13. John Ashbery, "Gray Eminence," *Artnews* 71 (March 1972): 26–7.

14. Jeremy Gilbert-Rolfe, "Brice Marden's Painting," *Artforum* 13 (October 1974):30–8.

15. Mel Ramsden, "'Brice Marden's Painting,'" *Fox* 2 (1975):8.

16. Marcella Hazen, *Classical Italian Cuisine* (New York, 1976), p. 451.

17. Prudence Glynn, *Skin to Skin: Eroticism in Dress* (New York, 1982), p. 43.

18. Alison Lurie, *The Language of Clothes* (New York, 1981), p. 117.

19. John T. Molloy, *Dress for Success* (New York, 1975), pp. 64, 137.

20. Ibid., p. 7; see also Quentin Bell, *On Human Finery* (London, 1976), p. 185.

21. Evelyn Waugh, *Brideshead Revisited* (New York, 1956), p. 92.

22. Alexander Kojève, "Tyranny and Wisdom," an appendix to *On Tyranny*, ed. Leo Strauss, trans. M. Gold (New York, 1963): 143–88.

23. Pierre Bordieu, *Outline of A Theory of Practice*, trans. R. Nice (Cambridge, 1977), p. 96. As Lionel Trilling, whose analysis I borrow from, notes, it is hard "to read *Rameau's Nephew* without a ready awareness of its ambiguity" (Lionel Trilling, *Sincerity and Authenticity* [Cambridge, Mass., 1972], pp. 26–47). Interesting accounts appear in Jean Hyppolite, *Genesis and Structure of Hegel's "Phenomenology of Spirit,"* trans. S. Cherniak and J. Heckman (Evanston, 1974), p. 112; Alexandre Kojève, *Introduction à la lecture de Hegel* (Paris, 1947), p. 135; see also M. M. Bakhtin, *The Dialogic Imagination*, trans. C. Emerson and M. Holquist (Austin, 1981), p. 126; Erving Goffman, *The Presentation of Self in Everyday Life* (Garden City, 1959), p. 249, and *Asylums: Essays on the Social Situation of Mental Patients and Other Inmates* (Garden City, 1961), p. 165.

24. *The Works of Aristotle*. Vol. 11, *Rhetorica*, trans. W. E. Roberts (Oxford, 1924), 1395a, 1408a; see also David Carrier, "Ekphrasis and Interpretation: Two Modes of Artwriting," *British Journal of Aesthetics* 27, 1 (1987):20–31.

25. Molloy, *Dress for Success*, p. 77.

26. Kennedy Fraser, *The Fashionable Mind: Reflections on Fashion 1970–1981* (New York, 1981), pp. 145–59.

27. Dan Sperber, *Rethinking Symbolism*, trans. A. Morton (Cambridge, 1975), p.93.

28. Dan Sperber, "Apparently Irrational Beliefs," *Rationality and Relativism*, ed. M. Hollis and S. Lukes (Cambridge, Mass., 1982), p. 176.

29. This is the argument of Donald Davidson in *Truth and Interpretation* (Oxford, 1984), chaps. 9, 10, and 13.

30. Danto, *Transfiguration*, p. 166.

31. Thomas Lawson, "Last Exit: Painting," *Artforum* 20 (October 1981): 40–47.

32. Thomas Lawson, "The Dark Side of the Bright Light," *Artforum* 21 (November 1982): 62–66.

33. Kate Linker, "From Imitation to the Copy to Just Effect: On Reading Jean Baudrillard," *Artforum* 22 (April 1984): 44–47.

34. Hal Foster, "Subversive Signs," *Art in America* 70 (November 1982): 88–92.

35. Hal Foster, review, *Artforum* 19 (December 1980): 72–73.

36. Craig Owens, "Representation, Appropriation & Power," *Art in America* 70 (November 1982): 9–21.

37. Carter Ratcliff, "Stampede to the Figure," *Artforum* 22 (Summer 1984): 47–55.

38. Carter Ratcliff, "Critical Thought, Magical Language," *Art in America* 68 (June 1980): 148–52.

39. Carter Ratcliff, "David Salle and the New York School," *David Salle* (Rotterdam, 1983), pp. 25–40.

40. Carter Ratcliff, "Art Criticism: Other Eyes, Other Minds (Part 5)" *Art International* 18 (December 1974): 53–57.

41. Gombrich, *Art and Illusion*, pp. 5–6; for discussion, see Michael Podro, "Fiction and Reality in Painting," *Poetik und Hermeneutik* 10 (Munich, 1983):225–37.

6. THE RHETORIC OF ARTWRITING

1. Arthur C. Danto, *Narration and Knowledge* (New York, 1985), p. xiv. This point is made also by Althusser when he describes Marxism as "a philosophy that is capable of accounting for the nature of theoretical formations and their history, and therefore *capable of accounting for itself*, by taking itself as its own object." Louis Althusser, *For Marx*, trans. B. Brewster (New York 1970), p. 39.

2. Ian Hacking, "Language, Truth and Reason," *Rationality and Relativism*, p. 65.

3. For a brief discussion of Steinberg, see David Carrier, "Painting and Its Spectators," *Journal of Aesthetics and Art Criticism* 45, no.1 (1986):5–17.

Index